Christian Jankowski

Everything Fell Together

Des Moines Art Center

Selected Projects

1992–2004

1. **Shame Box** 1992

2. **Groundwork** 1993

3. **Secure Space** 1994

4. **Class Reunion** 1995

5. **Desperately Seeking Artwork** 1997

6. **Playing with Sponsor Money** 1996

7. **Singing Custom Officers** 1999

8. **Mexico City Billboards** 2002

9. **Painted Lectures** 2000

10. **Questions for the President** 2002

11. **House of the East** 2000

12. **Let's Get Physical/Digital** 1997

13. **Create Problems** 1999

14. **The Day We Met** 2003

15. **Commercial Landscape** 2001

16. **My Life as a Dove** 1996

17. **Director Poodle** 1998

18. **Flock** 2002

19. **The Matrix Effect** 2000

20. **Congratulations** 2000

21. **Poster Sale** 2002

22. **Telemistica** 1999

23. **The Holy Artwork** 2001

24. **Talk Athens** 2003

25. **Puppet Conference** 2003

26. **The Hunt** 1992

27. **Rosa** 2001

28. **This I Played Tomorrow** 2003

29. **What Remains** 2004

30. **Hollywood Snow** 2004

31. **16mm Mystery** 2004

I.

Shame Box
Shamkasten
1992

Jankowski invites passers-by to express their personal shame on a placard, and then sit on a chair in the window of the artist's storefront apartment, holding their placards, for as long as they like.

Performance in collaboration
with Frank Restle,
Friedensallee 12, Hamburg,
color video (120 minutes),
and 34 black-and-white photographs.

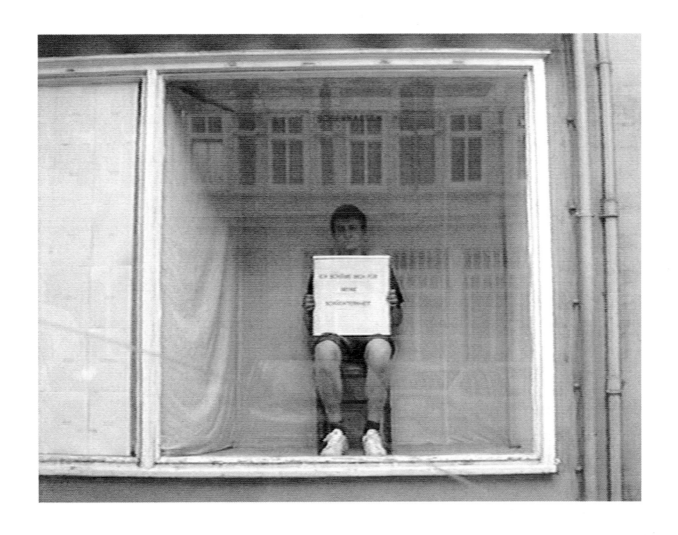

I am ashamed of my shyness

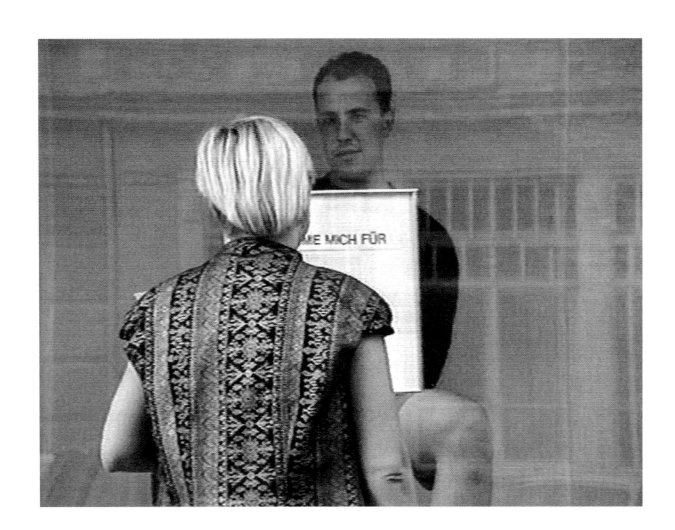

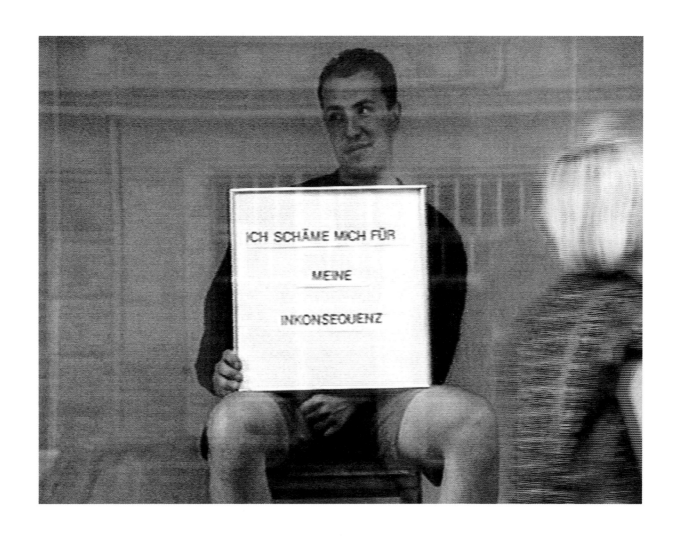

I am ashamed of my inconsistency

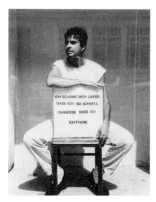

I am ashamed of
forgetting fast that
I exist

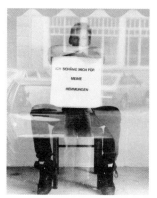

I am ashamed of
my untidy room

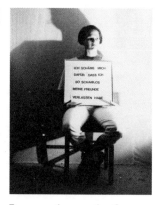

I am ashamed of
my inhibitions

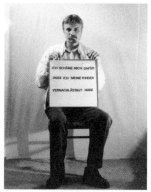

I am ashamed of
having neglected
my children

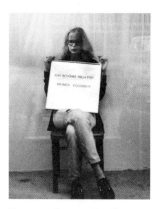

I am ashamed of
my egoism

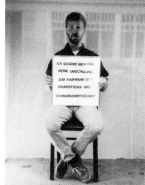

I am ashamed of
my re-education as
a real estate agent

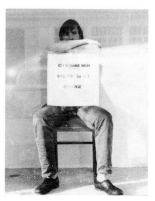

I am ashamed of
abandoning my
friends

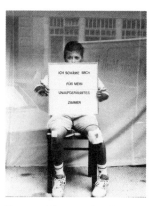

I am ashamed of
remaining silent
too frequently

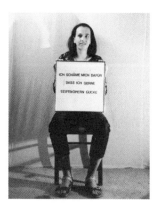

I am ashamed of
enjoying soap operas

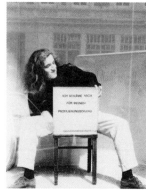

I am ashamed of
always wanting to
be in the spotlight

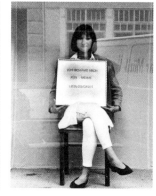

I am ashamed of
my resignation

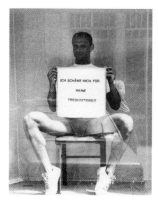

I am ashamed of
my horniness

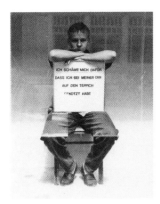

I am ashamed of
having thrown up on
my grandma's carpet

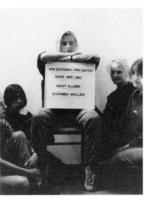

We are ashamed of
not wanting to be
ashamed alone

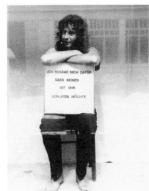

I am ashamed
because nobody
wants to sleep
with me

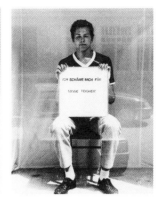

I am ashamed of
my cowardice

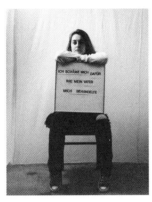

I am ashamed of
how my father
treated me

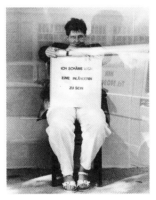

I am ashamed of
being a German
citizen

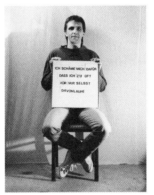

I am ashamed of
frequently running
away from myself

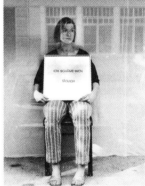

I am ashamed daily

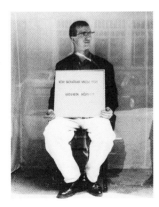

I am ashamed of
my body

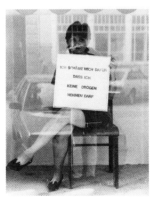

I am ashamed of
not being allowed
to take drugs

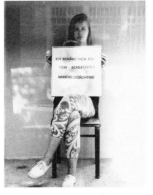

I am ashamed of
my bad memory
for names

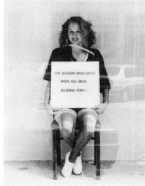

I am ashamed of
feeling too thin

2.

Groundwork
Bodenarbeit
1993

The owner of a sanding equipment rental shop demonstrates the proper use of sanding machinery by sanding the floor of the exhibition room at the Hochschule für Bildende Künste (Academy of Fine Arts), Hamburg. Not only is the video of the demonstration displayed on the exhibition room's freshly-sanded floor; the shop owner installs it in his shop as an instructional video for his customers.

Color video (6 minutes).

Opposite

Installation views.

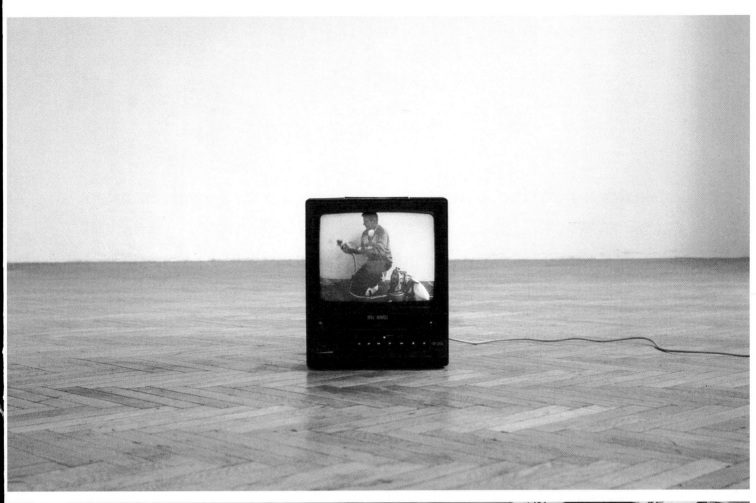

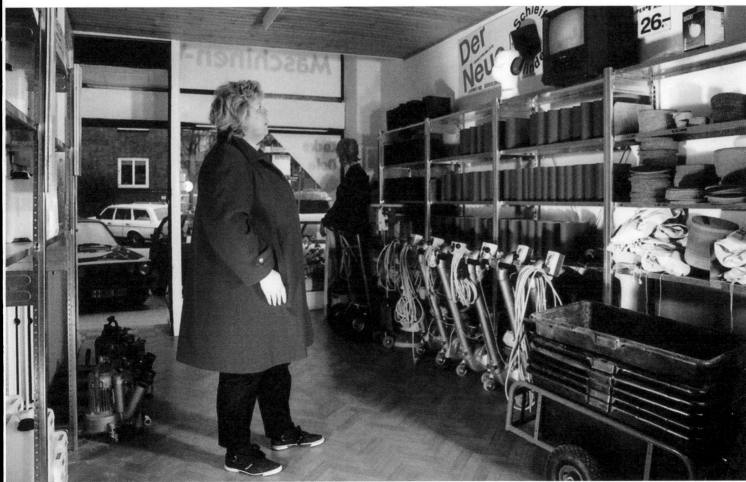

Secure Space
Der sichere Ort
1994

Jankowski hires a security company to guarantee the complete safety of guests inside his apartment. The company installs security cameras, covers the windows with bulletproof foil, and removes objects that could potentially be used as weapons from the apartment. Chairs and folding mattresses are provided for those who might want to sit or nap. For the next twenty-four hours, bodyguards monitor the interior, while Jankowski stands on the street, inviting passers-by to come in and enjoy total security. On their way in, all entrants are searched and scanned for weapons.

Performance at
Friedensallee 12, Hamburg,
and color video (24 hours).

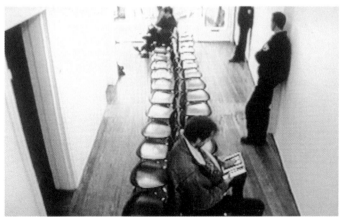

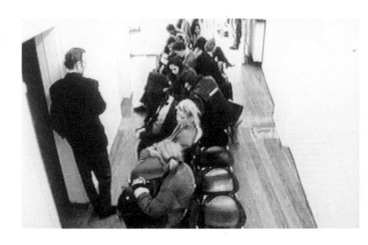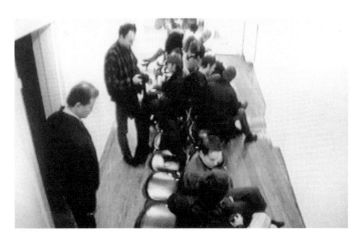

4.

Class Reunion
Klassentreffen
1995

Jankowski pre-emptively invites his fellow third year students at the Hamburg Hochschule für Bildende Künste for their 25th reunion, hiring a theatrical make-up artist to age the students a quarter-century. A fancy Hamburg restaurant caters the event, which is accompanied by a live music act. The aged artists are invited to contribute in any way they choose to the celebration: some give speeches, performances and toasts, while others provide spectacular dancing, all of which is recorded by a wedding photographer and a videographer who normally films family events. The camera man edits the final video, adding nostalgic music and cheap effects.

Performance
color video (20 minutes),
and photo album.

The students

(from upper left to bottom right)

Ali Hashemi
Athanasios Pallas
Jonathan Meese
Rüdiger Salzmann
Mark Noll
Christian Jankowski
Sandra Pohlmann
Dorothea Goldschmidt
Bianca Hobusch

*Hochschule für Bildende Künste,
Hamburg, 26.06.1995
Klasse Prof. Franz Erhard Walther*

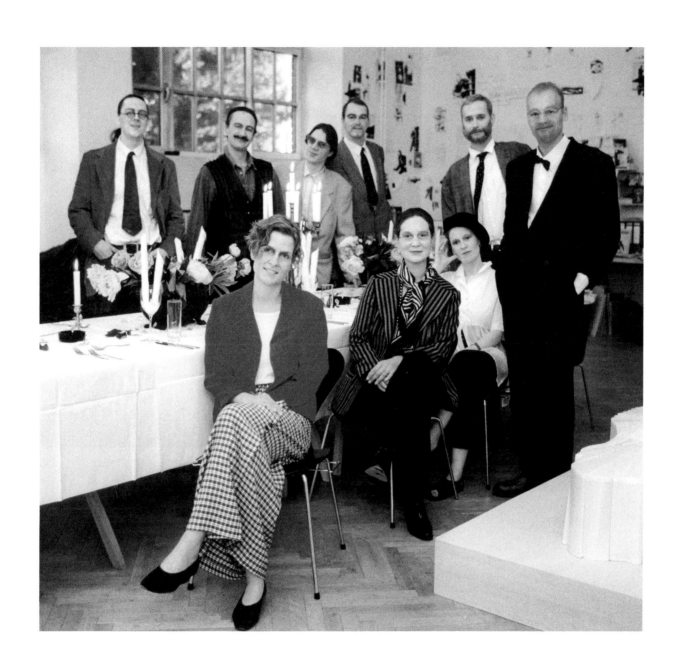

5. Desperately Seeking Artwork
Kunstwerk verzweifelt gesucht
1997

When commissioned to make a work in Graz, Austria for the exhibition *Zones of Disturbance*, Jankowski is struck by artist's block. Desperate, he seeks professional help, undergoing twelve intensive therapy sessions. In a final session, which is recorded on video, the psychotherapist summarizes the stages of his patient's self-realization and presents his conclusion. He identifies Jankowski's *Entwicklungskrise* (growing pains), and offers possible solutions. As he does so, Jankowski slowly rolls out of a rug on the therapist's floor.

Color video (18 minutes),
1 color photograph,
9 black-and-white photographs
with text, and letter.

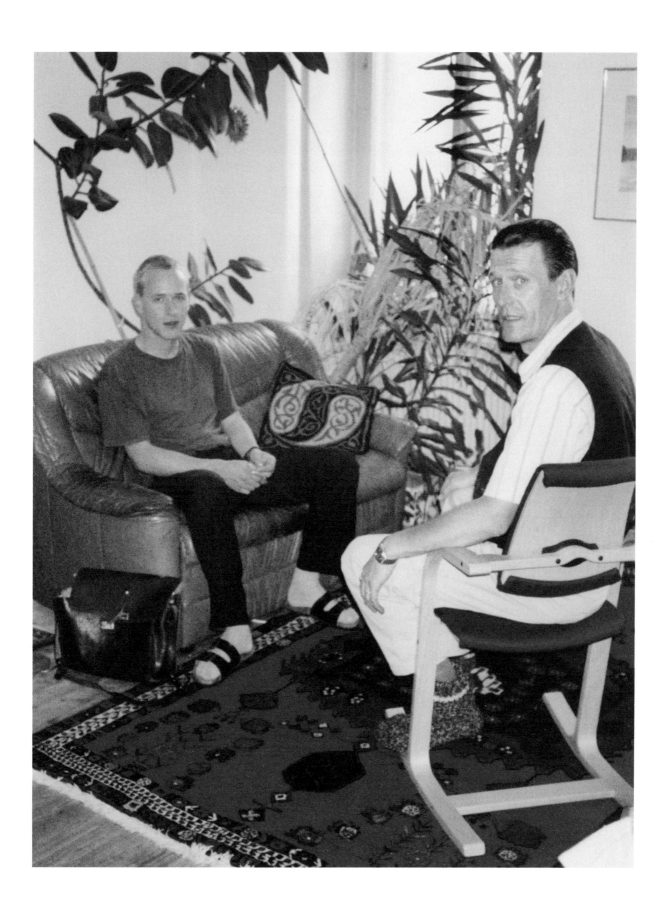

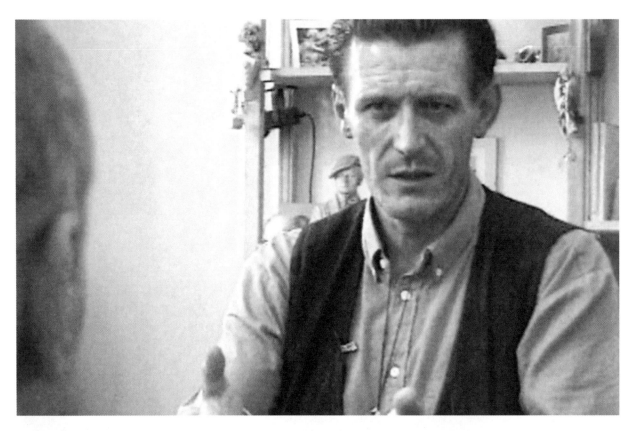
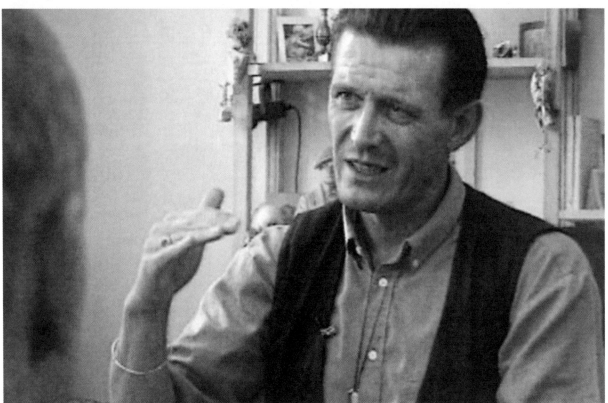

Final session

Therapist Dr. Siegfried Wesener-Gröbacher and Christian Jankowski are seated facing one another in his office.

Prelude: In a therapy-related exercise, a person is rolled up in an Oriental rug that lies on the floor of the office—the rug is unrolling ...

Therapist ———— Well, yes. From my point of view, it all started with a referral from a female colleague of mine. You came along and told me that a female colleague from the Styrian District Association, where you'd inquired, passed you on to me.

Interlude: The rug unrolls further ...

Therapist ———— And then my self-orientation, my inquiring: What? Where? How? ... and this slow collating of the individual pieces to an impression, for the moment at least. What is it all about? What's there? "Oh, here comes an artist from Hamburg, a young artist. He's to appear at the Styrian Autumn Festival" it slowly started to dawn on me ... to do something, and he is only just out of the academy of arts. He must be finding himself in a transitional stage or transition zone, going from a level of training towards becoming a professional—towards the autonomous execution of this profession of the artist, of a performance artist. And through this context—with the job pressure, the pressure to perform, and of not knowing what needs to be done exactly— through this he enters into this personal crisis-like condition.

Interlude: The rug unrolls further ...

Therapist ———— And then it becomes clear through exploration of your personal background and situation, that this is about a crisis-like state in connection to your development ... that an irritation has taken place... a disturbance, a word which is useful to call it, in connection to the title of the exhibition. And the disturbance goes along with the fact that the curator is a woman, who turns out to appear in a kind of motherly function, entering more and more into your personal world. And then through the demands of the assignment, this person created a disturbance, a zone of disturbance where something crisis-like, both personally and emotionally, started to occur.

Interlude: The rug unrolls further ...

Therapist ———— From my point of view, a conflict field was also created, and on this field, two different interests met and blocked each other: it was you, with your own interests, walking along your path, and then this female person stepped in and interrupted you with her assignment.

Jankowski ———— ... and the exhibition title.

Interlude: The rug unrolls further ...

Therapist ———— Something got in the way there, and it couldn't go on like it always had, so a new way had to be found.

Interlude: The rug unrolls further ...

Therapist ———— This also corresponds with the personal process. A repetition took place there—that's something you can say retrospectively—in the meaning of a personal story, one which very quickly reactivated both developed features and developing ones.

Jankowski ———— How?

Therapist ———— Meaning ... it was a kind of falling back into former circumstances of a familial nature.

Interlude: The rug unrolls further ...

Therapist ———— A third force was sought at this point—it was necessary, as I assess this retrospectively. There was a vacancy. A particular, specific quality of influence was sought, which was needed in order to mix and increase discussion so that a usable way through this labyrinth, this haze, could be found—so to say, a straight path towards the artwork ... to deliver, to fulfill the assignment without having to fail or totally lose composure.

Interlude: The rug unrolls further ...

Therapist ———— It also became obvious as a result of further questioning and clarifying, and of a transferral of information and interpretation, that it was essentially about the activation and appearance of a specific form of fatherly function. It was necessary to make it accessible, and to use it in order to make it possible for you to find your way from the initial commitment to the actual deliverance of the art piece.

Interlude: The rug unrolls further ...

Therapist ———— Here, it is the case that a process has taken place in twelve hours, or in twelve sessions, each one hour long... not to forget the time around it and the intervals between sessions, which were also productive and of importance. It is, anyway, a process which normally covers a longer period, so something very intense has certainly taken place here. The good thing, was that in the end, we weren't dealing with a disease with which you came, meaning a kind of mental illness, but we were dealing with both the natural development theme of becoming an adult, and the piece that was missing—which needed to be added. And then it was about preparing and creating the platform in order to make it transmittable, because it can be assumed that once you've reached the threshold of adulthood, your family, in an educational sense, has lost its power. In other words, all of these things are already long past and it is no longer possible to collect them directly from the family.

Interlude: The rug unrolls further ...

Therapist ———— What, then, was this peculiarity between your mother and you in the relationship? What is the specific feature in this difficult relationship? What was it caused by? Was it caused by a lack of fundamental attention or fondness, a lack of fundamental love and desire to have more? Or, as it became clear, was it caused by specific forms of respect, actually the lack of respecting the other's space ... in other words, meaning the requirement to stop, because if not, then intimacy tends slightly towards the abusive?

Interlude: The rug unrolls further ...

Therapist ———— I think in one way, she compelled you to be there for her and conveyed how important you are to her ...

Jankowski ———— Why only the mother? What about the father? I don't understand.

Therapist ———— ... in this near substitute for a romantic relationship ... Well, I think that in a setup such as this, the male partner always has an interest ... that his female partner does not turn to him and demand it from him, but that she somehow gets it elsewhere ... where it's easier to get and where it's less of a challenge. And on one hand, for you, it is something great to have such opportunities, to be so needed, to have such a special position, in a way. But on the other hand, it is also something displeasing. It is also not right—it requires a step back, because this kind of caring does not belong there. It belongs to a counterpart that still isn't really there, but will appear in adulthood as the female partner. And under these circumstances, you build a block of protection in the area of devotion and in the area of the heart ... and your propensity for being caught over and over again—meaning, being set under commission ...

Jankowski ———— What does that mean, "being caught"?

Therapist ———— "Caught," meaning that when a woman

engages you to create something for her, to give your most personal and your best ... then it can happen—this is the disturbance that triggers the irritation.

Interlude: The rug unrolls further ...

Therapist ———— Because how can you really give something of yourself, when you still haven't received something in particular, in this case from the paternal side? It has become obvious that something is lacking there. That particular support—in the form of confrontation, the form of strengthening, the form of sex-specific confirmation of one's own feeling, behavior, and approaches—has not adequately taken place in order for you to behave autonomously ... so that you can accept a commission without having to slip into this personal relationship sphere.

Interlude: The rug unrolls further ...

Therapist ———— So, speaking to you in your overexcited royal-prince-style behavior, and accompanying you down to common ground, and giving you the opportunity to come down—to allow the experience of a confrontation, a discussion, a meeting, and an intimate contact there, one that will be able to strengthen you in your own, your very own masculinity as a person—that was definitely the critical part for me.

Interlude: The rug unrolls further ...

Therapist ———— It is also a matter of descending from an attitude of, well, the tendency almost towards arrogance ... not in the form of a rise and fall, but of climb and descent to the common level earth. And as letting go of isolation-support in the form of foot-cushions, meaning slippers that are able to be removed, to feel what it means to stand on the ground and to permit an encounter on this ground.

Interlude: The rug unrolls completely, and Jankowski is free.

Therapist ———— There, where it comes to a parting after such a process, everything starts all over again from the beginning. ...

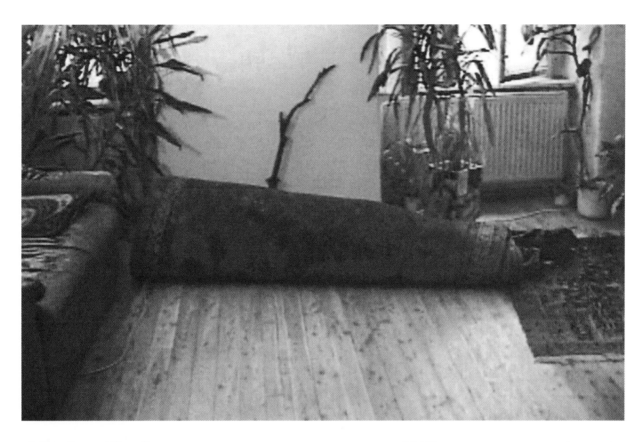

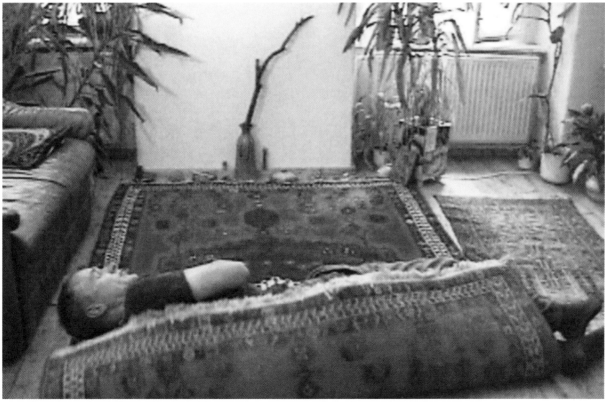

The secret of attraction is to love yourself. Attractive people neither judge themselves nor others. They are open to gestures of love. They think about love, and express their love in every action. They know that love is not a mere sentiment, but the ultimate truth at the heart of the universe.

Deepak Chopra

6. Playing with Sponsor Money
Spiel mit Sponsorengeld
1996

Jankowski approaches various businesses to sponsor his cover design project for *Texte Zur Kunst* #23. In exchange, the artist promises to include the names of the sponsors on the cover. With the intent of winning extra funds and representing the sponsors and magazine in the fanciest way possible—or lose everything—Jankowski takes the money to a casino. He plays roulette, betting the highest amount on the number 23 every time, until he has gambled away everything. Jankowski ends up using potato stamps to decorate the cover with the sponsors' logos.

Black-and-white photograph,
text, and *Texte zur Kunst* #23.

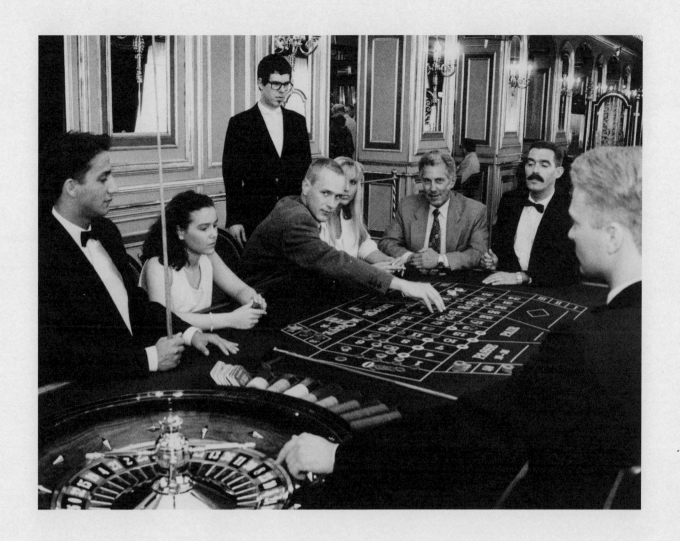

7. Singing Custom Officers
Zöllner singen
1999

French, Italian, German, and Austrian custom officers each sing their national anthem in front of their checkpoint. These songs are videotaped for an exhibition in the neighboring country of Switzerland. Upon entering Switzerland, which is not part of the EU, Jankowski declares the videotapes as artwork and must pay import duty. The final artwork consists of the resulting customs paper, and the four videos playing simultaneously on a pedestal in the shape of the Swiss cross.

4-channel video installation
and Swiss customs paper.

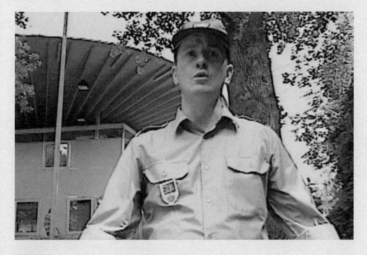

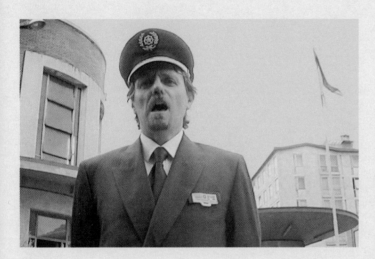
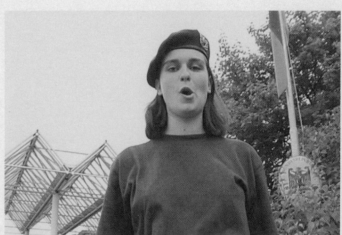

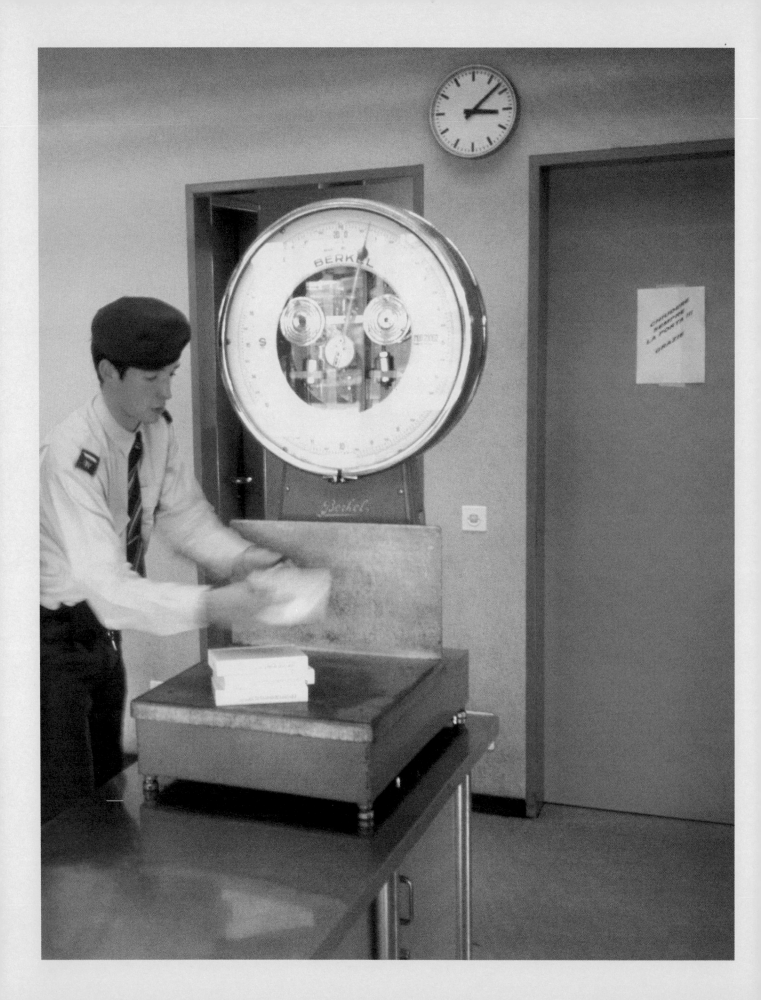

Zollausweis
Certificat douanier No **099726**
Certificato doganale

Kopie für
Copie pour Chiasso-Strada
Copia per

Ware Marchandise Merce	Tarif Voce di tariffa N°	Gewicht - Poids - Peso kg		Wert Valeur Valore Fr.	Ansatz Taux Aliquota Fr.	Betrag Montant Importo Fr.	c.
		netto net	brutto - brut lordo				
Italia							
4 CD DVD con contenuto	8524.530		05	400.-		esent	
artistico							
titolo « Zöllner Singen » 1333							

Empfänger
Destinataire Christian Jankowski
Destinatario c/o Centro d'arte contemporan.
 Via tamoro 3
 6559 Bellinzona

Zoll - Droit - Dazio

MWSt / TVA / IVA
7.6 % von - de - di Fr. 400.- 30 45

Total - Totale 30 45

Für das Zollamt
Pour le bureau
Per l'ufficio

Form. 11.10

8. Mexico City Billboards
Espectaculares
2002

To coincide with a symposium held in Mexico City on the topic of water, Universidad Nacional Autónoma de México (UNAM) and the Goethe Institut commission Jankowski to make a public artwork. He interviews the speakers at the conference regarding their lecture topics and asks how art may be able to illustrate global environmental issues. Then Jankowski approaches five local graphic design companies and asks them to design posters featuring water, using old ad campaign ideas that never made the final cut. Once the ads have been designed, he inputs the quotes from his interviews. The resulting five billboards are posted in Mexico City.

5 billboards.

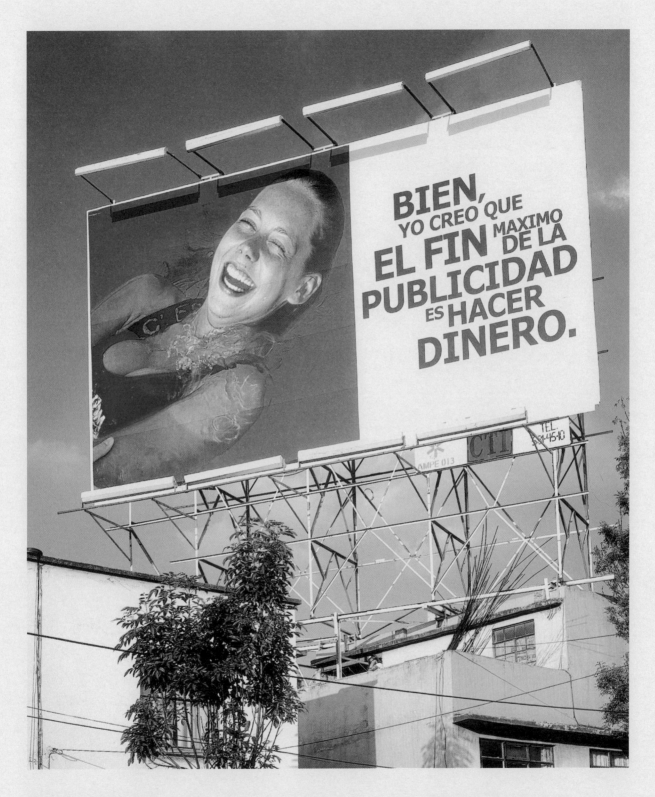

Well, I believe that the ultimate end of publicity is to make money.

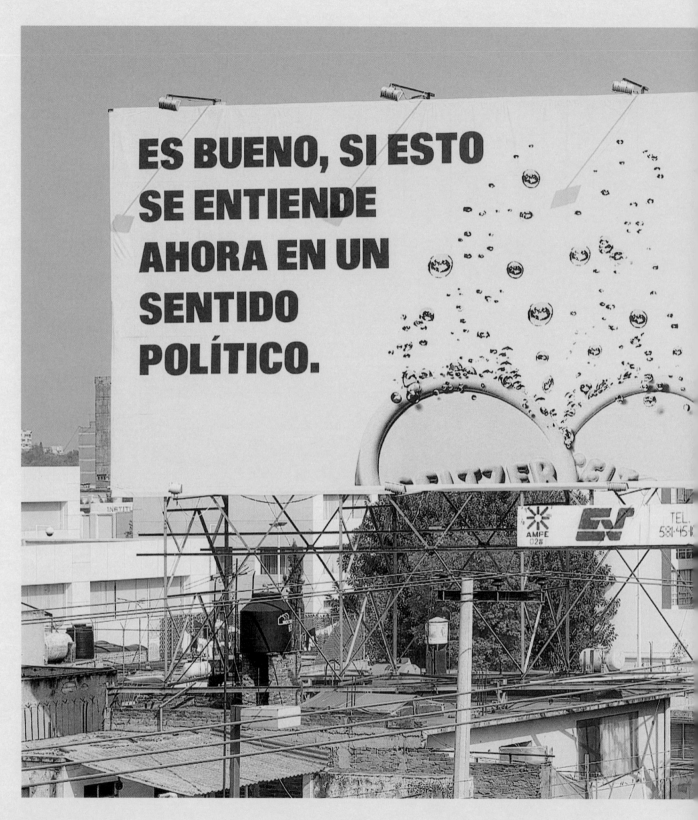

It'd be nice if this were understood as a political statement.

9.

Painted Lectures
Lehrauftrag
2000

The public relations manager of the Rheinisch-Westfälische Technische Hochschule (RWTH), a science university in Aachen, commissions a project in collaboration with the Kunstverein Aachen. Jankowski interviews the heads of five academic departments at the RWTH about the relationship between art and their respective fields. A group of student volunteers paints quotations from the interviews onto 30 banners, which are then hung up on the correlating department's building.

30 banners.

Final spread

Installation view,
Klosterfelde, Berlin

Where does simulation stop and reality begin?

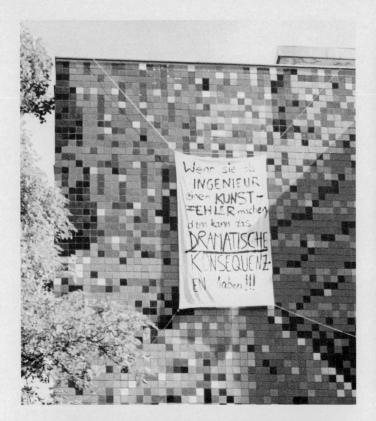

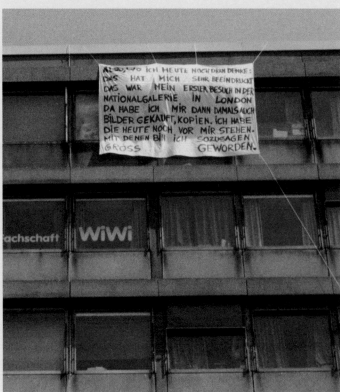

Professor Paul Beiss
Institute of Material Science

If an engineer makes an artistic error, it can have dramatic consequences!!!

Professor Manfred Zeidler
Institute of Mathematics, Computer Science, and Natural Sciences

When I think back on it today, my first visit to the National Gallery in London made a great impression on me. I also bought paintings there once, copies. I still have them with me today, I grew up with them, so to speak.

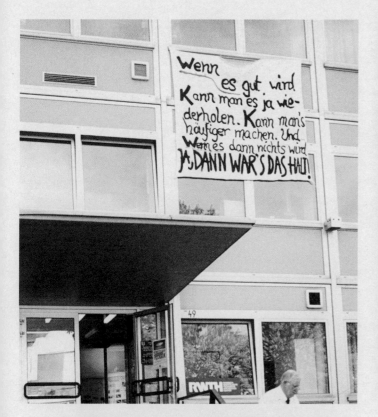

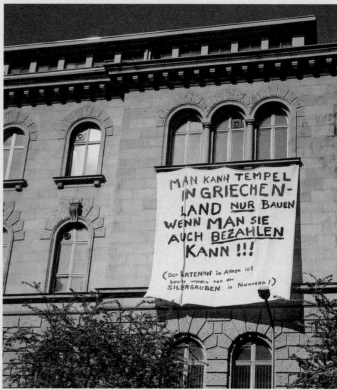

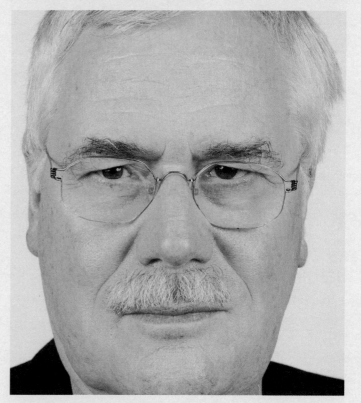

Professor Ulrich Dilthey
Welding and Joining Institute

If it goes well, we will do it again, we will do it even more often. And if it's not so successful—it's over!

Professor Andreas Seeliger
Institute of Mining and Metallurgical Mechanical Engineering

You can only build temples in Greece if you can pay for them!!! (The Parthenon in Athens was paid for by silver mining in Naureon!)

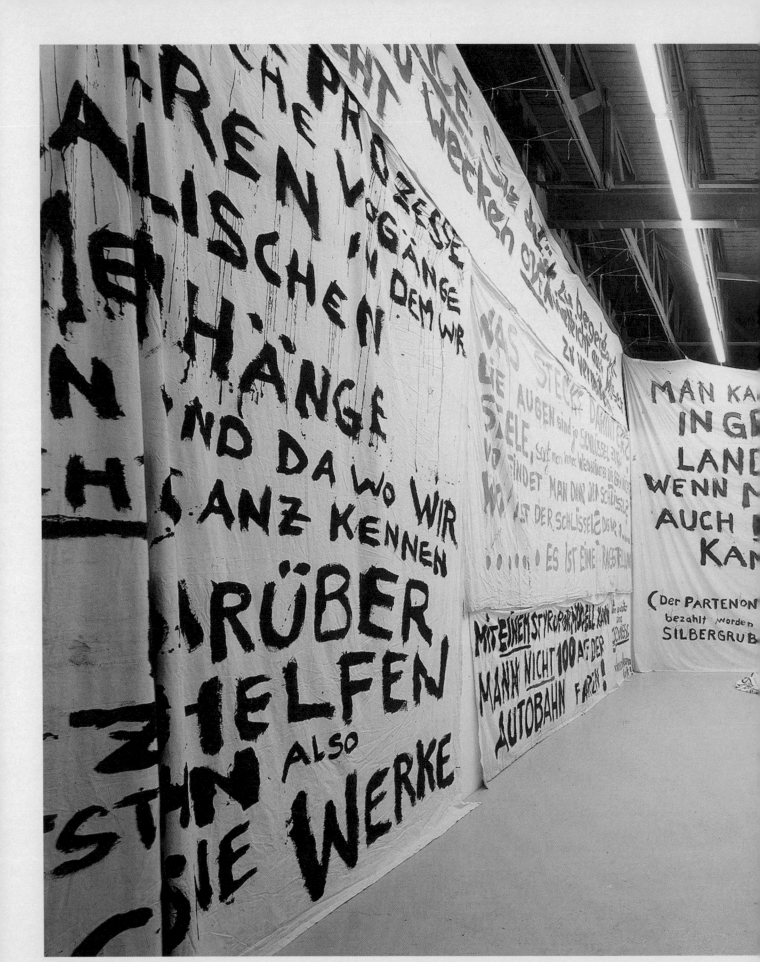

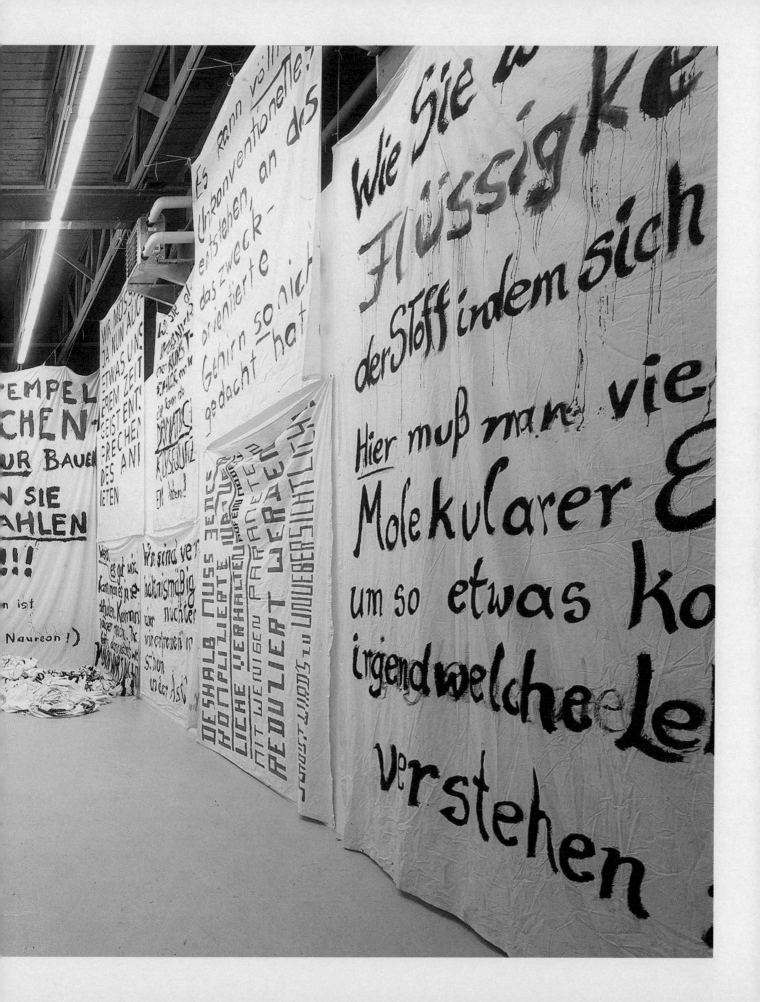

10. **Questions for the President**
 Presidentenfragen
 2002

For the 8th Baltic Triennial at the Contemporary Art Centre in Vilnius, Jankowski writes to Lithuania's president, Valdas Adamkus (1998–present), with questions about politics, economy, and art. Adamkus's answers are projected onto the wall at the triennial in disco colors by the same rotating light fixtures that had been used for the Lithuanian Pavilion at the Hanover Expo in 2000.

5 rotating light fixtures,
color photograph,
and letters.

II. House of the East
Haus des Ostens
2000

A few years after the Berlin Wall came down in 1989, the Hotel Sittavia opened in Zittau, in the former East Germany. This theme hotel is a miniaturized version of the German Democratic Republic (GDR), presenting life as it was during the Communist regime, with wall, curfew, and currency to boot. Jankowski advertises for people who had had a negative life experience under the Communist rule to take a trip with him to the hotel. There, he asks them to reflect on their life in the GDR as though they were still living it, and to work on a series of scenes: engaging each other in dialogues, and talking to the hotel staff, who play the roles of East German officials.

Color video (31 minutes).

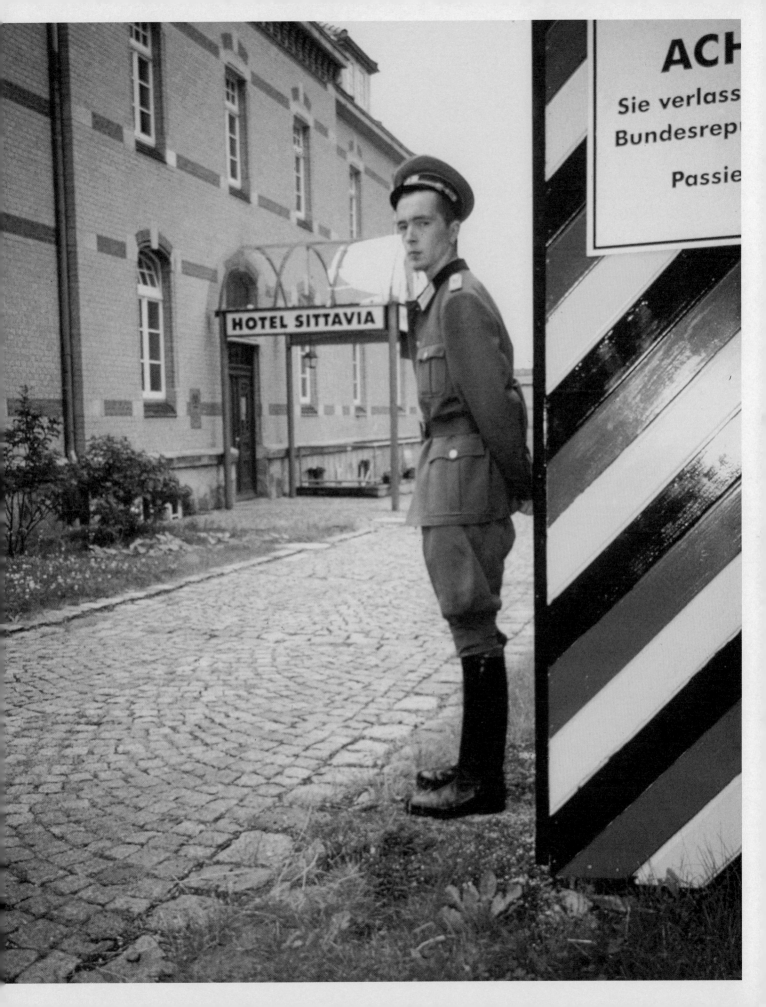

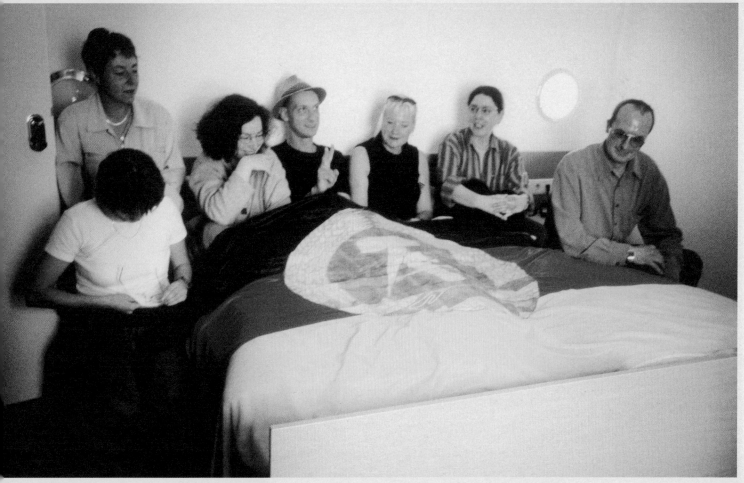

There are no limits on how much the heart can love, the mind can imagine, or the human being can achieve.

Lynne Cox

Let's Get Physical/Digital

1997

Internet chats are held over the course of seven days between the artist (at the time in Stockholm) and his then-girlfriend, Una Szeemann (in Milan), and transform into scripted dialogues. Seven actors, both amateur and professional, and all found on the Internet, bring someone they love to perform one of the seven scenes. The couples perform on a set cobbled together from objects ordered online to represent the fantasy meeting places (The Fireplace, The Bellydancing Corner, etc.) dreamed up in Christian and Una's conversations.

Color DVD (37 minutes)
and mixed media installation.

Final spread

Installation view,
Kunstmuseum Bonn.

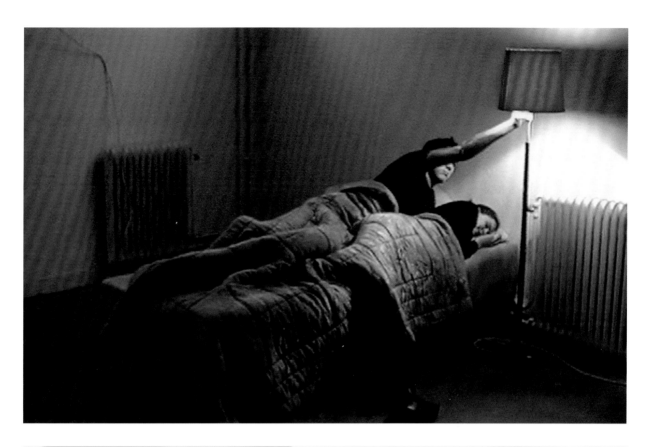

Then I forgot the password and my user name.

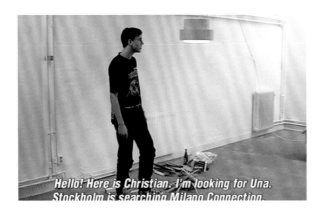

Hello! Here is Christian. I'm looking for Una.
Stockholm is searching Milano Connection.

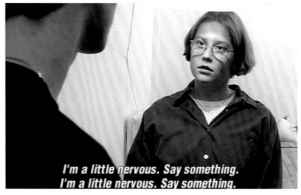

I'm a little nervous. Say something.
I'm a little nervous. Say something.

Eldstaden

The Fireplace

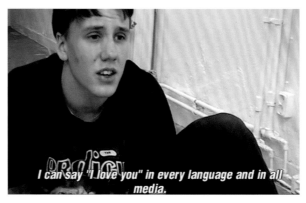

I can say "I love you" in every language and in all media.

It is seven o'clock. You don't seem to be here now.

I don't know how to get to you and everything is bad.

This is what I mean when I say that you interpret the things I write so dramatically.

Magdanshörnet

The Belly Dance Corner

Of course I'm here, my love. It's lovely to hear

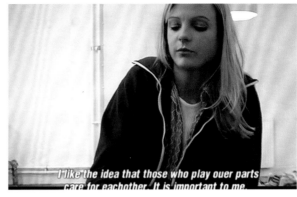

I like the idea that those who play ouer parts care for eachother. It is important to me.

Ok, now they will be able to experiment, even fill in a few of their own sentences if they want to.

Pasolinihörnet
The Pasolini Corner

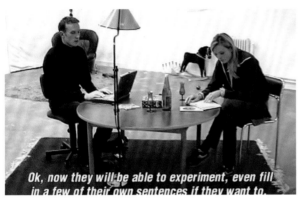

Hello, Christian. It's 04:40 pm and I am already here.

My dear, there you are. This is our last conversation in this room.

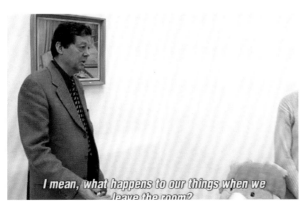

I mean, what happens to our things when we leave the room?

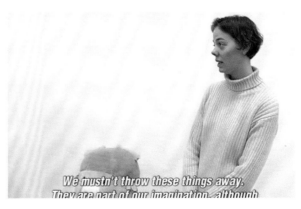

We mustn't throw these things away. They are part of our imagination, although

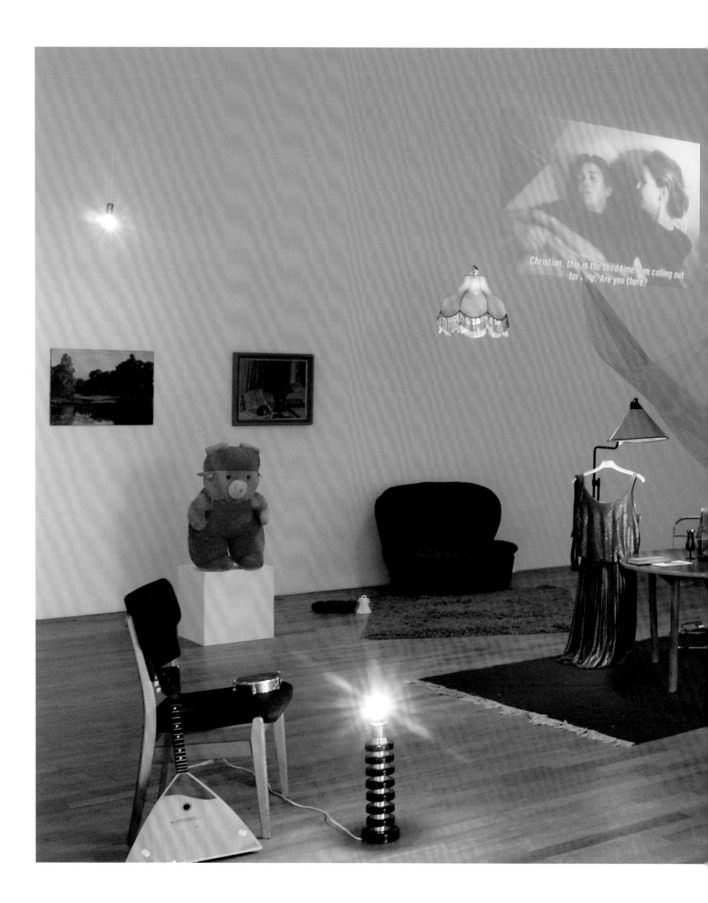

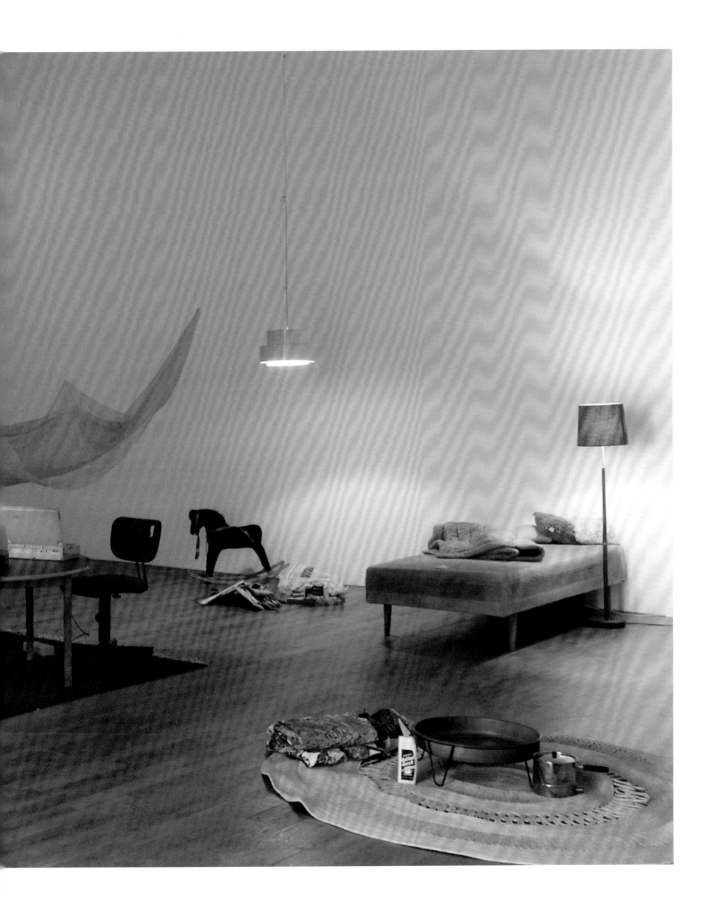

13. Create Problems

1999

Five couples from Wolfsburg (the divorce capital of the Germany) visit the Dolly Buster Studio, a professional porn studio in Dortmund. Each couple chooses a film set of their liking, such as *The Extreme Housewife* or *Piano Gigolo*. They then perform foreplay dialogues lifted from the exact same productions shot on their set. The moment the action should evolve into a real sex scene, one partner rekindles their last argument. Afterwards Dr. Fritz B. Simon, celebrity therapist, analyzes the scene.

9 scripts, 9 color photographs,
and color video (36 minutes).

Opposite

Production still.

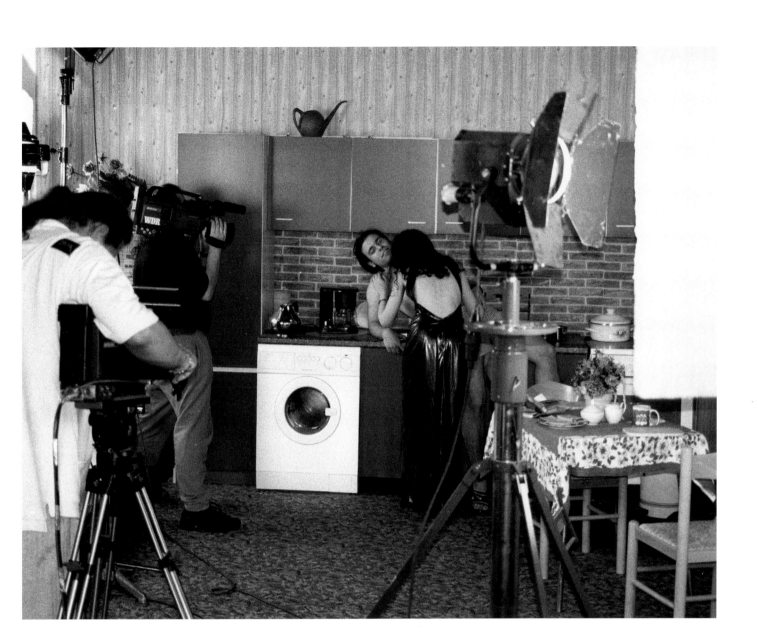

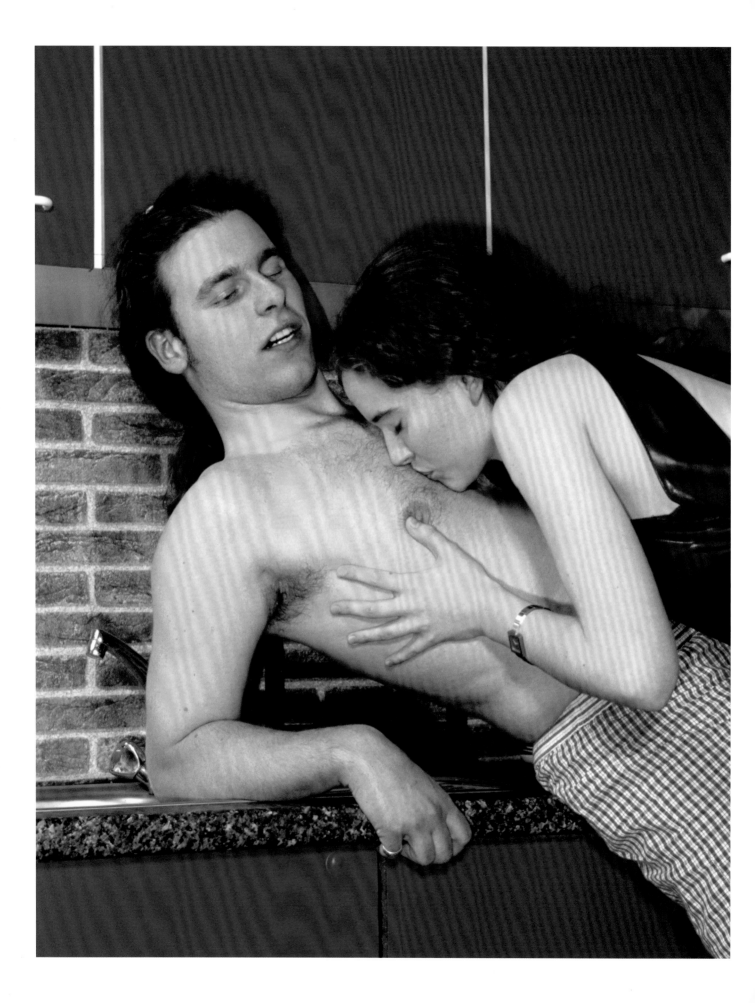

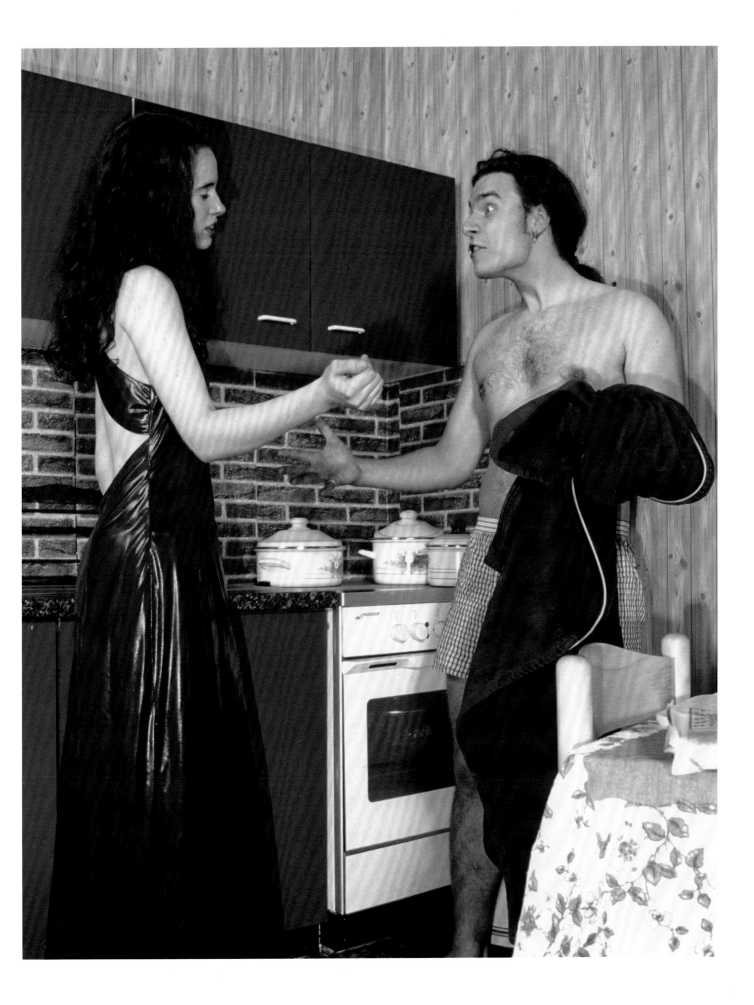

LIEBES-ZÜCHTIGUNGEN

DIE HEISSE AUTORIN

SUSANNE & MIRKO

SANDRA & ALEX

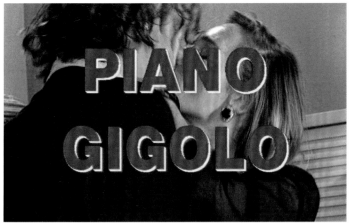

PIANO GIGOLO

KLINIK AFFAIRES

KATJA & BERND

NINA & PETER

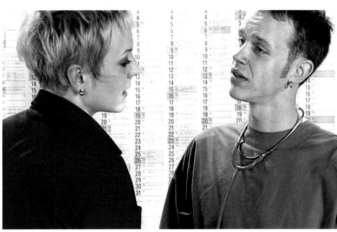

The Day We Met

2003

Jankowski collaborates with the karaoke company Taijin Media (the largest in Korea), to produce four video clips in which the artist appears as the main actor. Jankowski acts out love stories with various female characters written by Taijin's content director. The resulting videos play on Taijin's karaoke machines in bars worldwide, and are also used in a karaoke box gallery visitors are encouraged to enjoy.

Four karaoke clips
and karaoke box.

Opposite

Installation views,
Art Sonje Center, Seoul.

Final spread

Installation view,
Kunstmuseum Bonn.

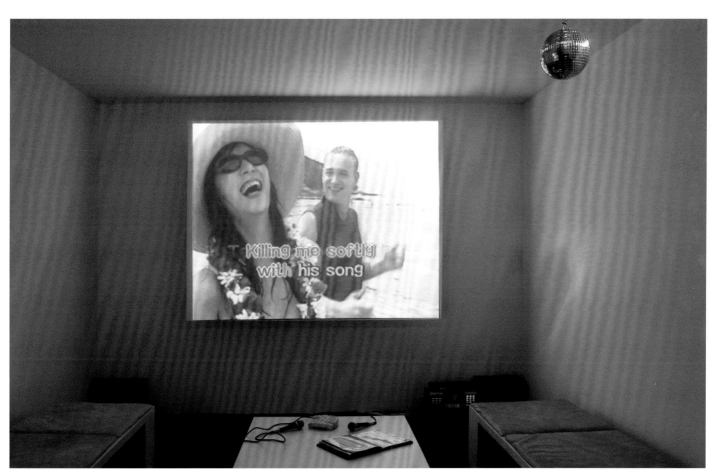

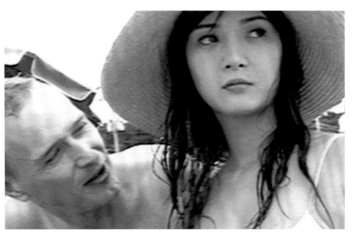

溶け出して mmmmh
토궤다시떼 mmmmh

見つめつづけていたい
미츠메츠즈케떼 이타이

불타는 그입술
묻힐거예요

消えるまで
키에루마데

この痛みが
코노 이타미가

자 떠나가요
Let's go

恐れてた
오소레떼타

目覚めれば君が
메자메레바 키미가

연인들의 해변으로 가요
Let's go

ささやく声が好き
사사야쿠 코에가 스키

耳元で mmmmh
미미모토데 mmmmh

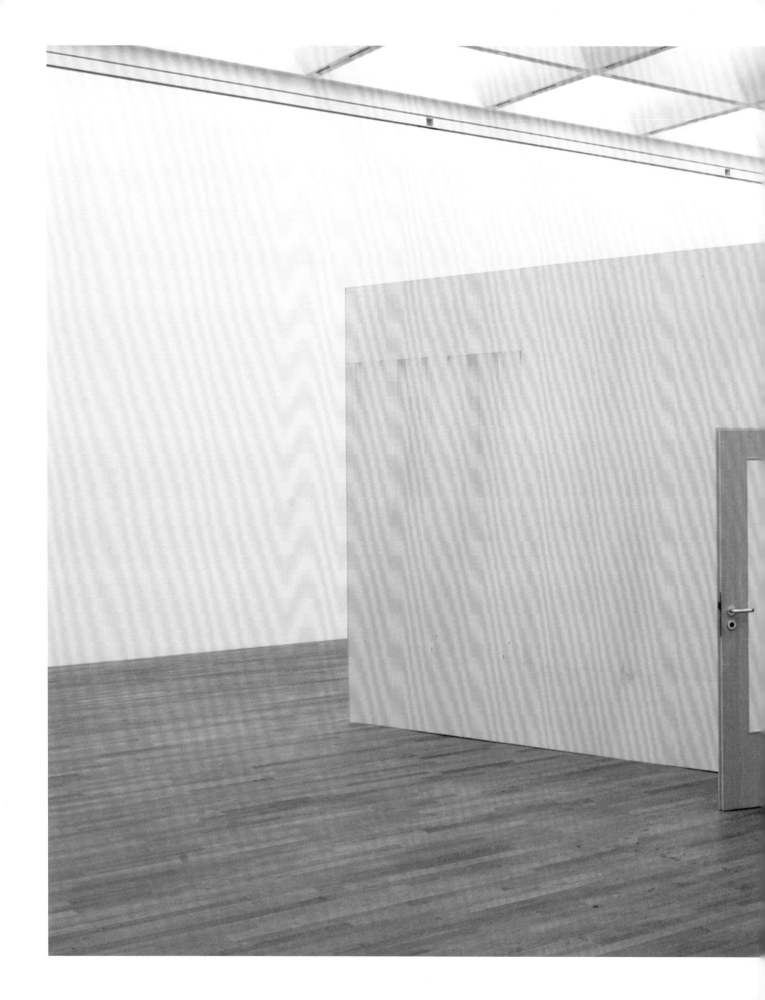

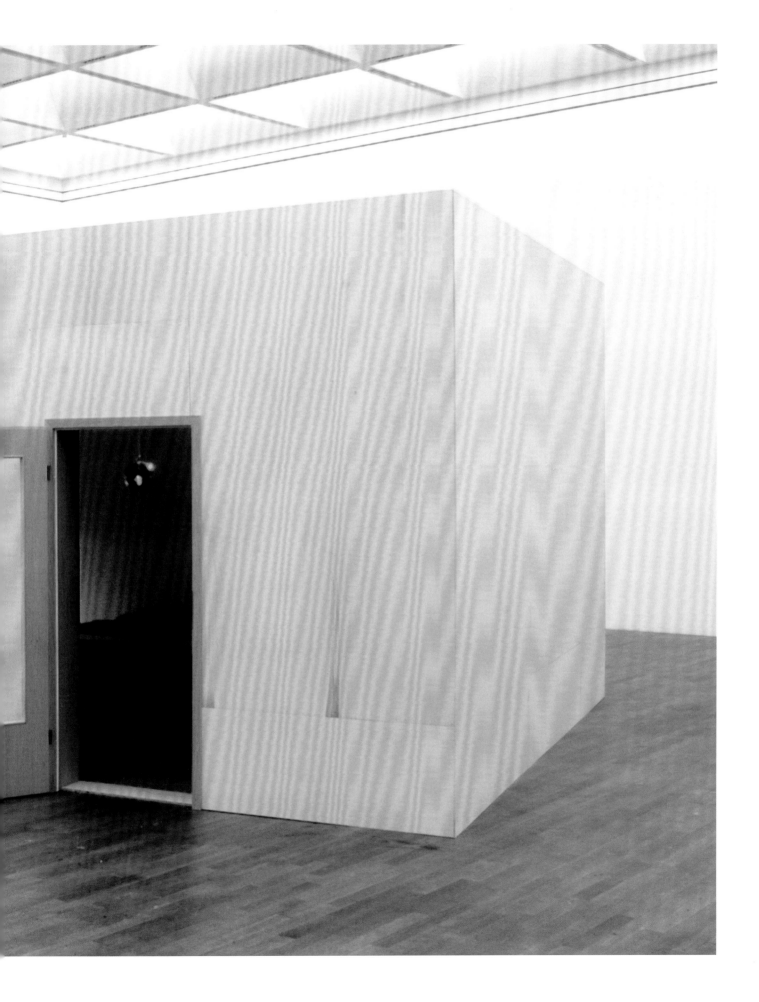

15. **Commercial Landscape**

2001

A boom in featuring the landscape of Tuscany in commercials prompts a movement to copyright the region, which in turn sets off a massive debate in Italy. Jankowski produces four of his own ads for Tuscany's commercial landscape. Actors recite a script made up of quotes from the newspaper articles that fueled the furor, in the most-filmed locations in Tuscany.

Color DVD (13 minutes).

Following spread

Installation view,
Kunsthalle Bremen.

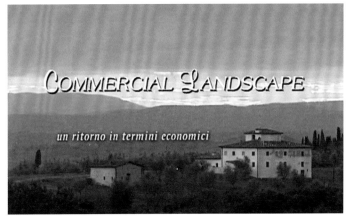

un ritorno in termini economici

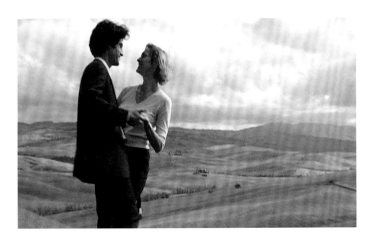

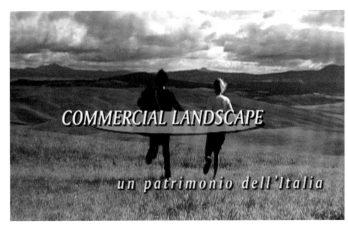

tutelare i consumatori nei confronti
della pubblicità ingannevole

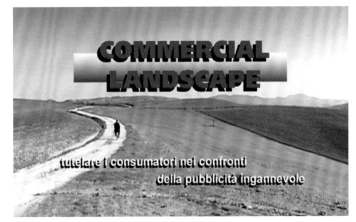

un patrimonio dell'Italia

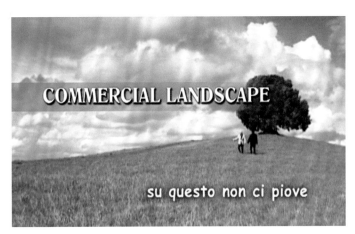

su questo non ci piove

We constantly cast the lure of expectation ahead of us hoping to hook a desired piece of the future. Something unimaginable always takes the bait.

Dee Hock

16. My Life as a Dove
Mein Leben als Taube
1996

At its opening, a magician transforms Jankowski into a dove for the duration of a three-week exhibition. Jankowski inhabits the gallery space, along with the other works of art. Gallery visitors are encouraged to let Jankowski out of his cage (as long as they put him back), to feed and water him, and to document his life as a dove with photographs and film.

Performance at
Lokaal 01, Antwerp,
color DVD (5 minutes, 41 seconds),
and 5 posters.

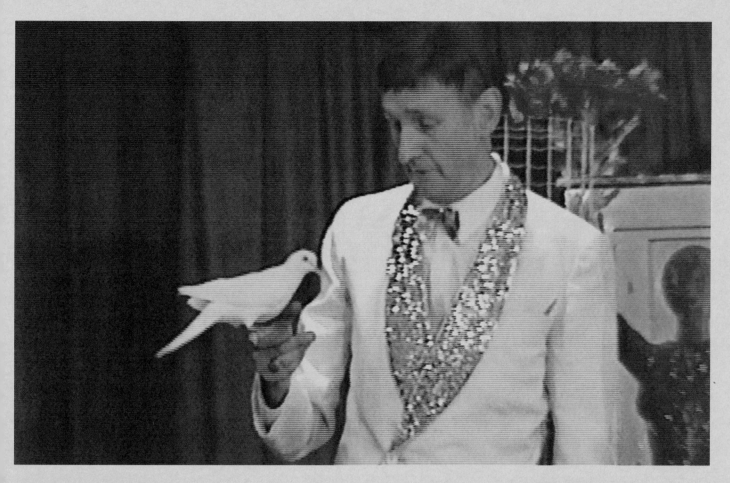

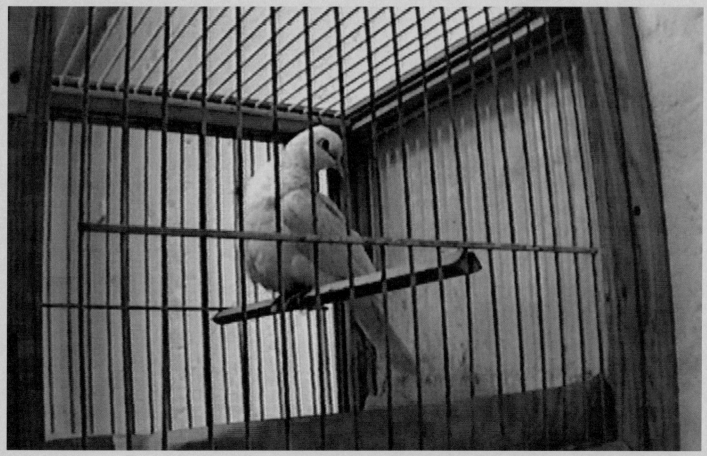

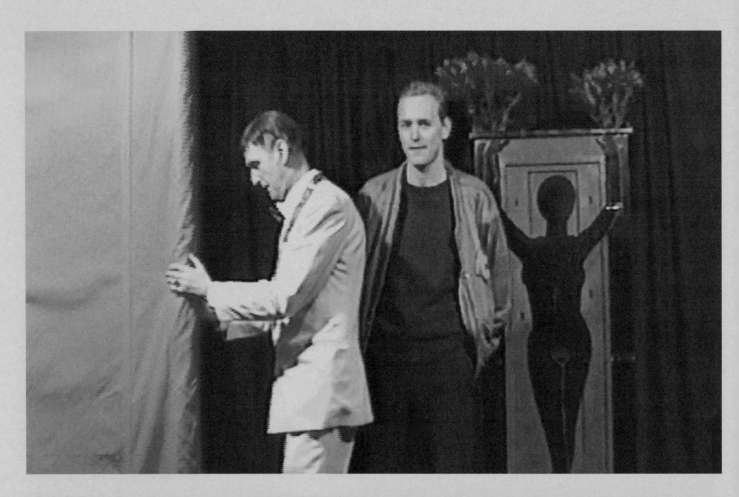

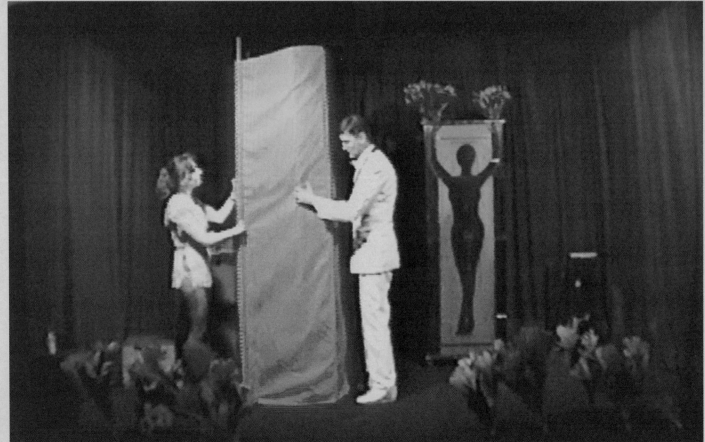

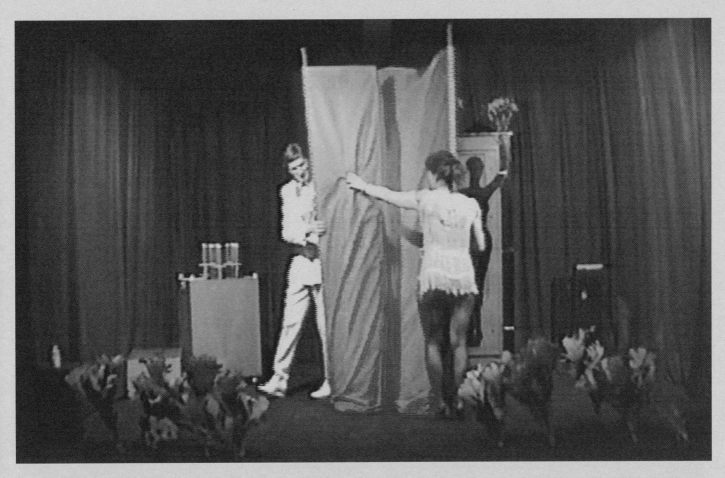

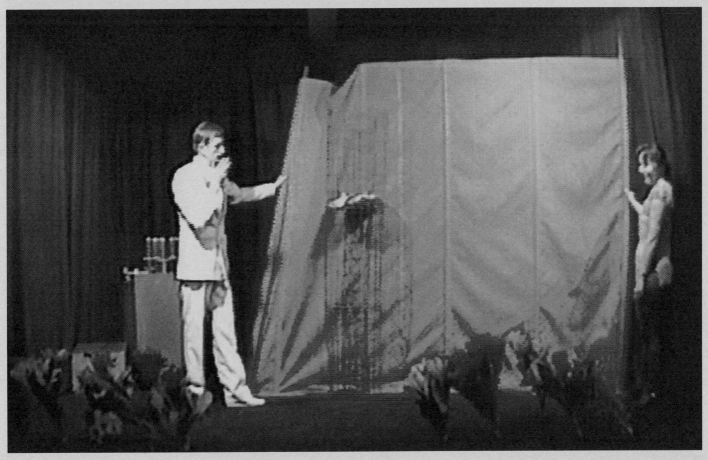

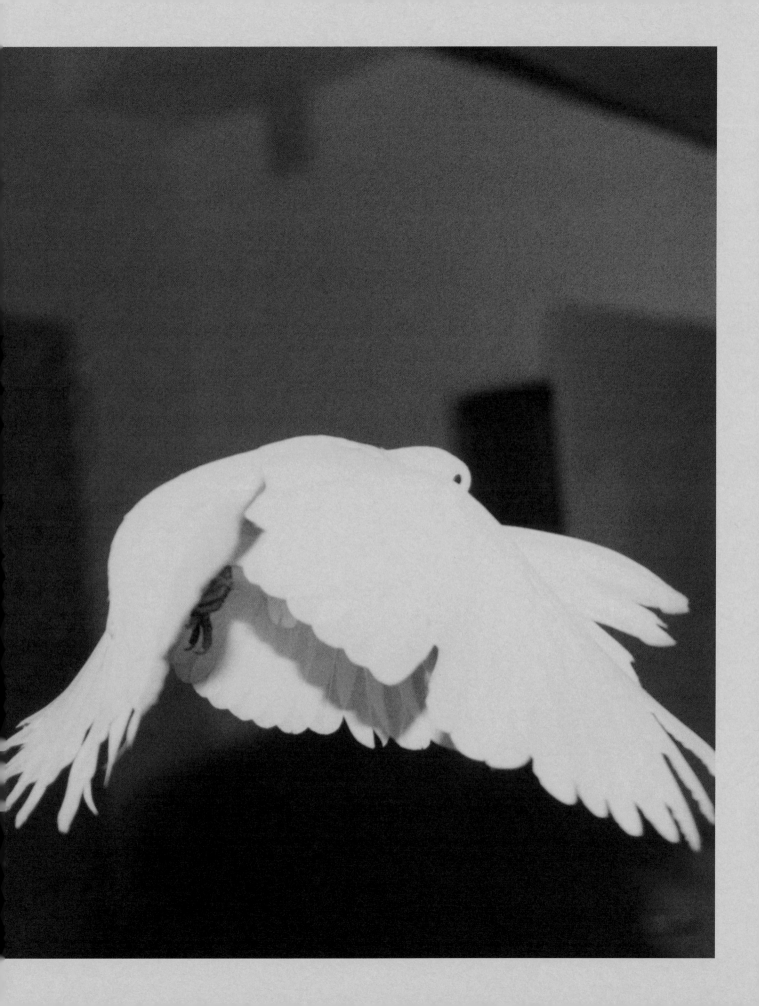

17.

Director Poodle
Direktor Pudel
1998

For *Body Check* at the Kunstverein Hamburg, Jankowski invites
the Kunstverein's director, Stephan Schmidt-Wulffen, to be
transformed into his choice of animal for the duration of the
exhibition. The director elects to become a poodle for three
days. A cruise ship magician Christian Knudsen performs the
transformation at the exhibition's opening. In poodle form,
Schmidt-Wulffen is filmed and photographed going about
his work for the next three days.

Performance at
the Kunstverein Hamburg,
color film on Super 8
transferred to DVD (8 minutes, 31 seconds),
and 5 posters.

Following pages

Production stills.

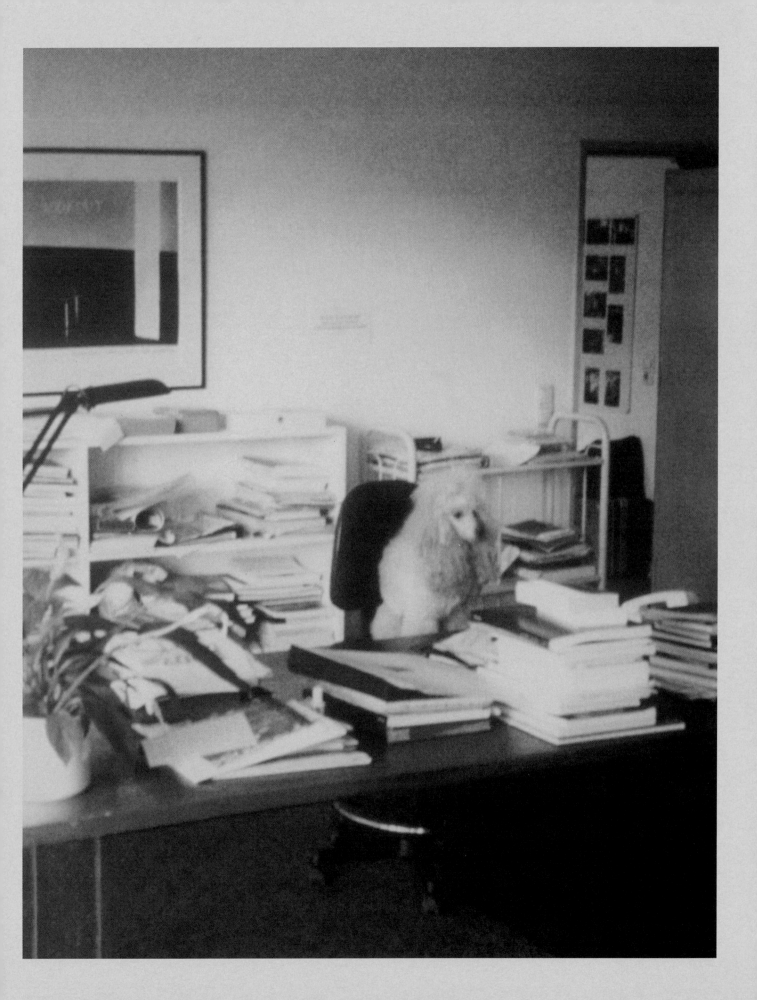

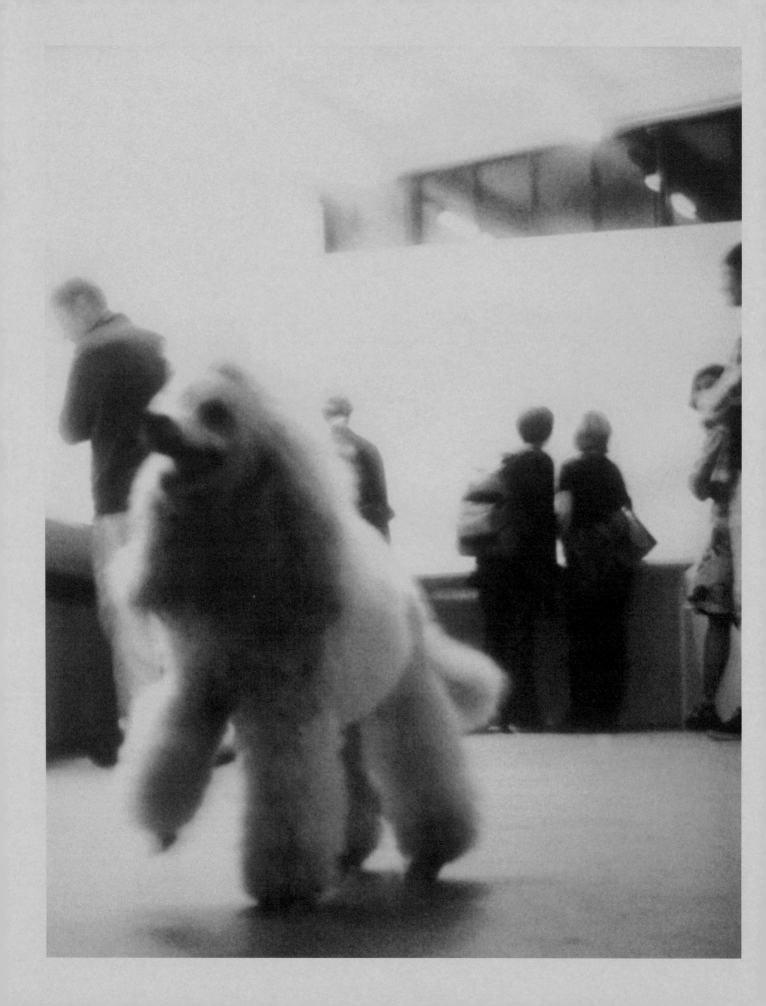

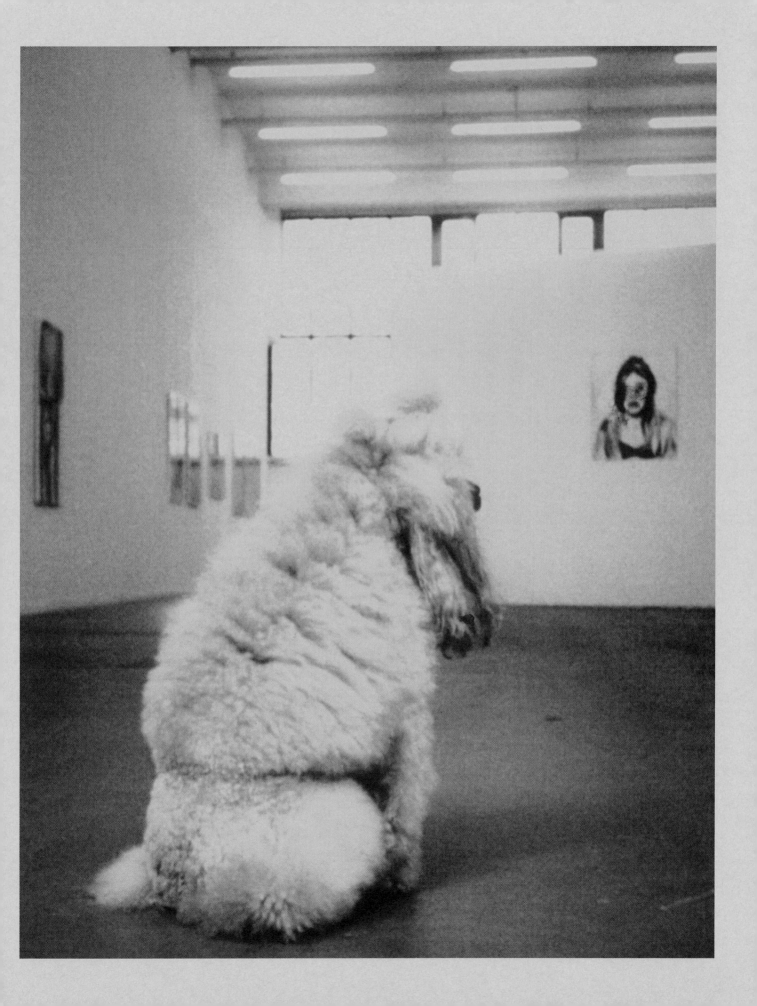

18. # Flock

2002

For a special preview of *ConArt* at the Site Gallery in Sheffield, friends of the museum and volunteers are turned into sheep. The magician Paul Kieve performs the act. The flock of Grey Faced Dartmoor sheep then follow one another through the exhibition.

Performance at
Site Gallery, Sheffield,
and color film in 16mm
transferred to DVD
(12 minutes, 15 seconds)
and 5 posters.

Following pages

Production stills.

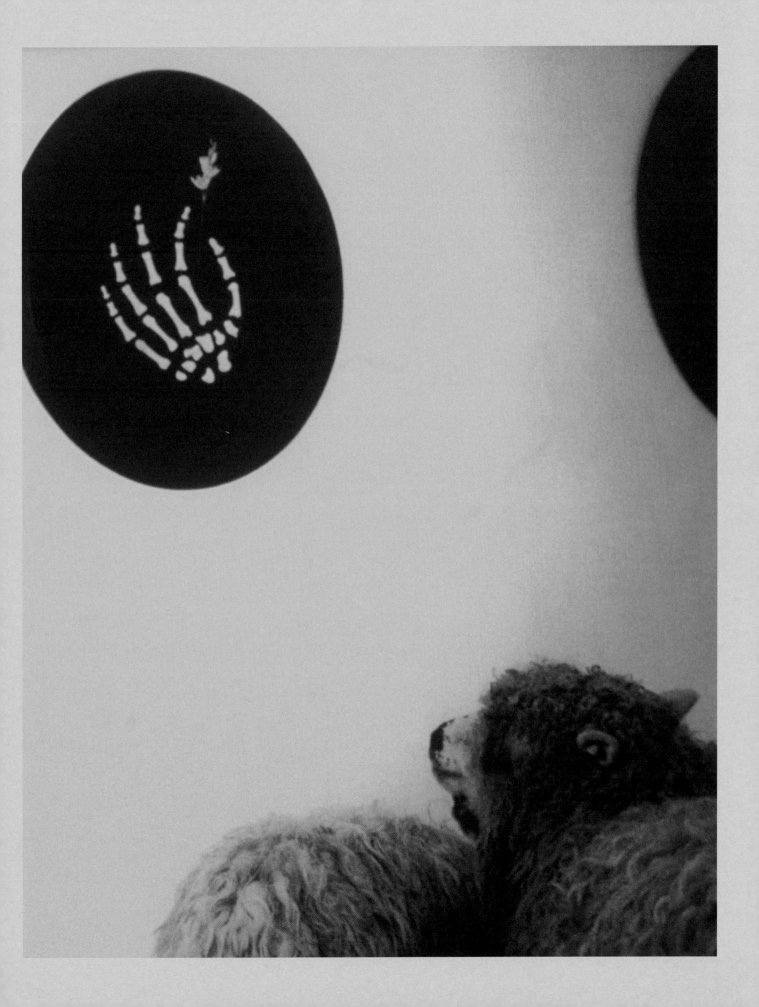

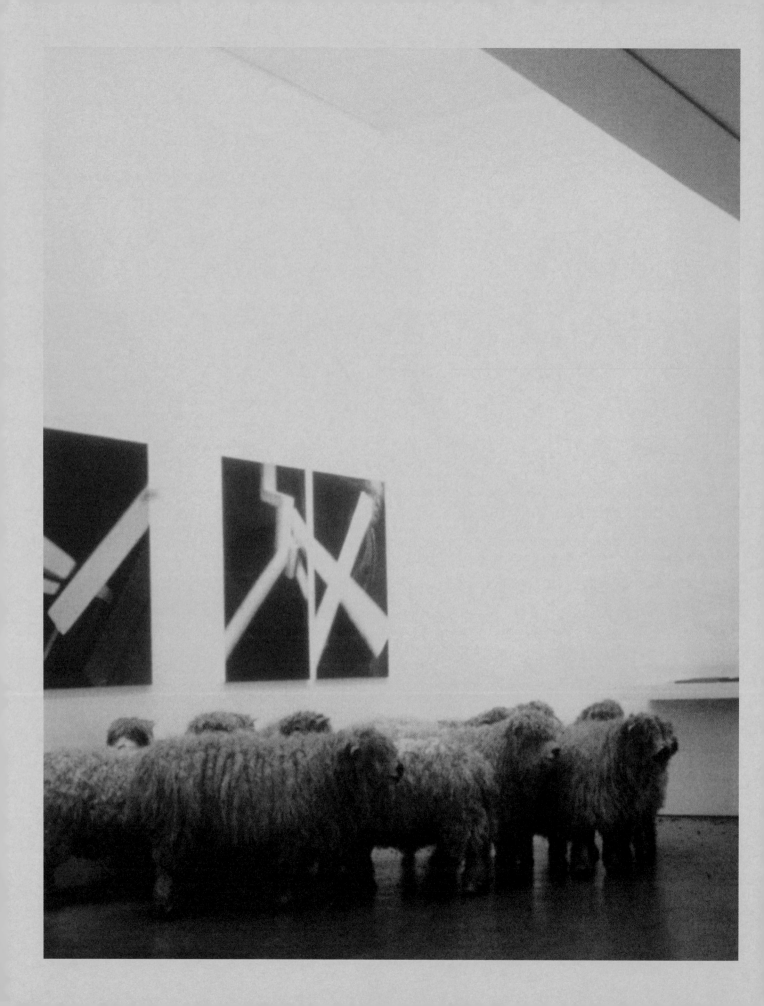

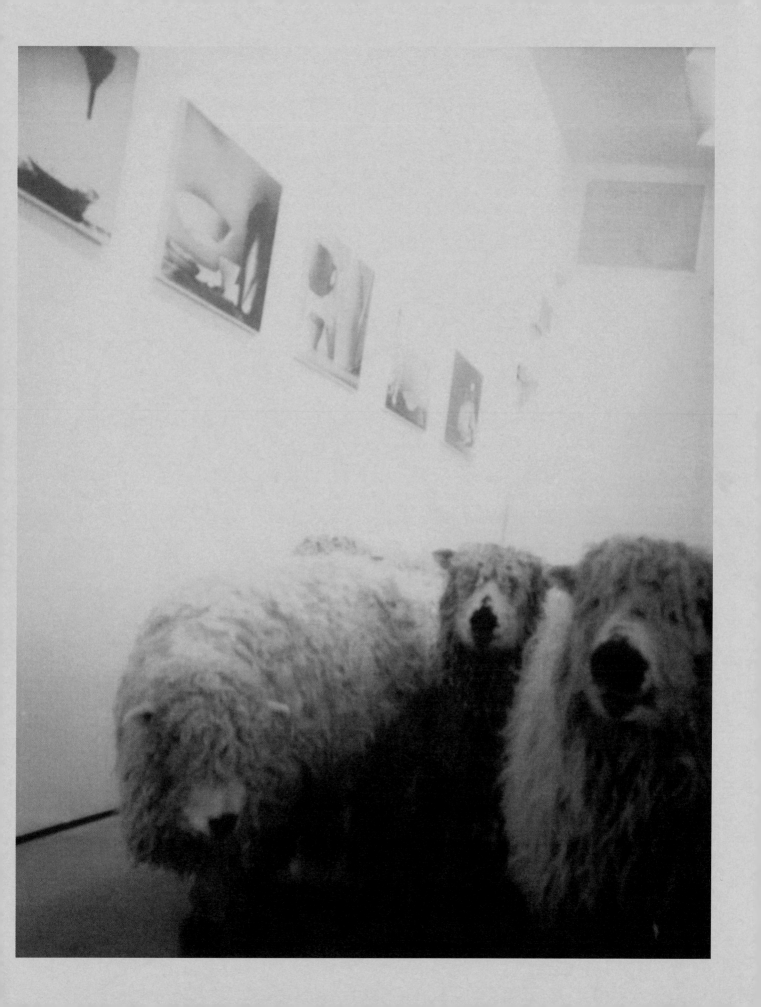

Christian Jankowski
Everything Fell Together

Des Moines Art Center

Table of Contents

p. 5 **Acknowledgements**

p. 7 **Introduction** Susan Lubowsky Talbott

p. 9 **Christian Jankowski: The Big Wow** Jeff Fleming

p. 14 **Complicated Transformations** Jordan Kantor

p. 17 **Concentric Circles, from *I'll Let You Go*** Bruce Wagner

p. 19 **A Spot in Time** Norman M. Klein

p. 22 **Bill Arning interviews Christian Jankowski**

p. 27 **List of Works in the Exhibition**

p. 28 **Biography**

Acknowledgements

I am grateful to the many individuals who have made this project possible. Christian Jankowski's primary dealers, Michele Maccarone, with Ellen Langan, of maccarone inc., New York, and Martin Klosterfelde, with Bettina Klein, of Klosterfelde, Berlin, provided invaluable assistance and encouragement throughout the process. At the Des Moines Art Center, I would like to acknowledge the steadfast support of former director Susan Lubowsky Talbott, along with the assistance of Rose Wood, registrar; Jay Ewart, chief preparator, and his staff Mindy Meinders and David Pearson; Jamie Miller, security chief; Jill Pihlaja, education director; and Laura Burkhalter, assistant curator.

This publication contains thoughtful essays and texts by Jordan Kantor, Bruce Wagner, and Norman M. Klein, as well as contributions from Bill Arning and the Brothers Strause, whose assistance with the film *16mm Mystery* was immeasurable. I am especially grateful for their participation in this project. Susan Sellers and the staff of 2x4 have done a remarkable job creating the framework in which these contributions commingle.

I am pleased to work with the Foundation for Art and Creative Technology in Liverpool, England, to bring this body of work to a British audience, and I am especially appreciative of Ceri Hand, director of exhibitions, for her support and interest in the exhibition. Likewise, Bill Arning and Jane Farver at the MIT List Visual Arts Center proved willing partners in presenting Jankowski's art to a larger American public.

The funders of Christian Jankowski include the Altria Foundation, the Institute for Museum and Library Services, and the Goethe Institut, whose support of this project made it possible. Last but not least, I would like to sincerely thank Christian Jankowski who, since our first meeting on a Berlin sidewalk, has been a wise, thoughtful, articulate, and humorous collaborator. I am grateful to have the opportunity to work with him and his art.

—————— **Jeff Fleming**

Introduction

About fifteen years ago my friend, the dancer Sally Gross, did a favor for a friend of a friend and agreed to let a German teenager stay in her New York loft for a week. The young German returned often to the United States and always stayed in Sally's loft. Sally told me he was remarkably talented and urged me to see his art as it developed from painting to performance, and then on to video. I was living far from New York so I never followed up. I even forgot his name. As time passed, I thought of him as Sally's remarkable teenager.

A couple of years ago on an Art Center trip, Jeff Fleming and I visited the Berlin studio of Christian Jankowski. We saw *The Holy Artwork* and *The Matrix Effect*, and decided he was an artist with whom we wanted to work. It was only after I returned to the United States that I realized the Berlin artist we were so taken with was Sally's friend from long ago, Christian. My story is a classic film scenario like the ones Jankowski manipulates in his work—serendipity and coincidence lead to recognition and a happy ending.

The happy ending for the Art Center is Jankowski's first major museum survey in the United States and the first solo exhibition our museum has organized around a film and video artist. As co-executive producer, the Art Center is also proud to have participated in the making of Jankowski's most recent film, *16mm Mystery*. The Art Center is renowned for its important holdings in modern and contemporary art, but it was late in collecting and presenting film and video: Jankowski's exhibition is a landmark for this institution.

A project of this depth would not be possible without the support of the exhibition's funders: Altria Foundation, the Institute for Museum and Library Services, and the Goethe Institut. Special thanks go to Jennifer Goodale, vice president, contributions; Diane Eidman, director, contributions; and Marilynn J. Donini, manager, contributions of Altria, and to Iowa Senator Tom Harkin and Richard Bender of his staff for their outstanding support of the Art Center.

Finally, I thank Christian Jankowski for presenting his work, Jeff Fleming for organizing the exhibition, and Sally Gross for spotting talent early on.

———— **Susan Lubowsky Talbott**

Christian Jankowski: The Big Wow

Jeff Fleming

A man walks steadfastly and with conviction through the streets of present day downtown Los Angeles carrying a film projector and a film screen. He ascends to the top level of a parking deck overlooking LA's colossal skyscrapers. Silently, he sets up the projector and the screen so that its back is facing us, loads the film, turns the apparatus on, and walks out of the frame. Then, one of the skyscrapers implodes.

In the film *16mm Mystery* (2004), this man, Christian Jankowski, takes as his starting point an eighteenth-century Baroque painting entitled *Retrato milagroso de San Francisco de Paula* (Miraculous portrait of Saint Francisco de Paula) (n.d.), by the Spanish artist Lucas Valdés (1661–1725). Jankowski encountered the painting while in Seville, Spain, and he remembers it depicting a religious procession in which individuals carry a canvas, visible only from behind, through the streets of a village, causing destruction in its aftermath. The viewer of this painting can only marvel at the power of the image on the canvas, and the fact we cannot see it heightens its mystery. Jankowski collaborated with Hollywood special effects wizards the Brothers Strause in *16mm Mystery* to explore the potentially miraculous effects of images on both their surroundings and on the viewer.

It should come as no surprise at this stage in the history of filmmaking that a film could appear to make the façade of a modern skyscraper in downtown Los Angeles crumble. Thanks to the increasingly advanced technology of special effects, anything is possible. Jankowski uses this technical knowledge to emphasize the inherent mystery of the moving picture, the movie's ability to seduce us into suspending our belief, and to redraw film's artistic parameters. His primary strategy is the reinstitution of ritual, or the Big Wow.

Walter Benjamin convincingly argued that ritual is absent from contemporary film, or indeed any mechanically reproduced image.[1] For Benjamin, the work of art was created for the purpose of the perpetuation of a community's spiritual or religious beliefs, i.e. for ritual. As he writes, "the earliest artworks originated in the service

of a ritual—first the magical, then the religious kind." The aura found in a unique work of art is part of the ritualistic process. (Benjamin's examples of artworks which contribute to the process of ritual are ceremonial or religious objects, such as Madonnas or the hidden sculptures in medieval cathedrals.) Although Benjamin argues that ritual has been made redundant by the age of mechanical reproduction, I would insist on our reviving the term. Ritual is still a means of inserting mystery into the work of art, but it is also a tool for communicating to the viewer a personal belief system, whether religious or secular. This belief could be that the contemporary museum has a mission to communicate art to a broad public, or that by watching evangelical television you're furthering your relationship to God. Such belief systems function within the social structures of entities like the contemporary art museum, which encompasses the relationships between the museum guards, the hierarchies in the curatorial department, or the relationship that the individual viewer holds to each work of art, or televangelism, watched for voyeuristic or transcendental purposes alike. By communicating such various belief systems Jankowski reinserts ritual and its intrinsic mystery (aura) both into the creative act and, subsequently, into the act of viewing a work of art. For him, ritual enables the recognition of a specific world view or the dialogue surrounding a system of beliefs.

He arrives at this point of recognition through collaboration, a circular method of creation, the use of magic or wonder, and humor. By making clear these devices in his work, Jankowski enables the viewer to experience the recognition of the a-ha moment, or the climactic Big Wow. The Big Wow is the moment of recognition of the effectiveness of ritual. (The American filmmaker) Walt Disney coined the term to explain the high point on an amusement park ride or the big, concluding special effect in a movie.[2] (The implosion of the skyscraper in *16mm Mystery* is a prime example because when we see it fall, we can only assume that it was the film that caused it to fall.) Together with the use of subjective voices and popular forms of

mass culture, the wow experience provides a critique of the detached nature of contemporary art production and positions Jankowski as one of the most thought-provoking image makers working today.

Jankowski's endeavors to re-mystify art are well suited to his choice of medium: the moving image. By its very nature the moving image constitutes a spectacle, an illusion, something beyond ordinary lived experience. Throughout its history, from the magic lantern and other early attempts at projecting light to contemporary digital renderings, the moving image has occupied a space at the intersection of reality, memory, and artifice.[3] Siegfried Kracauer, writing about watching old film footage, summarizes this idea: "The thrill of these old films is that they bring us face to face with the inchoate, cocoon-like world from which we come—all the objects, or rather the sediments of objects that were our companions in a pupa state ... Numerous films ... draw on the incomparable spell of those near and far away days which mark the border regions between the present and the past."[4] This space between reality and illusion is the location of the Big Wow, where dreams, memories, and time are all conflated.

Jankowski utilizes this space in *16mm Mystery*. As its title suggests, he posits that mystery is still potent in contemporary culture, despite the fact that our daily immersion in a steady current of moving images renders us temporarily immune to its power. Unlike early pioneers of film and video art who looked to the elements that make up a film or the technology of film or video as subject matter, Jankowski goes beyond these investigations to further the potential of the media to create spectacle, or the illusion of spectacle, and to mediate the space between reality and illusion. In doing so, Jankowski pursues an investigation of modern life and subjective experience, and conjures this crucial arena of conflict; he is its magician, the shaman of this ritual.

Early film and video works have always born a relation to its 'low,' popular form, television and the movies, and vice versa. Ironically, the look and feel of early avant-garde film and video works are seen today in television and Hollywood. Music videos, reality shows, and television commercials—the mechanisms that shape our needs and desires—all serve as examples of the crossover. This give and take, this circular relationship, isn't just fluid. Jankowski navigates this uneasy relationship between the 'high' and 'low' in his work, giving us the easy gratification of the Big Wow, whilst exposing the mechanisms by which it functions.

Telemistica (1999) and *Talk Athens* (2003) both engage the commercial television industry and employ a circular strategy to explore the way in which the works themselves are constructed. Sitting in his hotel room in Venice in the summer of 1999, Jankowski called up several fortune tellers on live Italian television and questioned them about his future and the future of the artwork he was currently creating. Jankowski asked: "Is this idea for an artwork a good one? Will my work when it is finished be beautiful? Will the public like it?" He then videotaped his own televized conversations with the fortune tellers. The very process of creating *Telemistica* is the completed artwork. The fortune tellers' complicity in Jankowski's art project (one of them is even aware of the goings on at the Venice Biennale and claims to have participated in it), and their commentary on art and the artist (e.g. "an artist or a painter is never satisfied with his work") makes us, as the contemporary art viewer, aware of the perilous nature of our own claim to connoisseurship. On Madame Feruglio's show, the background changes every few minutes to display different paintings from the Western canon—pointing to the way art is used to lay claim to a higher appreciation of culture, as well as to validate less widely accepted belief systems such as the occult.

In *Talk Athens*, Jankowski collaborated with a Greek television talk show host. As she interviewed her invited guests with questions about the purpose and nature of contemporary art and about the work they were in the process of creating (Jankowski's), the artist hovered around them silently, never speaking a word. The tape of the show then became the work of art. This circular format,

in which the very process of creation becomes the final artwork, provides a skillful analysis of the nature of contemporary artistic production and its place within commercial and entertainment structures. The culture of television contains various belief systems; Jankowski initiates our engagement with those systems, communicating them to us in a ritualized activity.

This I Played Tomorrow (2003) is made up of two parts. In the first, Jankowski interviews passers-by outside the Cinecittá film studio in Rome. He asks them if they want to act in a film and, if so, how they would like to look, and what would they like to be, and to do. In addition, Jankowski asks them questions like "Can film reveal the truth?" and "Do you think cinema can change lives?," to which many responded in the negative, instead philosophizing as to what might actually reveal the truth or change lives—thus exposing their own beliefs. In the second part, Jankowski creates a film at Cinecittá based upon his interviewees' answers, in which they star as the actors, with a resultantly disjointed narrative. This circular process and the participation of numerous individuals from many walks of life, gives *This I Played Tomorrow* an amateurish feel. The acting is hammy, but heartfelt, and the scenes shift abruptly. The process and the feel of this work encourage an exploration of the power of film, as well as an investigation of the movies' populist position in contemporary visual culture.

Jankowski's use of a circular process of invention takes us back to film's beginnings: the movies. In this circular process, the final product results directly from the actions of its creation, thereby commenting on the concept of simultaneity. Examples include Robert Morris's *Box with the Sound of Its Own Making* (1961), in which an audio recording of Morris sawing and hammering away at the box was contained within it, or Gary Hill's *Hole in the Wall* (1974), where Hill filled a hole in with a video recording of its making. Like these early works, Jankowki's efforts are circular, because they extend the critique of their medium into "the style, manner, and nature of the forms on which [they are] based."[5] *This I Played Tomorrow*, *Telemistica*, and *Talk Athens* all reference their own making. However, departing from the work of his predecessors, Jankowski takes this critique beyond just the technical aspects of the medium. His self-referential style of production is significant because it exposes the often mystified mechanisms of art-making (while simultaneously deconstructing the workings of television and film). It also breaks the pace at which we live, ironically, since it references this simultaneity. Events get broadcast around the globe as they happen (think of the hundreds of thousands who watched the Twin Towers fall live), rendering invisible the tools of their dissemination. To make these tools visible and to expose the workings of the film and television industries, thus prompting the Big Wow, is a radical action.

Another strategy which Jankowski employs to slow down the pace of modern technology is collaboration. The physical act of filming generally requires collaboration with actors, set designers, editors, and numerous others. But Jankowski takes it further by inviting individuals to participate in his work's very conceptualization, as evidenced in the works described above. This process is vital. Jankowski shares (or does he defer?) responsibility for the creative act, which in turn questions the role of the artist and the serendipitous participators roped in by Jankowski. Such a populist action invites an exploration of varied perspectives on life and different social structures within which belief systems are embedded (fortune telling, talk show hosting, aspiring to cinematic glory). This not only erases the boundary between low and high art; the moment at which the everyman going about his everyday business steps into the process of creating an artwork blurs any separation between art and the everyday.

Although it would appear from the works discussed so far that Jankowski has left contemporary art itself fairly unsullied, *The Matrix Effect* (2000) begs the contrary. Jankowski created *The Matrix Effect* in collaboration with the Wadsworth Atheneum and a cast of young

children who are transformed into the museum director, curator, and several contemporary artists participating in the Atheneum's highly acclaimed Matrix exhibition series. This exceedingly funny work cuts to the heart of contemporary art's closed system of language.

What Remains (2004) and *The Holy Artwork* (2001) serve as other prime examples of Jankowski's collaborative process. In the winter of 2004, the artist invited movie-goers exiting New York theaters to give their immediate responses to and opinions of the film they just saw, with the proviso that they not mention the film's name. In the resulting work, the participants critiqued various aspects of the movie, thus betraying their adept analysis/ slavish adoration/total confusion/immediately mundane responses. This work again calls into question the role and power of film in contemporary visual and popular culture, and even literalizes the "wow" experience. In *The Holy Artwork*, Jankowski's collaborators were Pastor Peter Spencer and the congregation of Harvest Fellowship Church in San Antonio, Texas. Upon Jankowski's invitation, Pastor Spencer agreed to give a sermon on art and to participate in the creation of a work of art, thereby making the seated audience do the same.

Like *16mm Mystery*, *The Holy Artwork* finds inspiration in a Spanish painting. Dating from the eighteenth-century it depicts a scene in which an angel, paintbrush in hand, completes an unfinished painting by an exhausted artist. Jankowski mimics this concept and updates the idea and format in his video by falling to the floor in front of the congregation, prompting the pastor to sermonize over him. The sermon was broadcast on Pastor Spencer's tel-evangelist TV show, and therefore reached a viewership much more diverse than your average contemporary art audience. Of course, Jankowski is far from the first artist to refer to historical religious imagery in contemporary film and video. Bill Viola's seminal flat-screen works of the late 1990s and early 2000s, which are motivated by the same populist intention as Jankowski's, bring to life art-historical images in very slow motion. Viola's *The*

Quintet of the Astonished (1999), for example, recreates Hieronymus Bosch's *The Mocking of Christ* (1490). As evidenced by the subjectivity and the intensity of emo-tional quality in these works of art, Jankowski also shares with Viola a will to believe in the transformative, tran-scendental power of ritual.

In an illustration of how far Jankowski is willing to push his use of collaboration, he did not see *16mm Mystery* until its debut at his Berlin gallery. The Brothers Strause, best known for their blockbusting weather sequences in *The Day After Tomorrow* (2004) were given freedom to execute the project, both directing it and creating its special effects. This total surrendering of creative responsibility again questions the role of the contempo-rary artist, the role of the viewer, and even invites us to consider the real identity of the artist. Jankowski in turn builds a dialogue or a site where dialogue can take place between different people or different belief systems. We take as a given the power of film and video to create illusory visions of society, to manipulate politics, and control our consumer desires, but here power is literal-ized, and is thus readily observable. *16mm Mystery* functions not only as a critique of the medium's power, but also, and most importantly, critiques Jankowski's own role as a collaborator in the inherent ability to manufacture illusion.

The surprising turns of events in *16mm Mystery*, *The Matrix Effect*, *What Remains*, and *The Holy Artwork*, and their subtle but decidedly engaging sense of humor entice the viewer in. While Jankowski is not just trying to be funny, he is keenly aware that absurdity and a sense of play are avenues to arriving at truthfulness. As opposed to falling into categories like 'political' or 'spiritual,' Jankowski's work is more "like a puzzle with three things that don't fit together."[6] He also embeds in the work a strong sense of human fallibility through the intentionally naïve or casual way he uses technology. This honesty is particularly significant in media usually associated with cool, emotional detachment.

Jankowski's earnest engagement of his medium enables him to recapture art's mystery. His use of a circular mode of production presents a critique of the contemporary relationship between artist and viewer and attempts to break down the speeded-up forms of communication which have worsened our contemporary alienation. In addition, he embeds a strong sense of a human presence in his work through a transformative use of collaboration, humor, the subjective voice, and the somewhat naïve manner in which he approaches technology. Jankowski destabilizes film's fabled objectivity by demonstrating our willing suspension of disbelief; we know moving images are an illusion, but we still allow ourselves to be tricked by them. He reasserts the transformative nature of contemporary art by re-infusing it with ritual—that moment when the recognition of mystery takes hold. Jankowski gives us the Big Wow.

1. Walter Benjamin, "The Work of Art in the Age of Mechanical Reproduction," in *Video Culture: A Critical Investigation*, ed. John G. Hanhardt (New York: Peregrine Smith Books, 1986), pp. 32-33.

2. Norman Klein, *The Vatican to Vegas: A History of Special Effects* (New York and London: The New Press, 2004), p. 307.

3. For a more complete discussion, see Chrissie Iles, "Between the Still and Moving Image," in *Into the Light: The Projected Image in American Art 1964-1977* (New York: Whitney Museum of American Art, 2001), pp. 33-69.

4. Siegfried Kracauer, *Theory of Film: The Redemption of Physical Reality* (Princeton, NJ: Princeton University Press, 1997), pp. 56-57.

5. David Ross, "Truth or Consequences: American Television and Video Art" in *Video Culture*, p. 170.

6. Conversation with the artist, March 7, 2004, New York.

Christian Jankowski's Complicated Transformations

Jordan Kantor

"Art is magic, and I believe that its reception mustn't be theorized. Art should remain something magical. It shouldn't be explained." Thus opines one of the main characters in the final scene of Christian Jankowski's video *Rosa* (2001). These are daunting words for a critic intent on interpreting, maybe even "theorizing," Jankowski's work. How might one begin to approach an art that so baldly proclaims its resistance to explanation? Simply taking this statement at face value, with proverbial hands thrown in the air, is unsatisfactory. Perhaps best first ascertain the basics: Who is telling us we shouldn't theorize this work, and in what context? Unfortunately, even these fundamental questions have complex answers and require extensive qualification, for Jankowski's art is dizzyingly self-referential and dotted with ventriloquism. Here, as in much of his work, establishing any speaker's "true" identity—and the reasons that person is speaking—is unusually challenging. Indeed, to even begin unpacking the voice declaring the "magic" of art, one must look beyond *Rosa* itself and glance back five years, to an earlier piece in Jankowski's nascent career: *My Life as a Dove* (1996).

To create *My Life as a Dove*, Jankowski hired a magician who appeared at the opening of one of his exhibitions and transformed him into a bird. For the three-week duration of the show, the artist/dove lived in a cage in the gallery, fed and photographed by gallery visitors. At the end of the exhibition, the magician returned and restored Jankowski to his human state. While clearly the work of an artist still finding his voice and beginning to grapple with his medium (the grainy video and funky posters that survive as residue of the performance have a low production value that recalls Martin Kippenberger more than Jankowski's own definitively slick style), *My Life as a Dove* nevertheless laid out one of the main themes that would run through his diverse production in the years that followed, to *Rosa* and beyond: that of the transformative possibilities of art.

The notion that art has the potential to transform is, of course, almost as old as the very concept of art itself. From early shamanistic uses to a millennium in the service of religion, art's primary historical purpose has been to facilitate a kind of transcendence of everyday life. In recent times, this idea has undergone a shift and is now generally conceived in political terms—that art can be a vehicle for social (more than spiritual) change. However, Jankowski's work does not address, or effect, transformation in these terms, at least not overtly. That is, unlike Joseph Beuys—one of the most influential German artists of the postwar era and a major figure for German art schools like the Hochschule für Bildende Künste where Jankowski was educated—in his work Jankowski does not appear to attempt to challenge social norms or conventions directly. Instead, he opts for a more poetic effect, in which the transformations within the work stand as a model for transformations outside it, that is, those wrought upon its viewers. By wryly tweaking expectations or conventions in his videos—by showing us transformations—Jankowski's art challenges our assumptions about the way we perceive the world. Rather than didactically presenting a social message, Jankowski's subtle approach has the ironic effect of opening up possibilities for more profound transformations. As the saying goes, honey attracts more bees than vinegar.

The transformations in *My Life as a Dove* are compounded exponentially in *Rosa*, in ways both internal and extrinsic to its final state. *Rosa* was born of extraordinary circumstances, which are worth briefly rehearsing here. In 2000, after having seen *My Life as a Dove*, the German film director Lars Kraume contacted Jankowski to request permission to borrow its concept (as well as that of another early work, *The Hunt* [1992]), for a movie he was making about an artist whose ideas are co-opted for commercial means, *Viktor Vogel—Commercial Man*. Undoubtedly attracted by the irony of this proposition, and sensing how the transformation intrinsic to the two works might be compounded, Jankowski granted the director license to adapt them. In exchange, Jankowski received permission to use the equipment, actors, set, and edited footage from the big-budget film to create a

new artwork. *Rosa* was the project that emerged from this opportunity, aptly named after the fictional artist with Jankowski's ideas who was exploited in Kraume's movie.

As a finished work of art, Jankowski's *Rosa* is comprised of two types of footage: those scenes taken from the final edit of *Viktor Vogel*, and new ones shot by Jankowski using the co-opted acting corps. For these latter scenes, Jankowski asked the actors to break out of character and offer their personal, unscripted answers to questions he posed to them about aesthetics, such as: "What significance does art have?" "How free are artists?" and "What are the limits of art, where does it begin and end?" In response to one of these questions, the actor who plays Viktor Vogel ruminates about the magic and inexplicability of art, speaking the phrase that appears at the beginning of this essay. Ultimately, then, the voice admonishing us to refrain from theorizing art is not even Jankowski's own; it is that of an actor who utters the admonition in a highly multivalent context. Indeed, seen in these terms, the quotation is deeply ironic: a work of art whose basic structure is built on relentless questioning is enjoining its viewers not to question. As Jankowski's authorial voice grows ever more obscure—and the answers his work offers become cloudier than their original questions—*Rosa* exhibits themes that appear again and again in the artist's work. Doubt, layering, ventriloquism, self-reflexivity, and transformation are all at the heart of Jankowski's project. Indeed, in its very obscurity, *Rosa*'s forest of signs and signification provides a perfect introduction to the art of Christian Jankowski.

If *My Life as a Dove* exemplifies Jankowski's early interest in the almost alchemical transformations of art and *Rosa* embodies its most recent expression, the body of work bracketed by these two projects tracks the evolution of the artist's exploration of these themes. In fact, *My Life as a Dove* is but one third of a trilogy of works addressing transformation in this way. The two other works, *Director Poodle* (1998) and *Flock* (2002), involve similar metamorphoses. In *Director Poodle,* a magician is hired to turn the director of the Kunstverein Hamburg

into a poodle; while in *Flock,* another magician transforms museum visitors into a flock of sheep. Both works comment on the sometimes vain and aggressive tendencies of some of those who run art institutions, and the herd mentality of many who attend them, but while the animals in the videos are ultimately turned back into humans, we the viewers are ourselves (hopefully) left transformed.

Less literal transformations characterize one of Jankowski's most affecting pieces to date, *Let's Get Physical/Digital* (1997), a work executed one year after *My Life as a Dove*. For seven days, the artist and his then girlfriend—one in Stockholm, the other in Milan—restricted their communication to chatroom conversations on the Internet. The transcript of their lovers' exchange was translated from German into Swedish and used as the basis of a script for seven vignettes, each acted out by different actors. These performances were videotaped and given English subtitles, and then broadcast over the Web. This final videotaped form, as well as the sets in which the actors performed the dialogues, comprises *Let's Get Physical/Digital*. As in *My Life as a Dove*, mediation and translation make up the very fiber of the work; there is nothing here that has not been put through some degree of transformation. And it is precisely in these moments of translation, when slippages emerge between the written and the spoken, and between the digital and the physical, that *Let's Get Physical/Digital* achieves its most powerful effect. For example, several times the transcript records a temporary lost connection between the two computers. Despite its obvious harmlessness, when being acted out face-to-face by two young "lovers" looking searchingly into each other's eyes, the repeated question "Are you there?" carries a potent emotional charge.

A more recent work, *The Matrix Effect* (2000), partakes of a similar kind of play-acting. Jankowski cast children to act out a series of interviews between a curator and famous contemporary artists. Seeing seven year-old incarnations of such art world heavyweights as Adrian Piper and Sol LeWitt blow air kisses and discuss such pressing issues as institutional critique is simultaneously

hilarious and disconcerting. Not only does *The Matrix Effect* throw into relief the self-importance and cliquishness to which the art world is sometimes prone, it also raises serious questions about contemporary art's meaning and audience (an issue that characterizes *Flock* as well). Indeed, the disconnect between the speakers and their words highlights the inaccessibility—and the occasional facileness—of much art today.

Jankowski's most recent project here leaves little doubt as to the importance the concept of transformative potential has for his art, and the sleight of hand with which he now engages it. Rather than presenting a collaboration in which the transformation is an end in itself, *16mm Mystery* (2004) is instead a fantastic and complicated ode to our common desire to be moved by art. Inspired by a Baroque painting that depicts a work of art being carried through the streets, felling bystanders with its awesome power, *16mm Mystery* presents a film within a film that has similar miraculous influence over its surroundings. In this five minute "mystery," responsibility for the creation of which the artist delegated to a special effects studio, Jankowski walks through downtown Los Angeles—the American storehouse of cinematic fantasy, akin to the Italian Cinecittà—before climbing to the roof of a building and setting up a projector and screen. When the artist sets the film rolling, its moving image—which is hidden to us—appears to cause a building to implode. As the skyscraper melts in over-the-top Hollywood fashion, Jankowski's proxy artists produce their ultimate testimonial to art's power to change the world. By creating the work at such a remove, the artist thus effects perhaps his most impressive transformation yet. Fashioning a work of multiple authorship and myriad meanings, Jankowski inextricably complicates the artistic process, setting up a forest of signs and significations resistant to simple explication—what more 'magical' feat for an artist for whom theory may be a dirty word?

Concentric Circles, from *I'll Let You Go*

Bruce Wagner

Amaryllis set out for the bridge. She'd been thinking that if she told Topsy about her mother, he might have an idea what to do. She passed a mission, then cut down Winston Street—sometimes he loitered on the sidewalk outside Misery House and made cardboard begging signs for the men in his distinctive calligraphic hand. He wasn't there. The orphan kept a darting, furtive lookout as she moved; she didn't want to be picked up for truancy.

On Grand Avenue, trucks and trailers lined the curb. Pedestrians gathered in curious clumps to watch, but there was nothing to see, at least so it seemed. Amaryllis slowed, wending her way toward the blaze of lights that came from the desiccated lobby of the Coronation, one of the bigger SROs. A distant shout of "Quiet!" and a baffled roundelay followed, each voice handing off to the next, all coming closer, some electronically enhanced—"Quiet!" Then another cavalcade. But instead of "Quiet!" this time they yelled, "Speed!" A girl with purple hair and a ring through her nose like a bull glared fiercely at Amaryllis, gesturing her to be silent. She froze. A voice crackled over a radio: "We! Are! Rolling!" Then, the final chorus: Rolling!—Rolling!—Rolling! The little girl quaked, waiting for a bomb to go off, certain that's what was happening. Under her breath, she beseeched: *Benedicta Benedicta Benedicta* ... and the world stood still. She prayed that if she died then and there, an angel's emissary would get to the babies and keep them from harm. She even wondered what a person who'd been blown to bits looked like in heaven. Then, the crackling voice tore into her reverie: "And ... cut!"

The woman with the bull ring echoed, with great purpose but to no one in particular, "Cut!"—then turned on her heel, leaving Amaryllis to fend for herself.

There was much coming and going and people laughing, and she was certain the bomb had been defused. The blinding lights still shone in the window and she made her way toward them. As she threaded the crowd, it was as if she were invisible. She passed a bum, who smoked and wore sunglasses. He rested a hand on his leg in regal fashion and guffawed, phlegmy and herniated, while a smiling, serious boy with headphones handed him a Styrofoam cup of coffee.

"All right!" someone yelled. "Here we go! Last looks!"

When Amaryllis got very close to the Coronation lobby lights, she hid behind a truck and watched a strange scene: a beautiful girl of about thirteen sat on an upturned wooden crate, hair brushed and combed by two bizarre-looking women with beehives and tattoos. The beautiful girl chattered with someone the orphan couldn't readily see. Then a man came along to powder her face while another smoothed the pleats of her dress and primped a collar. It seemed to Amaryllis everyone around the beautiful girl was polite and reserved and happy and the beautiful girl had made them so—just as she imagined life among the entourage of the Royal Kumari. Then she saw with whom the girl was gossiping: two friends sitting opposite on a shared milk crate, only theirs was horizontal to make them closer to the ground than she who was illuminated. Her companions were a boy and girl, both fair, red and pretty, and the girl's braids dangled so they nearly touched the grotty, gum-flattened sidewalk.

"Is that part of the movie?" asked the boy of the
 beautiful girl.
"Is what?" she said.
"The snot." He pointed to her nose.
"Are you to have snot?"

The beautiful girl grew serious as finger flew to nostril; then she looked at the boy with narrowed, beady eyes and he laughed. "I hate you, Tull! I *hate* you!" she said, but she wasn't really mad and the man powdering her backed off to fetch a Kleenex, which he then applied to the beautiful girl's upper lip until she seized it, completing the job herself. The other adults continued to brush and fluff and straighten and comb—the finishing touches of merry, manic elves.

"*Qui—et!*" came an anonymous voice.

And another: "Quiet, everyone!"
"First team!"
 More scurrying. More commands, and the adjusting
 of machines.
"And . . . roll sound!"
"We—are—speeding!"
"Roll camera!"
"Rolling."
"*And* . . . We! Are! Rolling!"

The voices made their way to the other reaches, where Amaryllis had stood in frozen repose only minutes before. Within an instant, the beautiful girl had stopped laughing and risen from the crate, which was neatly whisked away; her helpers lingered like bees reluctant to leave a flower. A gangly man stood by, listening to someone through headphones while holding a long pole, the end of which wobbled over the beautiful girl as she smoothed her own skirt. Then, a sudden, perfect silence. A man with long, stringy hair said: "Action, Boulder!"

At which the beautiful girl took a deep breath before walking determinedly toward the lobby door. A short muscleman type followed her with a camera strapped to a thick belt on some sort of hinged pivot; trailed by the man with stringy hair and then by the *other* man, gangly and serious-looking, the long pole held high over his head, along with assiduous minions who crouched and slinked noiselessly beside the beefy one with the pivoting camera, some holding aloft cables in his wake as if attending a rubbery bridal train—but the actress's entrance to the hotel was blocked by the bum Amaryllis had seen earlier. This time his dark glasses were gone. He carried a bottle of brown-bagged wine instead of a Styrofoam cup.

"Out of my way!" she shouted.
"*Your* way!" said the bum, hissing.
"You've always had it *your* way, haven't you, Missy?"
"I'm looking for my mother!"
 More stumblebums appeared.
"Hear her, boys? She's looking for Mother!"

They cackled and howled, rolling over the word in their mouths like pirates molesting a treasure chest.

In the midst of all this, the redheaded boy on the crate caught Amaryllis's eye. She grimaced and later regretted not softening her features when he smiled. As if aware of her discomfort, he turned back to the scene at hand. The beautiful girl vigorously pushed aside the lead bum, then stormed into the SRO. Apparently, this was the funniest thing in the world, because the bums let loose with an explosion of rollicking huzzahs; the man with the stringy hair watched like a giddy child at a puppet show, then yelled, "And . . . *cut* it!" They repeated the exact same sequence at least five times, the spaces between "Cut!" and "Action!" filled with a kind of wild yet militarily controlled commotion.

Finally, the stringy-haired one spoke animatedly to the sweat-soaked muscleman, who tried to listen but was mostly interested in the progress of those unburdening him of the camera, which they finally did, lifting it off like the saddle of a tired and finicky mule. A voice called out "Checking the gate!" while the gangly man peered into the lens. Then someone said, "Gate is clear!" and there were bursts of laughter all around. A familiar chorus of voices called "Lunch!" in the same staticky, concentric, fading circles. The girl with the long braids leapt up to join her beautiful friend, already set upon by the bees or elves or what have you, each of whom seemed to have bottomless pockets filled with small, significant items for every possible need. The redheaded boy—more orange-headed, really—turned again to catch Amaryllis's eye before she walked slowly backward, fading into the general disorder.

A Spot in Time:
Jankowski's Startling Special Effect

Norman M. Klein

The man walks like a professional assassin, at least according to what we know from American movies. In his austere blue suit, he might also be Bertolucci's 'conformist,' a fascist agent; but most likely, he is a kind of 'Jackal,' a hired killer about to murder someone in a Hollywood thriller. We watch him set up, from a roof deep inside downtown Los Angeles. First, he threads a reel of film, then opens a portable screen. The projector lights up, in a blinding iris. The screen catches the evening breeze. Suddenly, the man leaves the roof, just as the Deloitte and Touche office building across the street blows up. Or rather implodes like a Vegas casino. The glass-curtain wall drops its sheath. The naked skeleton of the building remains, with the skyline around it very still.

Then the film ends, neither an allegory nor a floating signifier; but rather a narrative hook, a piece of grammar from a story that never gets told. It is a special-effects moment, what I call three acts in a few seconds. That is the hook, an abstraction really, a morsel of story, a blank that suggests a presence. We are given our fondest wish, to see our worst nightmare turned into something innocent, blank, simulated. We are reminded that all cinema is a process of forgetting, of distraction.

I am also reminded of the philosopher David Hume arguing that the human mind tends to be "carried by habit." The order of events must make sense. The sun rises every morning. Then the sky lights up. The sun must be bringing light. It also must rise every morning. Similarly, a projector lights from the east; then a building implodes. The projector causes the implosion?

In movie editing, we invent story in much the same way, as in the famous Kuleshov effect. One shot follows another. A bowl of soup is followed by a man staring. We sense a disconnect. We fill this absence with story, with presence. The man must be hungry. It is the basic principle of montage; but also a crisis afflicting our media culture. Whoever seems to win—no matter how viciously—must be morally correct, because winning makes you look glamorous. And glamour means that you are not vicious.

Jankowski delivers a brilliant *coup de theatre* about

perverse habit—a spot in time suggesting an endless stream of momentary disconnects that have changed our political culture: our bizarre, uncountable elections; our media-concocted scandals; the way our media helps us misremember the present, through endless talk shows masquerading as journalism. But most of all, this spot in time exposes the fissure just before it is filled by story, right before we let the incongruities pass. The false sets up an imago, an interior image so fiercely glamorous that any picture that resembles it simply disappears. In that way, false violence 'displaces' real violence. We watch the simulation of another American skyscraper going down, like the death of analog movie projection itself. Replacing analog light on film—the projector—are digital special effects, a computer graphics (CG) sim-reality.

This is a film about the narrative power of simulation, of its scripted spaces, its false memory, for a culture steeped in apocalyptic fantasies, in movie versions of the rapture. Or passionate warfare as very cool, like an erogenous zone.

Logically enough, the western end of downtown Los Angeles has been selected often as an ideal place for this kind of sexy, cool disaster. Since the skyline went up, by the 1980s, dozens of films use it for apocalyptic statements. I lived near that skyline for twenty years. It looked solemn at night, lit up but uninhabited. During the day, it is a kind of grasshopper about to pounce. But most of all, it symbolizes to almost everyone I knew the empty planning of late modernism, the city of the future fifteen years too late.

This film is the final coda for that city (at least in Europe and America, perhaps not in China). Downtown Los Angeles is being turned into a cute but disengaged bedroom community, a suburbanized downtown. However, the western corner that Jankowski uses—even after six-year real estate boom—remains a blank, staring mindlessly, like the assassin, the projector, the building after the bombing.

Indeed, this film also speaks to the end of an era. This year, almost weekly, we see buildings go down—in this way—in Baghdad. As a result, for the Hollywood film

industry, hauntings after 9/11 have made effects like this too dangerous to simulate. Before 9/11 they suggested the next stage of the American crisis about to unfold (the imaginary violation to come). Now they were a coda to the first stage after the cold war ended, when movies were filled with imaginary military apocalypses, until the militarism of our current moment took over.

It is the blink turned into a masterpiece, about the gasp of non-recognition, reminding us that we are creatures of habit, whose collective memory is very much controlled through media. The camera lights up from the east. Then a building collapses. Afterward, the silence leaves us unable to complete the story, because to do that, we would have to engage our media crisis directly. We live through a secondhand nightmare, like secondhand smoke. It makes for a culture steeped in wonderful special effects, in what the Baroque theorists called "wonder," the sense of collusion of interactive fantasy. Thoreau once wrote that he would not walk across the street to watch the world explode. I wonder how he would express that sentiment today; and where this evacuation of our senses will take our hazardous culture and politics next? Jankowski leaves us with that question, and this is more than enough. I have seen dozens of special-effects films unable to say nearly as much, nor as eloquently.

Afterward: Guesswork

It has been three years since the implosion of a major high-rise building in downtown Los Angeles. The culprits have not yet been found. Attempts to lay the blame on Sunni terrorists have proven completely false; however, as so often the case today, most Americans believe the false story anyway.

To prevent more of the bloodshed that has shaken the world since 2008, a team of UN advisors have combed the entire area for months now, gone through every shred of evidence. They have interviewed over six hundred people. And still the fuse grows shorter.

Who would have imagined that this crisis would change hands so many times over the past three years, then wind up where it has? But I see no point in reviewing what everyone in the world already knows. It would be like inviting the demons to arrive even faster.

Instead, let me go over what remains hidden. Very often, a crack in the wall speaks louder by its absence than all the facts that are gathered. What is left unsaid aches to be noticed. For example, no one wants to explain why the implosion took place four seconds before a sound was heard. Why did the frame of the building descend so evenly, like poached flesh dropping off a skeleton? And why are the remains of forty-one of the victims still missing?

Finally, there is the utter perfection of the media image itself. For centuries, media disasters have been presented with a pristine irony, what Norman Klein calls a Baroque irony. One's fondest desire is to see one's worst nightmare, but in complete comfort, in epic lighting, with a bit of the artificial thrown in. It makes for a perverse distancing effect. And this effect has been tried many times before, in hundreds of pristine shipwrecks staged like chapels inside seventeenth-century theaters. Or in thousands of Christs crucified brilliantly in the movies, usually followed by soothing resurrections. In only fifty years, we have seen thousands of planet earths blown to rubble. Clearly, nothing comforts us more than visiting our own funeral, particularly if it is on the way home from work; it builds an appetite for dinner.

Disasters in the media reinforce our fear of terrorism; and yet, something comforting lies beneath it all. We need to see the worst in order to sleep at night.

Is it possible then that what we saw three years ago on TV—a building imploding—actually was faked, one of two separate events: one catastrophe shown on TV, another at the site? Was this what the assassin/film projectionist was trying to tell us? Do we prefer glass between us and our worst nightmare, to give us the illusion that a greater power has intervened? What's more, don't we actually sense that we are being manipulated like the boil in a teapot; and in fact enjoy it?

Over the past three years, nearly two hundred copy-cat implosions have taken place around the world—at least according to the cable news. However, each disaster has been reported differently at different networks around the world; and then differently again on the Internet, even with conflicting videos covering the same event. In the end, do we really care if an event actually takes place? Is it simply easier to let sleeping dogs lie, particularly if they lie on behalf of a greater truth?

It has been said that digital special effects are like painting with a machine gun. They add a perverse silence to our national crisis. We Americans watch our disasters cynically, but at the same time, without any critical distance. After all, the distance may be faked, nothing more than accelerated perspective, like the 'making of' for a movie that does not have to exist.

Interview with Christian Jankowski and Bill Arning

BA ——————— Two different sensibilities seem to function concurrently in your work. One of these is a distanced look at the inherent strangeness of human relationships—as if you were a space alien observing the way humans run their lives. But the other is this fantastic sense of empathy you show for your characters. There seems to be a conflict between the two responses. How do you see that conflict functioning?

CJ ——————— If you view human relationships not as a given, but as something constructed, then it can also be seen as an artistic field to work with. And I view the constructions with a kind of strangeness, not necessarily the people. When I work with people I do not see a conflict in their having different points of view. Many times this difference is exactly what I'm interested in hearing. Also I like aliens. And I know that I am an alien to many people I work with.

BA ——————— Conspicuously artificial relationships feature frequently in your work. In *Congratulations* (2001), for example, you commissioned professional speechwriters to script and read congratulatory speeches about the nominated artists at the awards ceremony for Germany's Preis der Freunde der Nationalgalerie. It is the type of bizarre situation that is totally normal in life: one introduces a speaker at a conference as if they are a dear friend and you have read all their books, but in fact you don't know them at all. There you construct a peculiar type of intimacy that's actually not intimate at all, within situations that are totally normal yet bizarre, if you think about it. Other situations you've used in your work are the therapeutic relationship or television psychics.

CJ ——————— Phone-in psychics are totally normal in Italy, but to see them in the Venice Biennale, reflecting on an artist's career, or about art, creates this sense of the bizarre. The psychics have their legitimacy outside of the art world. I end up involving many different types of professionals, "experts" in their particular fields, because of the need to make a statement about legitimacy. You're inside of this megashow, where a lot of careers are born. And the psychic allows you to reflect on superstition, and on my own position in the place where the curator puts my work, where the exhibition has asked me for a statement. So within that context, I make a new situation where one can question why people are looking for certain answers. That's how *Telemistica* (1999) came about.

BA ——————— How did this working method begin? It seems that even with the early work *Shame Box* (1992) you were already responding to the specifics of a site.

CJ ——————— Works like *Shame Box*, which I did while living in an apartment with a storefront window, exposed to passers-by, gave me my first audience, independent from any institution.

BA ——————— But wasn't this storefront an otherwise totally normal apartment? It only started seeming strange the more you made work in it and about it?

CJ ——————— I guess the window didn't make it such a normal thing, because immediately you had a public. I thought it was nice and cool living behind a shop window, but at first it was painted over. Then bit by bit, I used it as a frame for showing work. One of the first things I did when I moved in was put a painting inside of the shop window—facing to the outside—because I wanted to use the space. I wasn't embarrassed to show it, even though no one in the art school liked my paintings. Of course this was not the most creative thing to do, but gradually the idea became—in German it's 'Schaufenster der Alltäglichkeit'—a shop window of the every day.

BA ——————— Had you looked at conceptual strategies for schematizing daily life like Douglas Huebler's *Variable Piece no.70 (In Process) Global* (1971), which aimed "to photographically document the existence of everyone alive" or Martha Rosler's *The Semiotics of the Kitchen* (1975)?

CJ ——————— No, I learned about those artists a bit later. I think that most of the early performances simply came out of an interest in having fun, not making art.

BA ——————— So you came to this method of working intuitively, by just doing what interested or amused you.

CJ ——————— Right. The main force that drives me is always the pleasure of meeting people and putting things together in collaboration with them. I remember I found an old bathtub on the street and carried it home, because the apartment just had a shower. Then I installed it behind the window, and took a bath. Of course I closed the curtain. And then I thought, oh, I should make a performance with a public bath.

So then I carried this thing into the shop window and some students and I invited people from the street to take a public bath. A lot of people did! A lot of people got naked there! There was even a jealous guy who wanted to destroy the shop window because his girlfriend didn't want to get out of the bathtub.

BA ——————— And for *Shame Box*, you went out onto the street and asked people you didn't know to sit in the window with their shame?

CJ ——————— Well, everyday living in this private/public space had already begun to turn into a performance. When I invited friends over for dinner we would set up the table in the window, and then we would eat with our hands or have, say, a "Caravaggio" dinner, with togas on. We just saw ourselves poking fun at all of these fancy restaurants that had just opened up in our neighborhood in Hamburg, and it came only slowly into my mind that this could also be a way of making art. I was more interested in painting then, but people's reactions to some of the things that happened in the window made me take it more seriously. So then I did *Shame Box*.

Everybody has feelings of shame, but if they are neither Catholic or appearing on Oprah, they have no outlet for expressing them. My role in this project was to give people a kind of safe space in which they could act out the desire to confess.

BA ———————— And after that came *Secure Space* (1994)?

CJ ———————— Maybe a year later. The storefront apartment became increasingly connected to my studies at art school. Fellow students would come over and put on exhibitions there, and eventually my whole apartment became an installation space, at which point I made *Secure Space*. I stood outside for 24 hours and invited passers-by to come in and experience a secure space, which this security company had made totally secure with cameras and guards.

BA ———————— If you were trying to guarantee a totally secure space, wouldn't inviting strangers into it be a really bad plan?

CJ ———————— Of course my main purpose was not to make it to be 100 percent secure, I was more interested in the concept of security, as something unreachable and immeasurable, even if you have companies routinely paying for guards. You almost invite people to get aggressive when you emphasize security so much. Some security guy was sitting in the back balcony and checking to see if anything was going on. Of course there was nothing more than rats hanging around. You reach this kind of tension where nothing was left to chance, everything was about aggressively making it secure. In this artificial situation, people behave differently and people who didn't know each other were sitting next to each other and experiencing something quite unique with each other. I sometimes miss these unscripted roles in normal exhibitions ... I found it interesting to see who's watching who, is the security company on view, or is the company looking at the visitors? It's simply the situation and you have to react in it and find your place in it, you're not really provided with the information: Here is the beginning of the artwork, and here, it's over.

BA ———————— *Desperately Seeking Artwork* (1997) was the first time you went to another city, in this instance Graz, to make a work. Was that also the first time you used video as the final presentation form of a situational work?

CJ ———————— A lot my works had been documented by video already. For example, the surveillance camera tape from *Secure Space* is the documentation of the 24-hour performance, and is the final artwork. In each case the video took the same form it would have if it had not been an artwork. For example, therapists use videos to assist their patient's process of self-recognition and understanding. I brought other forms of video use—surveillance, entertainment, and therapy—into dialogue with contemporary art. But it's not simply a ready-made: I didn't just take a pre-made video from one format and put it in the art space. At the same time, these videos were representing a situation that was artificial from the very beginning.

BA ———————— Like award ceremonies, reunions are conspicuously artificial events that are nevertheless based on affection and real human interpersonal histories. In *Class Reunion* (1995), you had a make-up artist age your fellow students. That seems to me to be the first point in your work where the line between fiction and reality gets broken down. In the video, do

people pretend it is 25 years later? Do they make up fake histories as to what occurred during the intervening years?

CJ ———————— I kept it open. I did not script the events for the camera. In my introduction speech I referred back to events that held us together—real events—both positive and negative. Like good memories of art collaborations that had happened, and bad memories like one guy who was talking behind my back ... I used the moment to deal with relatively recent problems, and addressed them in a different way, by pretending it was years later. Jonathan Meese gave an absurd reading. Ruediger Salzmann recited a poem.

There were very touching moments and tense moments, too, where you start really identifying very strongly as a class, people who belong together, and on the other hand, by looking into our faces, there was this big question: Where will our art be in 25 years, and will we really be artists? What's gonna happen, because everyone tells you in art school, only 10 percent who get out will be artists ...

I think that's what creates the artificial-normal feeling that comes from the experience of the people filmed in the actual situation with their friends, but with the make-up and cameras. The guy documenting it was just told that it was a class reunion. He was outside the team.

BA ———————— That formal structure, in which the elements are set in place, the cameras record and the elements all end up where they should, runs through much of the work, such as *Desperately Seeking Artwork*. Every one of the elements is essential and visible in the final piece; there is nothing extraneous, no remainder, and no unused parts. In my understanding, one of the key aesthetic criteria by which conceptualism should be judged is by whether all the elements are accounted for in the final reckoning. I wonder if you could talk a little bit about this aesthetic approach?

CJ ———————— Many times, it is one very simple concept that is the foundation of the piece. But when I bring this concept to different cultural fields like television or therapy, the collaboration gets more complex, because the two interests interfere with each other. On one hand, these fields inscribe their purpose, and I insist on their relevance for the field of contemporary art.

One thing that was very important to *Desperately Seeking Artwork*, which also later on became a strategy in other pieces, was the idea that the crisis was resolved through the making of the work. The crisis is that you have to make a piece, it's a crisis each time! Of course, in this kind of moment, you express the doubts, but in a multilayered way, and you relieve the pressure.

This is the starting point that guides the artwork, and the aesthetics follow. I mean, the moment you call the fortune tellers, the format is already there, every element in the process is there. I try to leave the structure and the process of the system entirely how it is, I just make one conceptual difference, introduce a new element or approach. The image factory is the same ... it is just that the content is different, and the end result differs from what this media normally produces.

BA ——————— Well, it seems like in most of your best-known works every element is important in building the final piece. In *This I Played Tomorrow* (2003), the interviews with the "actors" become the subject of the film, and then their comments become their performances. What about when this holistic style of perfection in conceptual artmaking, in which each of the elements has to be visible in the end, doesn't work? I'm curious in cases where you couldn't come up with an idea, where the elements did not gel.

CJ ——————— Getting all of the elements together is the first problem, sometimes it's impossible. I was obsessed with this actor who played an American Indian in *Winnetou*, Pierre Brice. He was my first idol when I was a child. I followed him around for years to try to get him to be my blood brother, just like in the movie. I offered to do anything for him. Like he could give me a task and if I did it, then we would cut our wrists and exchange blood. I even went to the doctors to check that my blood was Ok. I would have done anything—if he sent me to renovate his summer house in France, or to Bosnia to bring some, I don't know, some food into a danger zone … both things. Anyway, he thought I was crazy. Or he was too senile. I confused him.

As for projects that did get realized, over the years I've come to see *House of the East* (1999) as a difficult piece too, but I could never go back and change it because it was so important at the moment of its creation. It was 10 years after the Wall came down, I was trying to deal with the very bad experiences people underwent in East Germany. To go to a GDR theme park hotel, and to put the actual people together in these rooms, created a lot of tension. I felt that I should have directed them more, encouraging conflict with the owners of the hotel or the guards. For example, the young guard who is in the video is approached and asked if there is any way to escape from the hotel. But the question I thought should've been asked was, "Would you really shoot if we tried to escape?" Which would've cracked the façade of game-playing. On the other hand, I did not want scripted lines and actors, so it seemed disre-spectful to tell somebody who had tried to escape from the GDR, was caught, and then spent three years in prison, how to act. When you do pieces like this you always realize afterwards that some chances had been missed to do something amazing. But then I always find out other things that I didn't expect would happen, so that compensates for it somewhat.

BA ——————— Yes, in each of the works there are elements, moments, and facial expressions that could not have been scripted, that have had to be a result of your ongoing relationship with your costars and collaborators. Is it important to you to develop a caring relationship with the people in your films?

CJ ——————— Yes, at least you have to be non-judgmental from the moment you start working with them.

BA ——————— Well, being cruel to your collaborators is bad for your karma, among other things.

CJ ——————— Yes. I hear that sometimes I totally piss people off, but I don't think so.

BA ——————— Perhaps some of the commentators on the films they've just seen in *What Remains* (2004) might have a right to be annoyed? You do let them hang there in their own absurdity.

CJ ——————— I don't think that *What Remains* really makes the commentators look bad as people. They are presented in a fragile, perhaps unpolished way. My motivation behind the project was to hear people create their own stories, and hear their emotions when viewing movies. And to simply let this be the film.

BA ——————— When watching that, I was reminded of going to see a movie with a group of friends who are sort of arty and cultured, and deconstructing the film afterwards like junior-league film theoreticians. I've been in enough of those conversations where I've said the most absurd things, so I actually felt the people in *What Remains* come out pretty human and sympathetic in the end, even if I snicker at them a bit during the piece.

CJ ——————— Many people think that my work is somehow ironic. I think that's the wrong way to look at it—it's much more open than that. I identify with the people in the film. I distrust coolness or being "correct" in a stylish way. I think viewers feel touched by these people showing so much about their personality, being human, and infallible.

I think when you consider that structures of dialogue are so firmly set—what you expect a talk show host or a museum director to say—that if you change or add one basic element and put it in a different frame, that opens up the possibility for a rare honest response.

I guess in this pretty controlled mass culture there is not much space for the audience to get emotional, or to hear thoughts from uncool people, or people who are not hyped, or who don't fit into certain standards of the media.

What counts in the end, are the personal stories people make out of what they see—what remains. And if a bad Hollywood movie causes someone to think in a constructive way, or helpful about his own life, then I think the artwork has achieved something beautiful —even if it's a bad film. For that reason I wouldn't see my work as intentionally making an ironic comment on things. It's possible to understand the work in an ironic way but that's just one option.

BA ——————— You ask people, yourself included, to make pronouncements in your work on two topics for which language usually proves inadequate. One is "love," which comes up in *Let's Get Physical/Digital* (1997) and *The Day We Met* (2003), and the other is "art." Viewers don't want to hear love and art discussed without irony because it makes us all very uncomfortable if it isn't alleviated by ironic distance.

CJ ——————— Maybe, but it's good when an artwork makes you feel uncomfortable.

BA ——————— I get a sense of discomfort frequently when watching your work. Particularly at how conspicuously white you look in the karaoke videos, considering the difficult history of war brides in Korea, and the long history of mixed race children across

Asia. I was especially uneasy in the scene where your fictional Korean girlfriend gives you the breasts made out of sand. You look like you are really cross when you wake up, although two minutes later you're dancing in the hula skirt trying to get her smiling again. I was busily unpacking the layers of dysfunction in my head.

CJ ———————— As far as *The Day We Met* is concerned, you have to look very carefully at the context. It was a piece made for a museum show in the Art Sonje Center in Seoul. It was more or less my ambition to do a project that somehow related to Korean culture. And what I found was karaoke. In among the English and Asian hits were songs by German metal groups like Rammstein, and melodramatic backdrop videos to create a romantic atmosphere. I simply thought if I were put in these videos, this could reflect on my role as a white guy in Korea.

In karaoke, West and East are meeting in an even more complex way than you mention … I thought this was the ideal medium to work with as a cliché about the culture. Clichés are a very stimulating starting point. They are loaded with so much energy, and you play with them.

Taijin Media were happy to write me into their karaoke videos, but they had also a very difficult task because they already had their audience in mind. For their particular audience, it's strange to see this white guy on the screen acting with beautiful Korean women. I can only guess that this is one of the reasons that three of the four stories have sad endings. In one story, the parents of one of the girls get very angry and give me money to leave their daughter.

I also found my alter ego in karaoke in a way, as a link between different cultures. The videos are still playing in karaoke bars all over Asia. *The Day We Met* has traveled to Germany, Spain, the U.S. and New Zealand, and it always seems to bring out a specific character from the audience. The Spanish immediately started to party so hard that we had to replace the museum's carpet right after the opening.

BA ———————— On the topic of the discomfort of human relationships, you don't confine the awkward moments to the love scenarios: in *The Holy Artwork* (2001) when you collapse before the pastor, everyone in the audience and onstage has to decide what to do and everyone is made psychologically uncomfortable. They glance around nervously until they can follow the minister's lead. It's a crisis point when the dynamics of social relationships become acutely visible.

CJ ———————— Totally. Yes. That's also one of the reasons that I really love to capture the first moment of the staged situations. As soon as what is going on becomes clear, everyone gets more comfortable, and those structures are not so visible anymore because they become routine. It's the same as the way your behavior changes in new surroundings—you keep your guard up. Some collaborators immediately try to take control of the situation and jump in; others don't want to put a foot wrong, as they feel themselves to be guests in another world. They don't have a real way to gauge the appropriateness of their behavior.

BA ———————— The fear of doing something wrong if you are not involved with art and are called in to collaborate on an artwork must be great. But as I said before, you don't make fun of your collaborators. They are always treated with a great deal of respect.

CJ ———————— I mean, I try to be unafraid of humiliating myself or looking "stupid", and I encourage my collaborators to be open, too. "Stupid" is a harsh word—but not always taking yourself too seriously helps, when collaborating. That also allows the collaborators to view their role as part of a unique situation in which social structures are different. In an artwork, new things can happen, unknown things can happen.

BA ———————— You also need a certain fearlessness to walk into the collaborations, particularly when you are working with big, wealthy and powerful concerns. I am thinking of how you got an "in" on the professional structures you explore (like Taijin Media, or Sesame Street). When I saw *16mm Mystery* (2004), my first thought was how the hell did he get access to this kind of special effects? And that's a part of the story too. It's another conceptual layer found in a lot of the pieces.

CJ ———————— Yes, that is totally right. The stories behind the works make you experience the film differently. You might think differently about *16mm Mystery* if you know how it came into being: art meets reality meets Hollywood. It is a different structure from a scripted, standard film, and I think that makes you look much more at the architecture of relations and the way they spill together and complicate each other.

BA ———————— Also part of your aesthetic practice is giving up control and letting things happen that you as Christian Jankowski, the artist, can't have the final say over. You've got to work with collaborators and say to them "Okay, I'm not going to do more than this. The rest is going to be up to you." You have mentioned before that this is a conspicuously lazy way of making art, but it seems like giving up control takes guts. Was it hard for you to give up control?

CJ ———————— The authorship, the responsibility, is always such a fundamental thing that an artist claims. The important thing is to start a project and get the right people together, and then the mechanism starts to take on an unpredictable shape. That's the moment where everything gets out of control. And then, Oops! There's the artwork. …

List of Works
in the Exhibition

Shame Box (1992)
Photographs
34 at 22 x 30 inches each, unframed
Courtesy of Klosterfelde
and maccarone, inc.

Shame Box (1992)
Video
120 minutes
Courtesy of Klosterfelde
and maccarone, inc.

The Hunt (1992)
Video
1 minute, 11 seconds
Courtesy of Klosterfelde
and maccarone, inc.

My Life as a Dove (1996)
Video
5 minutes, 41 seconds
Courtesy of Klosterfelde
and maccarone, inc.

My Life as a Dove (1996)
Silk screens
5 at 33.375 x 26.5 inches each
Courtesy of Klosterfelde
and maccarone, inc.

Director Poodle (1998)
Video
8 minutes, 31 seconds
Courtesy of Klosterfelde
and maccarone, inc.

Director Poodle (1998)
Silk screens
5 at 33.375 x 26.5 inches each
Courtesy of Klosterfelde
and maccarone, inc.

Telemistica (1999)
Video
22 minutes
Courtesy of Klosterfelde
and maccarone, inc.

The Matrix Effect (2000)
Video
34 minutes
Courtesy of Klosterfelde
and maccarone, inc.

The Matrix Effect (2000)
C-prints
8 at 18 x 22.5 inches each
Courtesy of Klosterfelde,
maccarone, inc.,
and Lisson Gallery

The Holy Artwork (2001)
Video
15 minutes, 52 seconds
Courtesy of Klosterfelde
and maccarone, inc.

Flock (2002)
Video
12 minutes, 15 seconds
Courtesy of Klosterfelde
and maccarone, inc.

Flock (2002)
Silk screens
5 at 33.375 x 26.5 inches each
Courtesy of Klosterfelde,
maccarone, inc.,
and Lisson Gallery

Point of Sale (2002)
Video installation
14 minutes, 17 seconds
Courtesy of Klosterfelde
and maccarone, inc.

The Day We Met (2003)
Video installation
Variable
Courtesy of Klosterfelde
and maccarone, inc.

Talk Athens (2003)
Video
23 minutes, 54 seconds
Courtesy of Klosterfelde,
maccarone, inc.,
and Lisson Gallery

This I Played Tomorrow (2003)
Video and 35mm film
Film: 12 minutes, 45 seconds
Video: 68 minutes, 6 seconds
Courtesy of Klosterfelde
and maccarone, inc.

What Remains (2004)
16mm film
11 minutes, 33 seconds
Courtesy of Klosterfelde
and maccarone, inc.

16mm Mystery (2004)
35mm film
5 minutes
Courtesy of Klosterfelde,
maccarone, inc.,
and Lisson Gallery

Biography

Born
1968 in Göttingen, Germany
Lives and works in Berlin and New York

Education
Hochschule für bildende Künste, Hamburg

One-Artist Exhibitions

2005

Everything Fell Together Des Moines Art Center, Des Moines, Iowa
 *(travel to MIT List Visual Arts Center, Cambridge, Massachusetts
 and FACT, Liverpool)*
Oops!...I did it again Centro Galego de Arte Contemporánea,
 Santiago de Compostela, Spain
Hollywoodschnee Galleria Gió Marconi Gallery, Milan, Italy

2004

Christian Jankowski – This I Played Tomorrow The Powerplant, Toronto
16 mm Mystery Klosterfelde, Berlin
Oops!...I did it again Kunst Museum Bonn
Kunstmuseum Kunstverein Göttingen
Now Playing maccarone inc., New York
No One Better Than You Dennis Kimmerich Gallery, Düsseldorf
The Day We Met Artist Space, Auckland

2003

The Real Fiction Centre d'Art Santa Monica, Barcelona
The Day We Met Art Sonje Center, Seoul
Christian Jankowski Museum für Gegenwartskunst, Basel
Bravo Jankowski! Lisson Gallery, London
This I Played Tomorrow MACRO, Rome
Puppet Conference Carnegie Museum, Project Room, Pittsburgh

2002

Christian Jankowski Mercer Union, Toronto
Christian Jankowski's Targets Washington University Gallery, St. Louis
Rosa Galerie der Stadt Schwaz, Schwaz
Point of Sale maccarone inc., New York
The Holy Artwork Aspen Art Museum, Aspen, Colorado
Lehrauftrag Klosterfelde, Berlin

2001

Christian Jankowski Swiss Institute-Contemporary Art, New York
Commercial Landscape—Christian Jankowski Galleria Giò Marconi, Milan

2000

The Matrix Effect Wadsworth Atheneum, Hartford
Play De Appel Foundation, Amsterdam
Telekommunikation Galerie Meyer Kainer, Vienna *(with Franz West)*

1999

Videosalon Videodrome, Kopenhagen
Telemistica Kölnischer Kunstverein, Cologne
Paroles Sur Le Vif Goethe Institut, Paris

1998

Mein erstes Buch Portikus, Frankfurt
Videosalon H. M. Klosterfelde, Hamburg

Let's Get Physical/Digital Klosterfelde, Berlin
1997

Galerie der Gegenwart Hamburg, 2097 Statement Art Forum, Berlin
Let's Get Physical/Digital Art Node, Stockholm

1996

Mein Leben als Taube Klosterfelde, Berlin

1994

Der sichere Ort Friedensallee 12, Hamburg

1992

Schamkasten Friedensallee 12, Hamburg (with F. Restle)
Die Jagd Supermärkte/Friedensallee 12, Hamburg

Selected Group Exhibitions

2005

Christian Jankowski Julian Dashper Yuk King Tan Boyd Webb
 Sue Crockford Gallery, New Zealand
Greater New York PS 1 Contemporary Arts Center, New York
Getting Emotional ICA, Boston, Massachusetts
Situation Comedy: Humor in Recent Art
 Independent Curators International, New York
Strangely Fine Galeria Estrany-De la Mota, Barcelona
Akademie. Kunst lehren und lernen. Kunstverein, Hamburg
Nuove Acquisizioni MACRO, Rome
Generation X Kunstmuseum Wolfsburg
Fair Use Hammer Museum, Los Angeles

2004

Treasure Island Kunstmuseum Wolfsburg
The Game Show James Cohan Gallery, New York
State of Play Serpentine Gallery, London
The Last Laugh: Humour in Contemporary Video Art
 LASALLE-SIA College of the Arts, Singapore, SG
Glück ACC Galerie Weimar
The Pattern Playback The Moore Space, Miami, Florida
100 Artists See God Institute of Contemporary Art, London
Étrangement proche-Seltsam vertraut Saarlandmuseum, Saarbrücken
Fade in – New Film and Video Contemporary Arts Museum, Houston
Fenster zum Hof NGBK, Berlin
Hors d'oeuvre: ordres et désordres de la nourriture
 Musée d'art Contemporain, Bordeaux
Infiltrate Substation, Singapore
Like Beads on an Abacus Designed to Calculate Infinity Rockwell, London
Paisatges Mediátics Fundación la Caixa, Barcelona
Prêts à Prêter 2 frac paca, Marseille
Spam Art and Advertising Museion, Bolzano
Art + Industry Christchurch Biennial, Christchurch

2003

Revolving Doors Fundación Telefónica, Madrid
Karl Schmidt-Rottluff Stipendium Kunsthalle Düsseldorf
Kunststation Düsseldorf Kunststation St. Peter, Cologne
Outlook Athens
Glück Luitpold Lounge, München
Christian Jankowski Eric Tschernow
 Centro d'Arte Contemporanea Ticino, Bellinzona
Internationale Münchner Filmwochen Munich
Extra Swiss Institute-Contemporary Art, New York

Actionbutton Hamburger Bahnhof, Berlin
© Europe Exists Macedonian Museum of Contemporary Art, Thessaloniki
Grotesk! Schirn Kunsthalle, Frankfurt a.M./ Haus der Kunst, München
Shine Museum Boijmans van Beuningen, Rotterdam
Project Artist Kunstverein Friedrichshafen, Friedrichshafen

2002

Public Affairs Kunsthaus Zürich, Zurich
Identity Fiasco Programa Art Center, Mexico City
To Whom It May Concern CCAC, San Francisco
Centre of Attraction 8th Baltic Triennial of International Art, Vilnius
Museum für Moderne Kunst, Frankfurt
Monitor II Gagosian Gallery, New York
Argos Festival Audiovisual Art Centre, Brussels
Grotesk! Schirn Kunsthalle, Frankfurt
Fridge Galerie Fraïch'Attitude, Paris
Video Zone Tel Aviv
Candice Breitz Christian Jankowski Kenny Macleod
 Anthony Wilkinson Gallery, London
Agua Goethe Institut, Mexico City
Mise en Scène: Curieux Videonale/Bonner Kunstverein, Bonn
Con Art: Magic, Object, Action Site Gallery, Sheffield
2002 Biennial Whitney Museum of American Art, New York
Art and Economy Deichtorhallen, Hamburg
Oh It's a Curator! Rotor Association for Contemporary Art, Graz, Guerro
Künstler-Selbstbildnisse Kallmann- Museum, Ismaning
Melodrama Centro-Museuo Vasco de Arte Contemporáneo,
 Vitoria-Gasteiz and Palacio de los Condes de Gabia, Centro Jose
Magnet: Foreign Artists in Tuscany (1945-2000)
 Fattoria di Celle, Santomato di Pistoia
In the Side of Television Espai d'Art Contemporani de Castello, Castellon

2001

Revolving Doors Apexart, New York
Sense of Wonder Herzliya Museum of Art, Herzliya
A Sense of Wellbeing The Imperial Baths Karlovy Vary, Prague
Tele(visions)-Kunst sieht fern Kunsthalle Wien, Vienna
Mit vollem Munde spricht man nicht Galerie der Künstler, Munich
Futureland Städtisches Museum Abteiberg, Mönchengladbach
 (also traveled to Museum van Bommel van Dam, Venlo)
Irony Fundació Joan Miró, Barcelona
 (also traveled to Koldo Mitxelena Kulturunea, San Sebastian)
Schau Dir in die Augen Kleines Museum, Fridericianum, Kassel
Lite Roebling Hall, Brooklyn
New Works: 01.2 Art Pace, San Antonio, Texas
Zero Gravity Palazzo delle Esposizioni, Rome
Media Connection Palazzo delle Esposizioni, Rome
 (also traveled to Ansaldo, Milan and Castel S. Elmo, Naples)
2nd Berlin Biennale Berlin
Kunstpreis der Böttcherstrasse Kunsthalle Bremen, Bremen
Position Report Brandstetter & Wyss, Zurich
Game Show Massachusetts Museum of Modern Art, North Adams
Hausarbeiten—der Alltag daheim Städtische Galerie Nordhorn, Nordhorn
Let's Entertain Kunstmuseum Wolfsburg
GeldLust: Modell Banking Kunsthalle Tirol, Tirol

2000

Neunzehnhundertneunundneunzig Kunsthaus Hamburg, Hamburg
Berlin—Binnendifferenz Galerie Krinzinger, Vienna
Modell, Modell ... Neuer Aachener Kunstverein, Aachen
Video Art Sept 2000 St. Petersburg
Neues Leben Galerie für Zeitgenössische Kunst, Leipzig
Drehmomente Sammlung Hauser und Wirth, Lokremise, St. Gallen
After Effect. A redesign of thinking Centre d'art Neuchâtel, Neuchâtel

Le Repubbliche dell'Arte Germania. La Construzione di un Imagine,
 Palazzo delle Papesse, Centro Arte Contemporanea, Siena
Preis der Nationalgalerie für junge Kunst Hamburger Bahnhof, Berlin

1999

VISA Galerie Johnen & Schöttle, Cologne
Fernsehabend 2 Galerie Meyer Riegger, Karlsruhe
Zoom Ansichten zur deutschen Gegenwartskunst,
 Sammlung Landesbank Baden-Württemberg, Stuttgart
 (also traveled to Kunsthalle zu Kiel and Villa Merkel, Esslingen)
999 Centro d'Arte Contemporanea Ticino, Bellinzona
Talk.Show. Die Kunst der Kommunikation in den 90er Jahren,
 Haus der Kunst, Munich
Surprise VI: Rollenwechsel Kunsthalle Nürnberg, Nürnberg
Home & Away Kunstverein Hannover, Hannover
Das XX. Jahrhundert Kulturforum, Kunstbibliothek, Berlin
Urban Islands Cubitt Gallery, London
German Open 1999—Gegenwartskunst in Deutschländ
 Kunstmuseum Wolfsburg, Wolfsburg
La Coscienza Palazzo Doria Spinola, Genoa
Crash Institue of Contemporary Art, London
Above the Good and Evil Paço das Artes, Sao Paulo
dapertutto 48th Venice Biennale, Venice

1998

Fast Forward—Body Check Kunstverein Hamburg, Hamburg
gangbang Galerie Margit Haupt, Karlsruhe

1997

Punch in out Kunsthaus Hamburg, Hamburg
Enter: Enter: Artist/Audience/Institution Kunstmuseum Luzern, Lucerne
L'autre Biennale de Lyon, Lyon
Take Off Galerie Krinzinger, Bregenz
Zonen der Ver-Störung Steirischer Herbst, Graz
Fasten Seatbelt Galerie Krinzinger, Vienna

1996

Spiel mit Sponsorengeld Spielbank Bad Neuenahr, Bad Neuenahr
 (was also cover for "Texte zur Kunst," August 1996)
... fra Hamborg og fra Kobenhavn Globe, Copenhagen
Weil Morgen Eisfabrik, Hannover
Kunst auf der Zeil Schaufenster im Disney Store, Frankfurt
Guillaume Bijl stelt jonge kunstenaars uit Hamburg voor Lokaal 01, Antwerpen

1995

... aus Hamburg und Kopenhagen Fahrradhalle, Offenbach
Ebbe in der Freiheit: "Club Berlin" 46th Venice Biennale, Venice

Public Collections

Hamburger Kunsthalle Hamburg
Kunsthalle Bremen Bremen
Kunsthaus Zürich Zürich
Kunstmuseum Wolfsburg Wolfsburg
Wadsworth Antheneum Hartford
Whitney Museum of American Art New York
Museum für Moderne Kunst Frankfurt
Frac Paca Marseille
Tate Gallery London
Museo de Arte Contemporáneo de Castilla y León León
National Galerie Berlin
Dallas Museum of Art Dallas

The Way I See It

The Way I See It #30

The secret of attraction is to love yourself. Attractive people neither judge themselves nor others. They are open to gestures of love. They think about love, and express their love in every action. They know that love is not a mere sentiment, but the ultimate truth at the heart of the universe.

Deepak Chopra
Author of *The Spontaneous Fulfillment of Desire* and other spiritual guides.

The Way I See It #34

There are no limits on how much the heart can love, the mind can imagine, or the human being can achieve.

Lynne Cox
Author of *Swimming to Antarctica.*
She broke the world record for swimming the English Channel.

The Way I See It #9

We constantly cast the lure of expectation ahead of us hoping to hook a desired piece of the future. Something unimaginable always takes the bait.

Dee Hock
Founder and CEO Emeritus of Visa, and author of *Birth of the Chaordic Age.*

The Way I See It #39

Every morning when I brush my teeth, I look at the aging face in the mirror & think, Wake up, honey, it could be worse. It could be happening to you.

Philip Levine
Pulitzer Prize-winning author of numerous poetry collections, including *The Simple Truth.*

The Way I See It #17

The world bursts at the seams with people ready to tell you you're not good enough. On occasion, some may be correct. But do not do their work for them. Seek any job; ask anyone out; pursue any goal. Don't take it personally when they say "no"—they may not be smart enough to say "yes."

Keith Olbermann
Broadcast journalist and host of MSNBC's *Countdown with Keith Olbermann.*

The Way I See It #10

A movie is not about what it is about.
It is about how it is about it.

Roger Ebert
Pulitzer Prize-winning film critic and co-host of *Ebert & Roeper.*

This is the author's opinion, not necessarily that of Starbucks.

30

Christian Jankowski: Everything Fell Together

The Des Moines Art Center published this catalogue on the occasion
of the exhibition *Christian Jankowski: Everything Fell Together*,
organized by Jeff Fleming.

Des Moines Art Center
June 23–August 28, 2005

Massachusetts Institute of Technology, List Visual Arts Center, Cambridge
October 14–December 30, 2005

Foundation for Art and Creative Technology, Liverpool, England
January 19–March 19, 2006

ISBN: 1-879003-42-2
Library of Congress Control Number: 2005921331

Essays by Jeff Fleming, acting director of the Des Moines Art Center, Iowa;
Jordan Kantor, assistant curator, Department of Drawings, The Museum
of Modern Art, New York; and Norman M. Klein, cultural critic, media and
urban historian, and professor at the California Institute of the Arts,
Los Angeles. Interviews by the Brothers Strause and Bill Arning, curator,
MIT List Visual Arts Center © each author

"Concentric Circles," from *I'll Let You Go* by Bruce Wagner,
copyright © 2002 by Bruce Wagner.
Used by permission of Villard Books, a division of Random House, Inc.

Des Moines Art Center
4700 Grand Avenue
Des Moines, Iowa 50312
515-277-4405
www.desmoinesartcenter.org

Design: 2x4, New York: Susan Sellers, Anisa Suthayalai
Editors: Emily Speers Mears, Ellen R. Feldman
Printed in Iceland by Oddi Printing

Funding for *Christian Jankowski: Everything Fell Togther* is provided by
Altria Foundation, the Institute for Museum and Library Services,
and the Goethe-Institut Inter Nationes.

 Altria

Photo and Cinematography Credits:
8. Mexico City Billboards Lente; 9. Painted Lectures Peter Winandy;
10. Questions for the President Wolfgang Träger; 11. House of the East
Detlev Endruhn; 12. Let's Get Physical/Digital Friedhelm Schulz;
13. Create Problems Bobe; 14. The Day We Met Friedhelm; 15. Commercial
Landscape Lars Lohrisch; 16. My Life as a Dove Marcus Gums;
19. The Matrix Effect John Groo; 20. Congratulations Marcus Gums;
26. The Hunt Frank Restle; 27. Rosa Andreas Doub; 28. This I Played
Tomorrow Max Penzel; 29. What Remains Max Penzel; 30. Hollywood
Snow Max Penzel; 31. 16mm Mystery Helge Gurell.

Thank you
The artist gives special thanks to Cynthia Leung, Sally Gross,
Miljohn Ruperto, and Max Penzel.

Every morning when I brush my teeth, I look at the aging face in the mirror & think, Wake up, honey, it could be worse. It could be happening to you.

Philip Levine

19. The Matrix Effect

2000

As part of its Matrix Series for emerging artists, the Wadsworth Atheneum commissions the artist to make a new work. Jankowski contacts thirty-five artists who have participated in the series, the former director, Jim Elliot, and Andrea Miller-Keller, the museum's previous curator, with a list of questions regarding past Matrix exhibitions. These interviews are transcribed and edited into an original script. Rather than casting the artists as themselves or using professional actors, Jankowski enlists untrained children for the roles. Set during a celebration of the Matrix's 25th anniversary, Miller-Keller, an eight-year-old girl, guides the viewer through encounters between the artists and Elliot. At the end they toast together. Thanks to the children's chance mispronunciations, "historical" artworks become "hysterical;" art "critics" become art "critters."

Color DVD (34 minutes).

Opposite

Jim Elliot

Following spread

Sol LeWitt

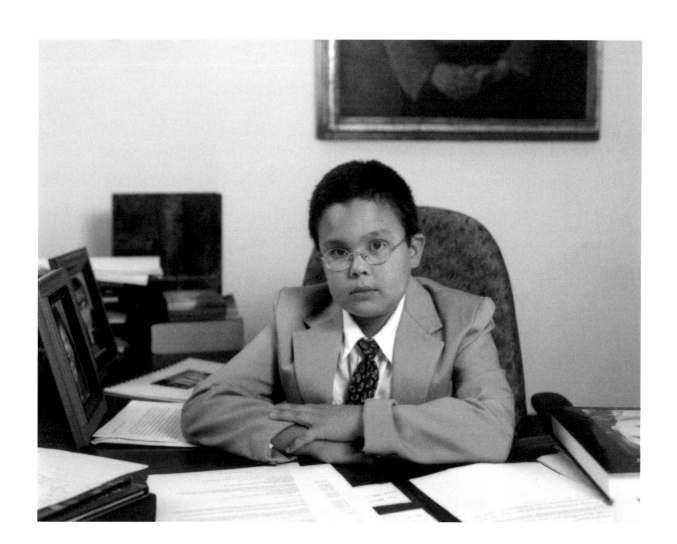

Wadsworth Atheneum

Narrator ———— It all began twenty-five years ago ... in Hartford, Connecticut, a small city in the northeastern United States. They started an experiment that would have far-reaching consequences. In the early seventies, a visionary group of curators and artists were determined to carve a place for the most ambitious contemporary art in America's oldest art museum, the Wadsworth Atheneum. They called the program 'Matrix'. At first, nobody realized what this dedication to new art and ideas would mean, but a quarter century later, there is no denying the uncanny power of The Matrix Effect.

Scene 1: A little girl stands in front of the main entrance of the Wadsworth Atheneum. She looks to be about eight years old.

Andrea ———— Hi, my name is Andrea Miller-Keller, and this is the Wadsworth Atheneum. I was curator of contemporary art here for very many years. Today we're expecting some artists to join us to celebrate the 25th anniversary of Matrix. I've arranged for them to come and meet with us so you can learn more about it. Everyone's been experiencing The Matrix Effect. Come, come with me and you'll see ...

Andrea approaches the front doors and meets a young boy standing on the steps.

Andrea ———— (to camera) There's Jim Elliott, the father of Matrix! He was director here from 1966 to 1976.

They hug each other and enter the museum.

Andrea ———— It's so nice to see you again, Jim. Tell us, how did it all start?

Andrea and Jim walk through the entrance hall.

Jim ———— Well, before I came to this museum I was chief curator at the L.A. County Museum of Art. We started to think how contemporary art can play a more active role. But I left L.A. County before the concept had really been worked out. So I worked on it here and tested out the Matrix on a few people.
Andrea ———— Can you explain the concept?
Jim ———— It was to respond quickly to contemporary art and for it to be a constant presence in the museum. Some people found it really hard to grasp, but you really got the idea. You were motivated and enthusiastic, so I offered you the job to be a curator.

Andrea looks up and notices a very little boy, wearing eyeglasses, standing on the second floor.

Andrea ———— (to Jim) Look, there's Sol LeWitt, one of our first Matrix artists.
Andrea ———— (to the little boy) Hi, Sol!

All three children wave to one another.

Andrea ———— (to Sol) Wait for me—I'll join you!
Andrea ———— (to Jim) I'll see you later for drinks!
Andrea ———— (to camera) Sol LeWitt really made radical changes in Western art. He pinpointed the fact that great art starts with great ideas. He's one of the founders of what's been called Conceptual Art.

Andrea meets Sol on a balcony overlooking a wall drawing by Sol LeWitt.

Andrea ———— (to Sol) Hi Sol.
Sol ———— Hi.

They kiss shyly on both cheeks.

Andrea ———— Hey Sol, as one of the first participants, what do you remember most about your 1975 Matrix show?
Sol ———— Very little! I think it was a wall drawing ... The only thing I remember doing is doing a poster.
Andrea ———— Today, as one of America's best-known artists, your work is very familiar here. Why do you think it was so hard for many people to understand 25 years ago?
Sol ———— You have to ask the many people.
Andrea ———— Well, on the other hand, what's your sense to why all your early wall drawings were so important to artists, critters, and curators?
Sol ———— Again, you have to ask them, because I have no idea.
Andrea ———— In 1973 you wrote, "I believe that the ideas, once expressed, become the common properties of all. They are invalid if not used, they only can be given away and not stolen." What was the importance of that belief then—and now?
Sol ———— It's an enduring truth.
Andrea ———— What do you remember of the art classes you took here when you were a little boy?
Sol ———— I remember one class—I think they played music and showed us slides of paint ... paint ... or something. I remember not knowing what to do.
Andrea ———— So how did it feel to finally have your own work showed here?
Sol ———— Good!

They turn around and look at Sol LeWitt's conceptual wall drawing in the entrance hall.

End of excerpt.

Opposite

Glenn Ligon

Final spread

Christo and Jean-Claude

Congratulations
Herzlichen Glückwunsch
2000

Jankowski is one of four artists nominated for the Preis der Freunde der Nationalgalerie—Germany's answer to Britain's Turner prize. The nomination includes an exhibition at the Hamburger Bahnhof in Berlin (part of the Nationalgalerie); the winner, who is announced at the exhibition's end, receives 100,000 DM ($60,000). Jankowski hires four professional speechwriters, briefs them with press material, and asks that each one write and perform a congratulatory speech awarding the prize to a shortlisted artist. Performed in front of an audience of extras representing the Friends of the National Gallery, each speech differs greatly in tone, as the speechwriters' specialties vary from politics to business to personal speeches. The four videos are installed in four adjacent cubes, so that a viewer standing in the middle is exposed to all congratulatory speeches simultaneously.

4-channel
video installation.

Final spread

Installation view,
Hamburger Bahnhof, Berlin.

Dirk Skreber

The winner of the first Prize of the National Gallery for Young Art is: Christian Jankowski.

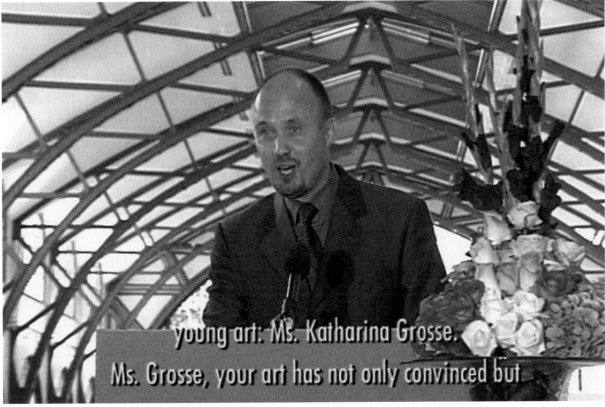

young art: Ms. Katharina Grosse.
Ms. Grosse, your art has not only convinced but

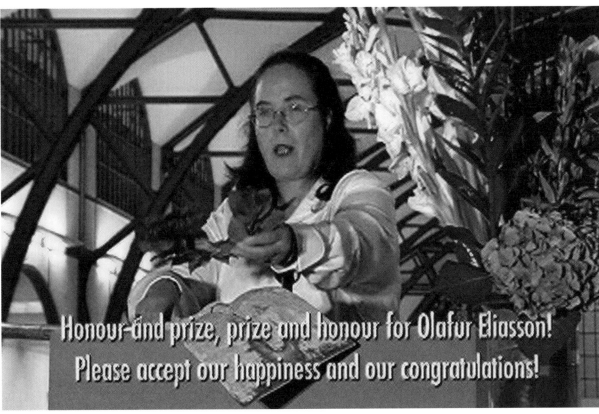

Honour and prize, prize and honour for Olafur Eliasson!
Please accept our happiness and our congratulations!

Poster Sale

2002

Visiting St. Louis's Washington University for a lecture and exhibition, Jankowski happens upon a poster sale. He photographs the students with the posters they've just bought. The forty small-scale photographs are themselves turned into a single poster.

Poster and
40 color photographs.

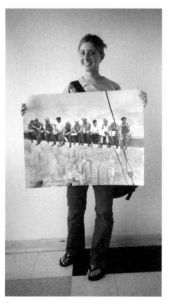 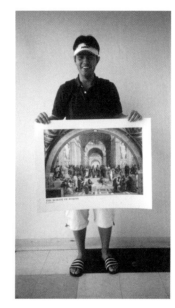

The world bursts at the seams with people ready to tell you you're not good enough. On occasion, some may be correct. But do not do their work for them. Seek any job; ask anyone out; pursue any goal. Don't take it personally when they say "no"— they may not be smart enough to say "yes."

Keith Olbermann

Telemistica

1999

In Venice for the 48th Biennale, Jankowski learns Italian. Speaking live on the telephone to five TV fortune tellers, the artist asks them each essential questions pertaining to the artwork he is in the process of creating.

Television broadcast
and color DVD (22 minutes).

L'ALTRO MODO
DI ESISTERE

If you have got

ask, tell me, and

PER DIRETTA

0425.411.999

UDINE.

omething more to
will explain better.

PER PHENDJATRI

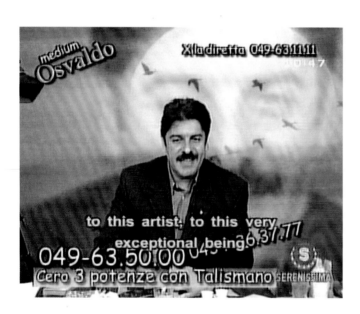

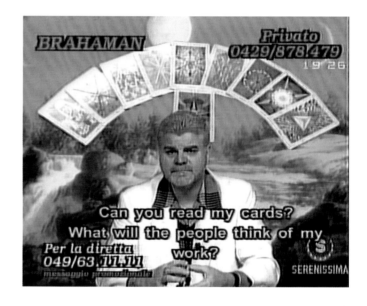

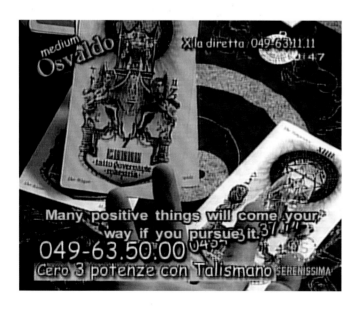

Maestro Antonio Vitale

Jankowski —————— *calling Maestro Vitale and speaking Italian with a heavy German accent* Hello? ... Good evening!
Vitale —————— Good evening!
Jankowski —————— My name is Christian.
Vitale —————— Christian?!
Jankowski —————— Yes ... ehmm ... I have a question about my work ... yes. Excuse me ... I am German ... please excuse me ... I don't speak Italian very well.
Vitale —————— Me neither, we have something in common!
Jankowski —————— Can you please speak slowly? Yes ... ehmm ... I have an idea for my work and I would like to know if this idea that came to me is good, if it is interesting, if it is sufficient and original!
Vitale —————— Alright, where are you calling me from, Christian?
Jankowski —————— From Venice.
Vitale —————— How old are you?
Jankowski —————— 31.
Vitale —————— Do you know your sign?
Jankowski —————— Ehmm ... I am a Taurus!
Vitale —————— So, did you recently have your birthday, or is it coming up?
Jankwoski —————— Birthday?
Vitale —————— Count the years ... practically when one ... ehmm ... if you were born on the 7th of May, the 5th ... When were you born?!
Jankwoski —————— Ah! Yes, yes, yes, yes, the 68 ... 6 ... 8 ... in the year 68.
Vitale —————— Yes, but the day of the month.
Jankowski —————— Ahh, yes! April ... the 21st of April.
Vitale —————— 21st of April! Oh, yes it's the last day ...
Jankowski —————— Yes, yes! Please excuse me!
Vitale —————— No, no, don't worry! But even in Germany you know something about astrology, right?!
Jankowski —————— Yes!
Vitale —————— Also about magicians ... they also exist ... okay. So ... why did you call me?
Jankowski —————— I am an artist and I'm thinking about a new art piece.

Vitale lays down the tarot cards.

Vitale —————— Well then ... the idea that you have, Christian, is definitely positive.
Jankowski —————— Ah! Good!
Vitale —————— Something important surrounds you, or your artistic work - a person of the female sex?
Jankowski —————— Yes?!
Vitale —————— You see ... because this is very important for your future. It is really a point of departure where you will do things with much skill and dexterity. The card of the magician also means ... the magician is a starting point, dexterity and skill, and there will be a renewal ... like if you would start to do something fundamentally new.

Barbara Feruglio

Feruglio —————— Something beautiful will happen tonight. We will see if the first person is the one I wanted to ... hello?
Jankowski —————— Hello, good evening Barbara!
Feruglio —————— Is that an English accent? ... English?
Jankowski —————— I am Christian.
Feruglio —————— So let me explain to our viewers what it is all about, okay?
Jankowski —————— Yes.

Image in the background changed to a nude painting by Gustav Klimt.

Feruglio —————— Christian called me during the week. He is a young artist who thought occultism that is so fashionable today could be the subject of a work to be presented at the famous Venice Biennial.
Jankowski —————— Alright!
Feruglio —————— So, now if you want to ask your question, I will answer you. But don't forget: know that what I say goes! Okay?!
Jankowski —————— Okay, I wanted to ask this question: Will I realize my work, will I find people to help me complete my work? These are my problems: I don't have much time, not much money ... but I have much willpower.
Feruglio —————— Like all the big and young artists. Well done - never let go - not even for a second, because desires come true only with strong tenacity. You have to hold on and insist.

She lays down the tarot cards.

Feruglio —————— Not much money, I can see that. You couldn't lie to me because I see that there is little money. I'll tell you more: from what I can see, you definitely will be a successful person in life. I see it and if I tell you this, that means it is so. In one sense you are a winner. I'm not just telling you this, because, as the people who know me know: I always say what I think. Therefore, I'm not just telling you this to make you happy or anything else. Even if I don't know you, from these cards I can tell you that you are a winner. What does it mean? ... That you probably have innovative, good, valid, concrete ideas.
Jankowski —————— Ah, good ... hmm ...

Background switches to a landscape painting.

Feruglio —————— Well then, you already had someone who you hoped or believed would help you, but you were let down. Right?
Jankowski —————— Yes?
Feruglio —————— Don't be insecure, because I can see that someone promised to help you.
Jankowski —————— Yes?
Feruglio —————— But you don't really believe in it.
Jankowski —————— Ahh ...
Feruglio —————— But there is a project and financial support, call it as you will. I don't know what it is. Understand? That means money. Support will arrive in a short time. Listen, concerning your career in general, it will be a successful career, ehmm ... There still will be moments... How should I say it? You will feel a little bit down because you still haven't reached what you want. There will be other difficult moments. I tell you this in advance, but don't get desperate, because I can see that you will do it.
Jankowski —————— Okay.
Feruglio —————— Don't think that you are by yourself, because in the moment you tell yourself you are alone ... pouff! ... comes help.
Jankowski —————— Ah good, okay!
Feruglio —————— I can see something else here. Which country do you live in?
Jankowski —————— Ehmm ... Germany.
Feruglio —————— Because I can see that this career will take you away from your family and your home.

Screen switches back to an image of Schinkel's starry sky.

Jankowski —————— I'm really sorry. I don't speak Italian very well.
Feruglio —————— Listen—your career. In the future you will gain success ...
Jankowski —————— Yes, I understand ...
Feruglio —————— That means slowly, but you will reach it ...
Jankowski —————— Yes ...
Feruglio —————— Some time there will be a distance between your home and your family. This makes me suppose that you will work more outside of your home country. Do you understand?
Jankowski —————— Aha ... aha, okay.
Feruglio —————— If you have anything else to ask me, tell me, and I will explain better.
Jankowski —————— Yes ... okay. Thank you, Barbara.
Feruglio —————— Bye and good luck! And say greetings to the Venice Biennale, an exceptional show. Naturally we all know about its enormous prestige.

Medium Osvaldo

Osvaldo —— Good morning?
Jankowski —— Hello, good morning Osvaldo.
Osvaldo —— Yes, what do you want to ask me?
Jankowski —— Yes, I want to know ... I am doing a piece of art ... I am doing a new piece of art?
Osvaldo Yes?
Jankowski —— Yes! Ehm... I want to know if, if... ehm, ehm, the, the, ehm ...
Osvaldo —— Will go well?!
Jankowski —— Yes, yes, it will go well, but will the work be good when the ...
Osvaldo —— Perfect.
Jankowski —— ... the exhibition...?
Osvaldo —— Where are you calling from?
Jankowski —— From Venice... I want to know if my work, when it is finally finished, will be presented well... if the conditions will be ... optimal?

Osvaldo lays down the tarot cards.

Osvaldo —— Look, no need to doubt, there will be a big surprise for you, a revelation. All the cards are promising. Look, there isn't a negative card! You only need more willpower.
Jankowski —— Yes?!

The television studio cuts the phone connection.

Osvaldo —— Don't believe those who speak in a negative fashion or who inspire doubt. You must listen to yourself faithfully because it is sufficient to reach that which you want. Many positive things will come your way if you pursue it. Though I can't tell you too much, at the very least there will be something positive. All the best from the bottom of my heart to this ... to this artist, to this very exceptional being.

Brahaman

Brahaman —— Hello?
Jankowski —— Hello!
Jankowski —— Can you read my cards? What will the people think of my work? And will they like it? Will I be successful?
Brahaman —— Christian, how old are you?
Jankowski —— I am 31 years old.
Brahaman —— Yes, what kind of work do you do?
Jankowski —— Ahhh ... I am doing a new art piece that is almost finished and I will soon present it to the public.
Brahaman —— Where are you originally from?
Jankowski —— Ahhh ... I am from, I am from Germany.
Brahaman —— Yes, but were you born in Germany?
Jankowski —— Yes, yes, the name is Pole ... Polish, but I am from Germany. I don't speak Italian very well, I'm really sorry.
Brahaman —— No, no. But it is easy to comprehend. The importance is to understand each other ...
Jankowski —— Yes, yes ...
Brahaman —— ... with those few words.

Brahaman lays down the tarot cards.

Jankowski —— Excuse me ...
Brahaman —— Now listen to what I say to you.
Jankowski —— Yes.
Brahaman —— Can you hear me?
Jankowski —— Excuse me, I am only interested in the public's reaction to this particular project.
Brahaman —— Yes, yes, it's coming to me now ...
Jankowski —— Ahhh ...
Brahaman —— What you are doing will be very well accepted, but will be difficult to realize economically, you understand?
Jankowski —— Ahhh ... and the public?

Brahaman —— ... will be very, very happy! But I repeat, I see that it will be triumphant ... Let's say it ... ehmm, it will be well accepted, let's say it in simple terms ...
Jankowski —— Ah ... really!
Brahaman —— But I repeat, I see a difficult balance between the financial success—in other words, the economic rewards ... I see ...
Jankowski —— Ahhh ...
Brahaman —— For that, be a little patient. But concerning, let me say it like this, for the work that you are doing, I see very good things.

Chiara Sibilla

Sibilla —— Good evening.
Jankowski —— Good evening Madame Ci ... Chiara.
Jankowski —— Yes, I have a question ... ehmm ... I am working on an art piece that is finished—that is almost finished — and I want to know if I will be happy and satisfied when my work is finished ...
Sibilla —— An artist is never satisfied.
Jankowski —— Yes? ...
Sibilla —— An artist is never satisfied—there is always something to cut and adjust. Am I right?
Jankowski —— Yes, but ...
Sibilla —— No, no, no. Continue.
Jankowski —— Will this work be of great importance for my life in the future?
Sibilla —— What is it, a sculpture?
Jankowski —— No, no, a video installation, new art.
Sibilla —— I understand.
Jankowski —— Yes, a video installation with a projection and photography.
Sibilla —— Mhm, where are you calling from?
Jankowski —— From Venice.

Sibilla lays down the tarot cards.

Sibilla —— A situation ... it is not yet fully developed ... it is a situation that will give you great satisfaction, also in an economic sense.
Jankowski —— Aha!
Sibilla —— ... Also in an economic sense, though not immediately, but by the end of June.
Jankowski —— Yes.
Sibilla —— End of June, okay?!
Jankowski —— Ehmm ... But will I soon be satisfied with this or not?
Sibilla —— Yes, I said the end of June: one month, 35 days, nothing more.
Jankowski —— And will it be of great importance for my artistic development or for my future?
Sibilla —— Ehmm ...
Jankowski —— This work?
Sibilla —— Yes, I have said that there will also be economic satisfaction.
Jankowski —— Ah ... okay, thank you very much.
Sibilla —— All the best!
Jankowski —— Yes, good-bye.
Sibilla —— Good-bye ...
Sibilla —— *turning to the audience:* Anyhow, an artist or a painter is never satisfied with his work—there is always something to complain about ... The mothers only are the ones who will always say, "Oh, how beautiful!" But I am different. Even when my son was born, I said, "Gee, how ugly!" So, I can honestly say that I am always consistent.

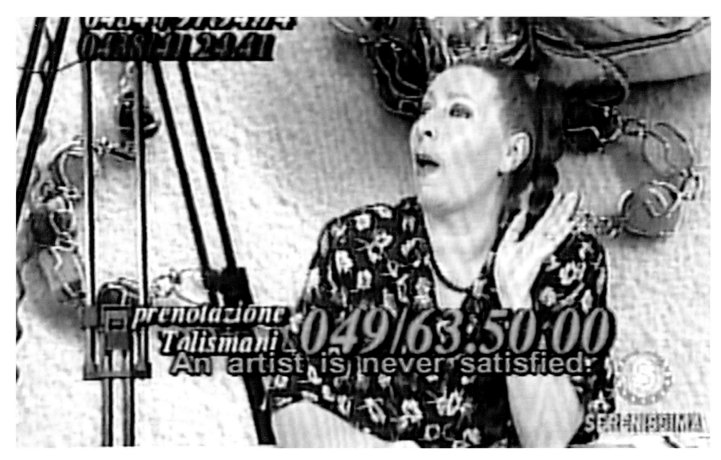

23. The Holy Artwork

2001

Jankowski films Pastor Peter Spencer's televangelical sermon at the Harvest Fellowship Church. Pastor Spencer invites Jankowski up onto the stage, where he falls down as though possessed. Pastor Spencer's own camera crew takes over the filming, which from there on is executed in full-blown televangelist style. The artist's collapse is used by the Pastor as a means to sermonize on art, creativity, and religion to his congregation, his viewers, and the art world. He prays on Jankowski's pre-arranged request for *The Holy Artwork*, and asks that it be a bridge between art, religion, and television. The sermon is broadcast on Pastor Spencer's own show three times.

Television broadcast, performance,
and color DVD (15 minutes, 52 seconds).

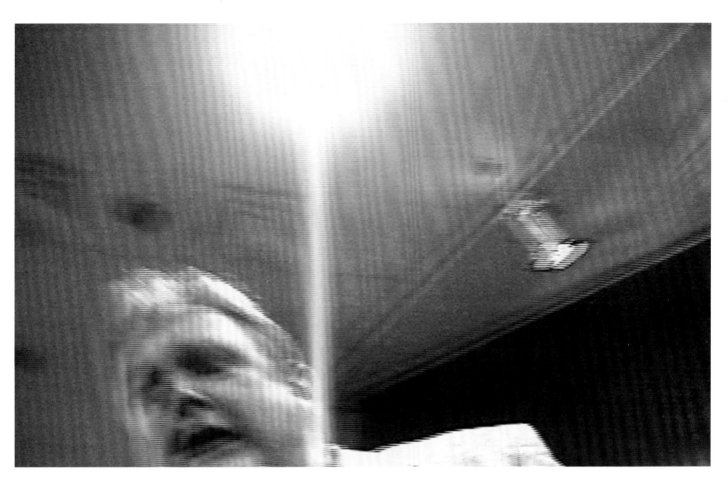

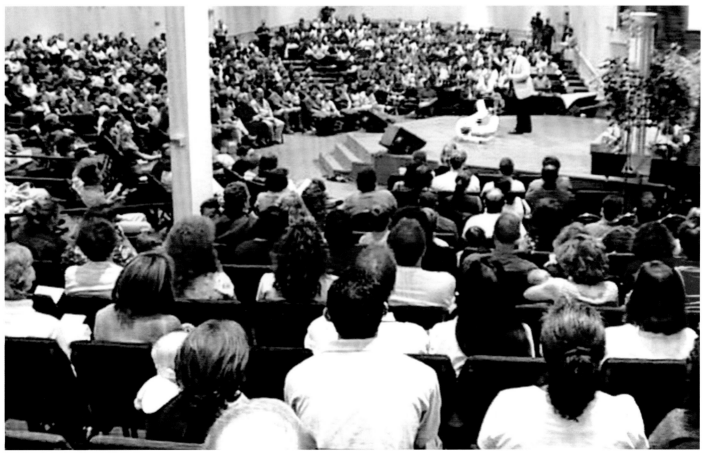

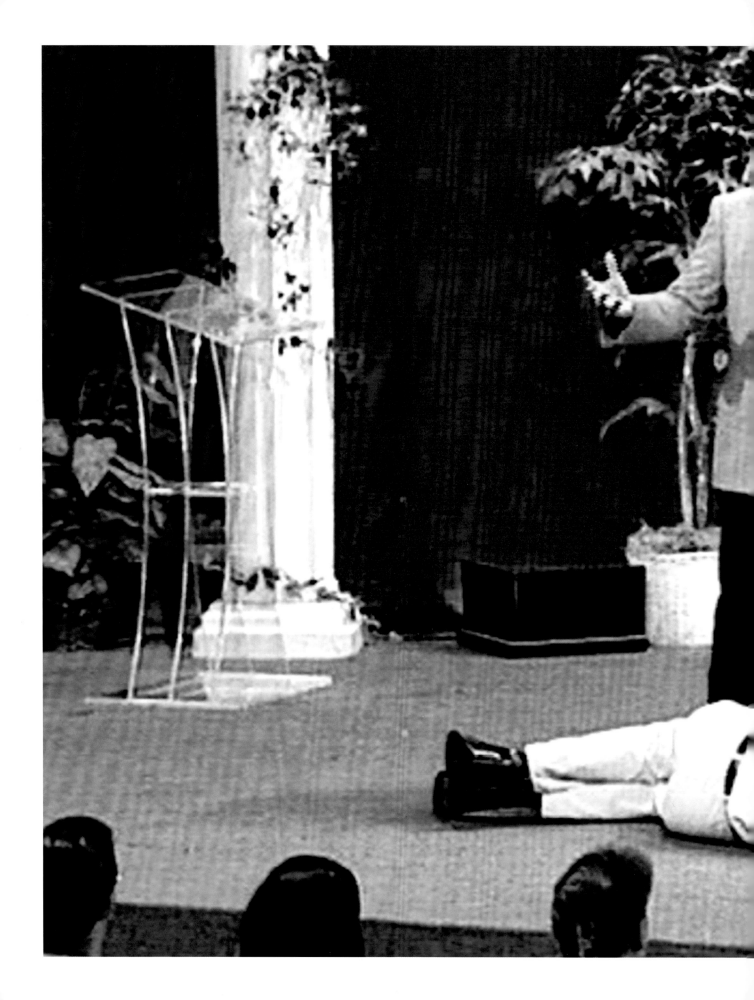

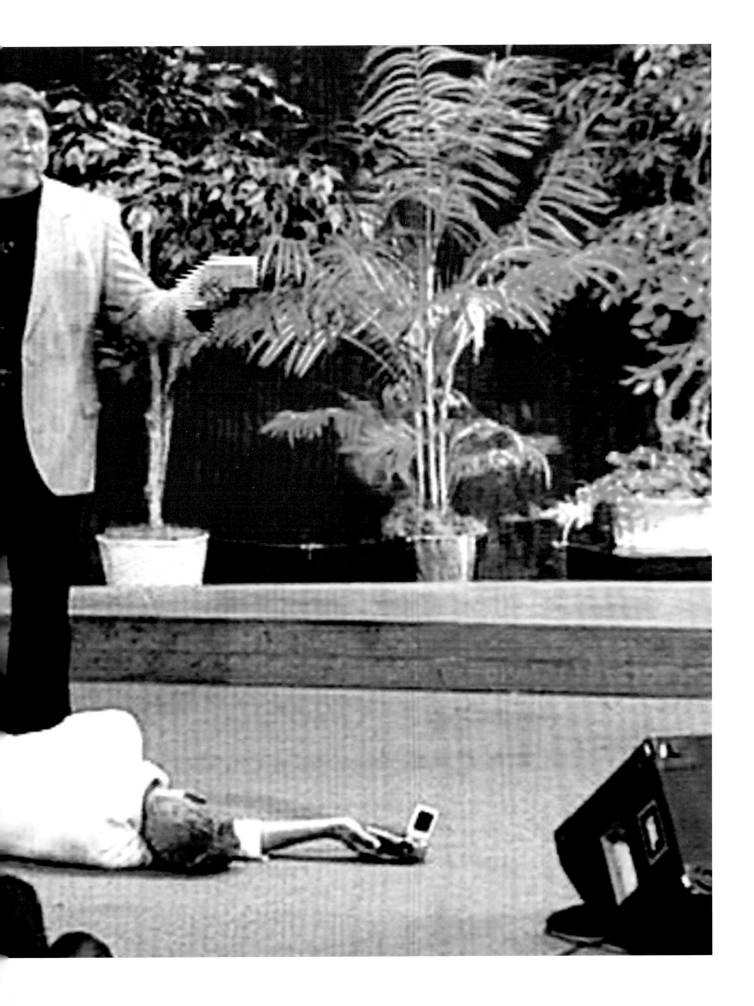

Peter Spencer
Pastor - Harvest Fellowship Church

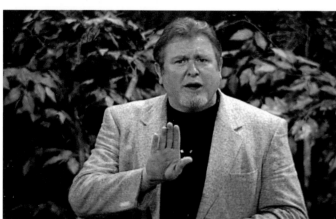

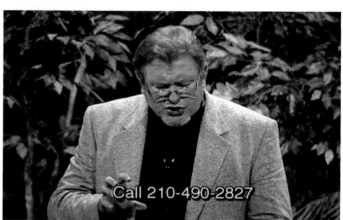

Call 210-490-2827

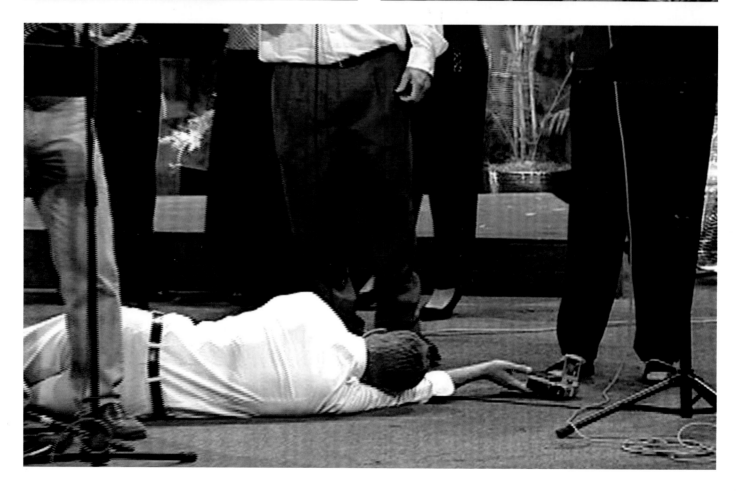

Harvest Fellowship Church

Chorus sings

Image of the congregation from the perspective of Christian's wobbly hand-held camera, as the sermon begins.

Pastor —————— We are going to have just a minute of prayer. And as we are going into this minute of prayer I want to just communicate in a very interesting way. We have somebody who is with us here today. He is doing something very special. He is just going to take a couple of seconds here as I communicate to you. Would you come on out, Christian? This is Christian, he's from Germany.

Perspective moves with Christian's hand-held camera out of the audience, approaching the stage, where the Pastor is waiting.

Jankowski ————— *(from behind the camera)* Hello!
Pastor —————— You know, he and I were talking about ... err ... artistry. And we were talking about how God is the ultimate artist. And so he shared something with me which is important.

Christian arrives. Camera stops just in front of Peter's face.

Jankowski ————— Hello, Peter!
Pastor —————— Hey, it's good to see you.
Jankowski ————— Oh ...

As Christian falls, camera perspective switches from his hand-held to the church camera system used for TV broadcasts. The artist is seen falling before the audience. He lies motionless at the Pastor's feet, fallen camera in open hand. Camera switches to a close-up of the Pastor.

Pastor —————— He just did about the last thing that you would have expected him to do: he fell over. And I know you wonder why. Let me just tell you. What you are looking at today is not just a video. It is what is considered as Holy Art. Holy Art? Let me tell you what Holy Art is. Those of you who are watching in this hall are going to be experiencing Holy Art in an unique way. Some of you are watching this on television. We greet you as well. It's good to have you.

Blue caption appears briefly at bottom of screen: Peter Spencer, Pastor – Harvest Fellowship Church

Pastor —————— And some of you are watching these videos, these pieces of art, in an art gallery. It's an art setting. And the reason it's art is because it's never been seen before.

Yellow caption appears briefly on screen: Call 210-490-2827

Pastor —————— You've never seen Christian fall on this stage, you've never seen this piece of Holy Art. And that is what makes it art. You see, art is actually a creation. Now, I come from the world view that there is only one creator but many people who are creative. And what Christian is doing in this piece of art is much like what a painter would do who has a paintbrush. He would take that paintbrush and he would use it from the palette and go to the canvas and paint something unique. But the attention often times gets away from us and we focus too much on the paintbrush of life, or too much on the artist of life, or too much on the canvas. And we need all three! So, today we need you in three realms. See this in a multi-dimensional way. This is not just a one-dimensional piece of art. You see, we are body, soul, and spirit. We need an audience here, we need an audience on television, we need an audience in the art gallery. And we need you at different levels to understand what we are doing today—and I think you will. You see, when Christian fell down he basically is like a person who's dead. He's like the paintbrush, but now we transfer. He's like the video camera—he was here recording. But he's only an instrument. And as he fell his camera is no longer being used.

A family listens carefully; the wife glances at her husband and gives him a skeptical look.

Pastor —————— Now instead of just a single camera there is another camera which you are watching. In fact there are many people who are going to work on this project to make it happen. Art is not just for a single person. Art is actually an event which occurs because of many people. You see, there would be no artist if there wasn't a canvas and paintbrush. But there would be no purpose of the canvas and paintbrush if there weren't people to watch and look at the art.

An older couple watches intently.

Pastor —————— So, what you are understanding is that a piece of art is only art if there are people to see it. It can only become a piece of art if there is an artist who has yielded to inspiration, as well as there needs to be a canvas and a place to place it. And so it literally takes a team effort. And that's a miraculous thing. Art is miraculous, because we are able to, every single day, see something new that's never existed before. God is a creator. And when He created us, He did it in his image according to the Bible. Did you know that of all the animals, the only one that actually had God breathe into him was the human being?

A mother listens, captivated, with her baby sleeping quietly next to her.

Pastor —————— All others were created, but God actually breathed into man to make man unique like Him—body, soul, and spirit. Not just the body and the soul, but we have a spirit. And that is where spirit or inspiration comes from. It's because of the spirit that we have. Beavers pretty much build dams as they have for thousands of years. Birds build nests like they always have. But humans have the ability to create. But we are not creators, we are creative.

Camera frame shows the congregation from behind. Two large movie screens hang on either side of the stage. The image is simultaneously projected onto the screens, so that the camera films its own live recording. This way, a feedback occurs, an 'image in the image' effect.

Pastor —————— And today you are seeing something which is creative. You are experiencing something new which only human beings can truly understand of all this kingdom, phylum, sub-phylum, class, sub-class, order, genus, family, or species. It's only the human being that can experience the creation of the new.

Close-up of the Pastor.

Pastor —————— Now, one of the things that is extremely important to understand as we watch this piece of art is that it took Christian emptying himself, falling down, no longer becoming the center of attention, to make this a great piece of art. Human beings, when we create things, often have the tendency to look in the mirror and worship ourselves, adore ourselves, because we think: Look at the great thing I did.

People pay close attention while one man with a white beard chews gum and looks bored.

Pastor —————— But I've never known a camera to worship itself. It may have taken some beautiful photography, but the real attention goes to the one who is behind the camera—the Spielbergs, the other great directors. Those are the ones that are understood as the genius—not the camera. And so today we have to understand that the miracle of art is not because of us, the paintbrushes, or us, the cameras of life, but it's because of the Great Artist, the Great Creator who gave us the ability to feel inspiration by His power! You know, sometimes people don't understand how we can be on three levels at once. In fact, I often explain when I am teaching about the Trinity how you can have the Father, the Son, and the Holy Spirit—they are all one God, as in the Old Testament, it says

we have one God. Yet there are three personages. In Hebrew actually ... the language shows that there are three personalities of God, yet the verbs are those which are singular verbs talking about a plural God. And this is how it works: today you are at many dimensions. Now, you can see this in a flat way as a painting or you can use all of your spiritual dimensions to understand this artwork. The same way you can have H_2O water, in three dimensions: you can have a cloud overhead while you hold a glass of water in your hand that has a piece of ice in it. Three forms: solid is the ice, liquid is the water, and, of course, the gas, H_2O, the cloud. I am a father to my son. I am a son to my father and a husband to my wife—it doesn't mean I'm schizophrenic.

People laugh out loud.

Pastor ———— Though that's a good possibility, that doesn't mean it ... But it simply means I have the ability to have three things happening within me at once. The purpose of Holy Art is to try to reach into your life and have you stop looking one-dimensionally at a flat image, and start seeing a dimension beyond that image. To sense that there is more than just the flesh, more than just the body. Even more than just the soul. It's to see the spirit. "Years ago God created the Heavens and the Earth," it says in Genesis 1.1. He created it—in Latin it's *ex nihilo*—out of nothing. What a phenomenon! But John 1.1 explains how He did it: it says He spoke it by the word. It says, "In the beginning was the word." The word was with God, the word was God, the same as the beginning with God and all things were made or created by Him. By the word. Greek: *hologos*. God actually spoke and it came into being. Now follow: He not only created the earth, but He created Man. You know why? Because he couldn't have a piece of art to show off without having someone to see it. You see, it takes you as the audience to make Holy Art truly Holy Art. Adam and Eve were created so they could enjoy the painting of God. God had the painting done, but what was his paintbrush? His name was Jesus. He was the Word. He spoke out, there's the paintbrush. Great image of the universe, there is the painting, or the videography, you might say. And He is the Great Artist.

A view from one side of the church shows hundreds in the audience. While the artist lies motionless, the Pastor makes a gesture towards the people.

Pastor ———— So, if you get nothing else today from this Holy Art, it is critical that you understand this simple point. You are going to see many creative things, but there is only one creator. And hopefully not only will you walk away with more than a one-dimensional, flat concept of art. But hopefully today you will walk away having had your second, your third part of your being come to life. See things spiritually. Because when this body dies, the spirit is all that's left. And the key is: Did you understand the creator of the Great Painting of Life before you face him for eternity? And that is what we must do. So, not only today you have seen a creative piece. Hopefully you've met the Artist, the Creator, who started this painting way back at the beginning. And the reason He did the painting, He created you so you could enjoy it. And that's love. Artists don't think about the money, artists don't think about the glory.

Close-up of Christian lying on the floor.

Pastor ———— They think about the people who will see it. Will they be touched? Today Christian's heart is that you're touched. And the original painter's heart that gave us the miracle of cameras, that gave us the miracle of materials so that we can do what we are doing today, the One who created all of those images, the One who created all of those elements is also saying, "I hope today you're changed. You walk away from this painting not one-dimensionally, but multi-dimensionally."

Shot of congregation as Praise Team begins to sing. Camera moves back to the stage, where the artist still lies on the floor, surrounded by the musicians. Blue caption appears on the bottom of the screen: Praise Team. Harvest Fellowship Church.

Camera zooms in on Christian as the song ends. Audience applauses. Camera cuts back to close-up of the Pastor. He is now wearing eyeglasses and looks down at a sheet of paper in his hand. He begins his interpretation of Christian's prayer request.

Pastor ———— So, what we do is, we want to thank the creator God for the gifts he's given to us. It's simply a courtesy, but it's also a way of showing that you appreciate what's just happened.

Eyes closed, he bows his head and continues speaking.

Pastor ———— So we are going to agree and say: "Thank you, Lord, for creating video." That this is a medium that we can use to communicate.

People pray, heads bowed.

Pastor ———— Thank you for the knowledge and the wisdom in all of the people who collaborated together to make this miracle happen. And thank you, Lord, for the opportunity to make this Holy Artwork. And for those who caught Christian's vision, because it takes more than just the artist—it takes those who believe in the art. Father, we want to say thank you ...

A woman makes notes in a book.

Pastor ———— ... for letting this artwork reflect even the materials which you have created that could be put together and show the inner possibilities, while pointing beyond them. Father, we want to thank you that there's even purpose in this Holy Artwork. And that purpose was to reach into the hearts of those watching one-dimensionally ... and let them know that there are many dimensions to the body, soul, and spirit, so that it would reach beyond this moment in time. In fact, let this art, this Holy Art, last beyond even our lives. Whether it'll be a century or ten centuries, may this artwork last and continue to teach the message. May it even expand our definition of art. And let this artwork—Father, God, we pray—question and challenge the art world and bring it to a level of a spiritual dimension. Father, we want this Holy Artwork to make people in the church understand the value of contemporary art, and we pray that this artwork, this Holy Artwork, will be a bridge between art, religion, and television.

Camera zooms out slowly. Pastor is standing over the artist.

Pastor ———— May we end one-dimensional lives and may we experience the dimension of your glory, your power, your spirit, and your will in our lives. We pray these things, by the power in Jesus Christ. Amen.

Pastor leans over and reaches out to pull Christian up. Camera and perspective switch from the church camera system to Christian's hand-held. In the frame, a shaky close-up of Peter as the artist rises.

Pastor ———— Thank you, Christian. Thank you.

Congregation applauds.

Jankowski ———— *(from behind the camera)* Thank you. Thank you, God. Thank you for making this possible! Thank you very much.

Perspective moves off stage with Christian, and he finds his seat back in the audience.

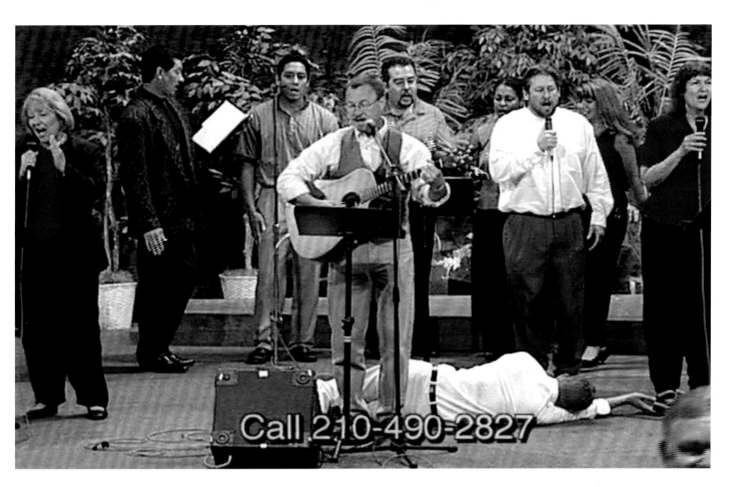

Call 210-490-2827

Talk Athens

2003

On *Get a Taste*, a talk show broadcast live on Hellenic Television One, a silent Jankowski appears alongside the Greek television talk show host Bilio Toukala and her guests: Nikos Vernikos, a contemporary art collector; Milena Apostolaki, a politician; Christos M. Joachimides, the director of Outlook; and Augoustinos Zenakos, an art critic. As the guests wax philosophical about the significance of Jankowski's silence which, as the host has explained, turns the talk show into his artwork, Jankowski gets up and starts to walk around.

Television broadcast, performance,
and color DVD (23 minutes, 54 seconds).

Today "Get a Taste" will have
a bit of a different taste.

He plans to turn this TV show into a work of art.

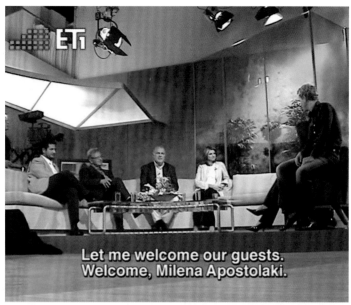

Let me welcome our guests. Welcome, Milena Apostolaki.

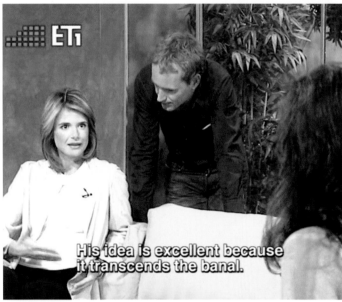

His idea is excellent because it transcends the banal.

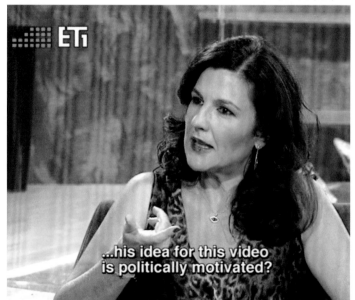

...his idea for this video is politically motivated?

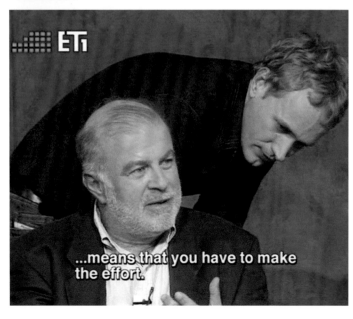

...means that you have to make the effort.

...it makes you more patient and teaches you to compromise.

"Get a Taste"
Live on ET1

Bilio ——————— Today *Get a Taste* will have a bit of a different taste. This part of the show will become itself a work of art. The person you just have caught sight of behind me is a German artist who will remain silent throughout our discussion. He plans to turn this TV show into a work of art. I'm happy we'll be talking about this event today. Let me welcome our guests. Welcome, Milena Apostolaki.

Apostolaki ——————— Good evening.

Bilio ——————— How are you?

Apostolaki ——————— Fine. And happy to be in your show to talk about this important event to take place in our country.

Bilio ——————— Mrs. Apostolaki is a politician and a former minister. Let me also welcome Mr. Nikos Vernikos. How are you?

Vernikos ——————— I feel great to be in such good company.

Bilio ——————— Me too. Mr. Vernikos is a businessman as well as an art collector. We'll explain later why someone who might only be looking after his own business is so deeply involved in art collection and culture. Let me now welcome the man behind this exhibition a man who has worked for more than three years to organize this event, Mr. Christos Joachimides, the artistic director of Outlook. Good evening.

Joachimides ——————— Hello. I'm glad to be here with you. It's the first time at least here, that I see this unique idea implemented.

Bilio ——————— Let me also welcome a colleague and art critic, well known for his column in *Vima*. Augoustinos Zenakos.

Zenakos ——————— Good evening.

Bilio ——————— Good evening, Mr. Zenakos.

Zenakos ——————— Congratulations on deciding to implement this idea.

Bilio ——————— Finally, let me welcome Christian Jankowski. He's sort of a silent witness, an observer. Christian Jankowski is German, and one of the biggest names in the world of modern art. He's been in Greece before and it was his idea to turn this show into a work of art. He'll take the video of the show and process it. He may shorten it to show it at Outlook and then at other museums where he exhibits his work.

Jankowski wants to stand up, but the microphone cable that is connected to his body holds him back. He unplugs the microphone.

Right, we won't need the mike since Christian will be silent.

Joachimides ——————— In Greece this is the first time we approach modern art in a hitherto unknown way. Hence the presence of our friend and great artist, Christian, who will give us a first glimpse of what is about to happen in Greece.

Jankowski walks behind the sofa some guests are sitting on.

Bilio ——————— Let me explain to viewers who may have just joined us as well as to those watching us on cable that Christian, whom you see walking about the studio, is a German artist who wants to turn the video of the show into a part of his work. One of the reasons why he has decided to do this, is because he wanted to give a say to silence. To process the relationship between silence and speech. This is a chat show. It uses speech as its medium. Christian wants to ask: What happens when silence comes? When it denies the very existence of the journalist? In a country with discourse at the foundation of its democracy, what about political discourse? Does it still weigh as much as it did in the past?

Apostolaki ——————— I think discourse still counts not axiomatically, as a dogma, but because it invites counter-discourse and through this process we get to the heart of matters. But I take your hint; some things have lost their value because we devalue them in the way we handle them. Often our words sound hollow and suspect, perhaps rightly so. If we are able to do something about this negative image ... I'm among those who believe that discourse still counts. It is the core from which creation begins. As for the idea of your guest, who is our guest too, what I think is more important is the fact that he reminds us that contemporary art is the transformation of the banal. His idea is excellent because it transcends the banal.

We all seek something new in all areas of life. In politics, the new left, the progressive movements, they all desperately try to articulate something new and original. This anguish exists in art as well as in other areas. Humanity has experienced the new and the progressive through art. And that's where we expect to find it.

Bilio ——————— Mrs. Apostolaki, do you think that Christian's idea for this video is politically motivated? Do you find there's a political dimension to it?

Apostolaki ——————— The way you put it, I think, there is a large dose of political motivation in art because art produces messages. We've seen art inspire resistance and demands. New movements spring from it because of its great power. It's probably the medium with the greatest power to transmit messages and to bring people together through the channels of communication that it builds.

Bilio ——————— And to advance society ...

Apostolaki ——————— To take it a step forward.

Bilio ——————— Before I ask Mr. Joachimides why Christian has picked our channel to create his work of art ... Mr. Vernikos, you are a successful businessman. You're also an art collector. Why does a businessman become a collector of art?

Vernikos ——————— As a businessman, I believe we can't have development without culture. Fortunately, I'm not alone in believing that culture and art ensure for us what is called sustainable development.

Bilio ——————— In other words, you have money but instead of buying a new car, or a new house, or boat, you invest in modern art.

Vernikos ——————— I don't invest, I please my fancy, I live. I believe I'm not here just to make more money. Civilization is the greatest heritage I have and I feel that the least I can do for my own well-being and for my debt to society, I can do it through culture. I've found contemporary art to be the easiest to deal with. Other forms of art need special education and knowledge. With contemporary art, you derive enough satisfaction from getting to know the work itself and the artist. The fact I met Christian today was a great pleasure to me. Tomorrow I'll decide to buy one of Christian's works. I don't see it as an investment, but as the good life.

Bilio ——————— I like what you say. Would you buy a work like this video now?

Vernikos ——————— When it comes to video art, I will if I like the artist. For me the artist's personality ...

Jankowski sinks down behind the sofa.

Bilio ——————— He's creeping up to you but he doesn't understand you.

Vernikos ——————— I'll be able to see this in the video. It will be a surprise ... In contemporary art, you get to know the artist, the creator. If we don't have the right chemistry, it affects my choice. I often buy a work because I like the artist or to get to know him better because I find him interesting.

Bilio ——————— It's an interesting approach. Mr. Zenakos can tell us more. He's written reams about how contemporary art, all forms of art as well as politics, everything really, requires education. It's not necessary to grasp and be grasped by it at once. But eventually you need to understand its language and, to understand it, you need to know its alphabet.

Apostolaki ——————— I understand what Mr. Vernikos says about the relationship between the artist and the art collector; however there is a danger in this. When we read about great artists whose works have become a part of our civilization, we realize they had appalling personalities and yet they were great artists.

Bilio ——————— Mr. Vernikos, if you had known Toulouse-Lautrec

in person I doubt that you would want to buy one of his works.

Vernikos —————— Contemporary art is the most accessible form of art.

Bilio —————— Cost-wise, you mean?

Vernikos —————— Yes, but also easier to get to know. To go to opera ... I mention this because you know we've been campaigning with Vasso Papantoniou for a new opera in Athens.

Bilio —————— Vasso Papantoniou has made it the aim of her life.

Vernikos —————— And it's my honour to join her in this campaign. So I mean to say that with contemporary art, anyone can go to a gallery that is next door to his house and ask for an explanation about that strange thing he sees hanging from the wall or built on the gallery floor. It's accessible, it's easy. You don't need to spend much or even read much about it. You go, you ask, you learn. I was lucky enough to know important people like Christos who have educated me about an entire world which now gives me the joy to live and meet new people like Christian here, and wherever I may go on business I feel at home, among friends.

Bilio —————— Mr. Joachimides, tell us why Christian has chosen our channel for his video. We are one of the sponsors but that wasn't the reason, was it?

Joachimides —————— It wasn't. It was his idea to do something which in our country is unique. It is a first. No one expects to see an artist who doesn't talk. It goes against the grain. There's usually too much talk on the media. So he sets up this performance from which he will create a work of art. What do I mean by 'art'? Let me make this clear because, after all, it is a question of education. In art, the average art lover expects to see a painting that is immediately recognizable. Performances of contemporary art are a little different. They relate to the intense dialogue of contemporary artists with the modern media, digital or other. This is very different from a work of painting or sculpture. It's another form of expression that uses the same processes the same authentic and strict processes as any other work of art that happens to be more familiar. It is a surprise, a stimulation that catches us unawares. But this is not important. It's part of the technique.

Bilio —————— So why has he chosen our channel for his video?

Joachimides —————— Because it's a good program and between us, he's learned from friends that you'd understand better what he's trying to do.

Bilio —————— Mr. Zenakos, will you explain why these art works are so important? You write a column in *Vima* that one doesn't have to be an expert to read.

Zenakos —————— Take for instance the work Christian is making. Right now I can say this, which may shed some light on his choice. When you set up a TV show, you aim it at the viewers. It is important to believe there is a viewing public. When an artist creates a work, he does it because he wants to create it. He does wish that it does well and succeeds. But even if no one was going to see it, he'd still do it. It is a personal need.

Bilio —————— Yes.

Zenakos —————— So there are two situations that are interconnected but also quite different. As a work of art, this is Christian's personal vision. As a TV show, it concerns thousands of viewers who are watching, trying to make something out of it. This is a link between art and the real life which is extremely valid in contemporary art.

Apostolaki —————— And I was reminded by something that Malraux had said—since my participation in this very interesting discussion has something to do with politics—and Malraux, a man of letters with a great contribution to France's political life as minister of culture in de Gaulle's governments, had said something that greatly impressed me when I read it. He'd said that one should use the mediums of art and become familiar with art as much as possible not for the purpose of giving more art to life but to give more life to life. And I don't think there's anything more important than the contact we can have with art in any of its forms. Whether it's an exhibition or a great film or play or opera, it makes you feel that you live more ...

An Outlook trailer is shown.

Bilio —————— We're back. Do I look different as a work of art? How do I look, Mr. Joachimides?

Joachimides —————— What makes the difference between life and a work of art?

Bilio —————— We'll get our answer from his video. Mr. Zenakos, do you think that the number of those interested, the curious ones, those who wonder what is going on there ... is that number increasing? Does an event like this make more and more people interested in such things? Does it make them want to find out more about such events?

Zenakos —————— Well, look at him. Wouldn't you want to find out more about what this man is trying to do?

Bilio —————— Christian is also very cute.

Zenakos —————— I do think that many works of art are devastatingly interesting. They make you wonder what are the thoughts of someone who's done this or that. We are here because Christian has had this idea to get us together and make us talk about someone who himself does not talk. It is a bit strange, isn't it?

Bilio —————— After all, this is a study in silence. At a time when we all talk too much, as Mrs. A pointed out. Politicians also talk too much, I mean too much. Wouldn't you agree, Mrs. Apostolaki?

Apostolaki —————— They do, but not all of them.

Bilio —————— At a time when there's much talk, and TV presenters are among those who talk too much, and there's also too much information, there's this man who says, "Let's get together and see how one can function through wordless communication." Mr. Vernikos, as a person and a businessman, not as an art collector, what do you think when you hear that we learn through this other form of communication: the communication of bodies, messages of a different form?

Vernikos —————— Man's ability to communicate is a great gift. To communicate with others, regardless of education etc. Involvement in art and culture helps to develop this gift. To communicate with a silent man like our artist here means that you have to make the effort. This kind of effort will help in all aspects of your life.

Joachimides —————— It also stimulates you.

Vernikos —————— It stimulates you and also it makes you more patient and teaches you to compromise. You want to understand what he's trying to say. Then you think, am I a retard? Why can't I understand him? And then you find out that even Christos Joachimides, educated people like this guru of the arts, even they do not understand, and you are filled with relief. If Christos can't understand him, then I'm not a retard.

Bilio —————— I'm sure you will understand then what contemporary art is like.

Bilio —————— I wish you all the best then. Thank you, Mrs. Apostolakis, Mr. Vernikos, Mr. Joachimides, Mr. Zenakos for being here today. Let me thank Christian Jankowski again, who was here as a silent figure. He wants us to keep a minute's silence, but I'm afraid we can't do this as we have to go over to our next feature.

Vernikos —————— Fifteen seconds, perhaps?

Bilio —————— 15 seconds on TV, Mr. Vernikos, can be a very long time.

Vernikos —————— How much do 15 seconds cost?

Bilio —————— I don't know. We have to ask. But Melvin Sparks is waiting ... Would you like to stay and listen to him until six?

Vernikos —————— Let's stay! Why not?

Bilio —————— Mrs. Apostolaki, you'll like his music.

Apostolaki —————— I'm sure I will but I'm afraid I'm pressed for time.

Bilio —————— I was sure about it. Politicians always are.

The Melvin Sparks band plays. Jankowski and Bilio start to dance as titles roll.

Do I look different as a work of art?

-We'll get our answer from his video.

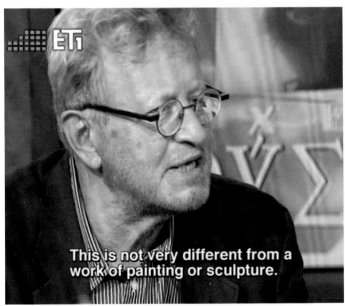

This is not very different from a work of painting or sculpture.

-Let me explain to viewers who may have just joined us...

This is a link between art and the real life...

As a TV show, it concerns thousands of viewers...

As a work of
Christian's pe

, this is
sonal vision.

25. **Puppet Conference**

2003

Famous television puppets have assembled for a forum on puppetry and mass media at the Carnegie Museum, moderated by Art Cat, the Carnegie's educational mascot. Grover, Fozzie Bear, and Lamb Chop address issues surrounding their own identities, their function on television, the roles of televised puppets, and the messages of their respective programs. The Sock Puppet reports live from Times Square on the conference.

Color DVD (25 minutes).

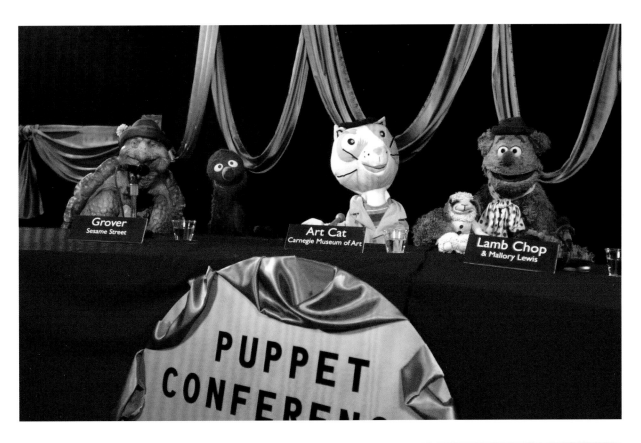

A movie is not about what it is about. It is about how it is about it.

Roger Ebert

The Hunt
Die Jagd
1992

For one week, Jankowski only eats groceries he shoots in the supermarket with a bow and arrow. If security guards catch him and throw him out, he goes on to the next supermarket. One such uninterrupted excursion is filmed. While the arrows are still stuck in the products, the cashier rings him up as if nothing were out of the ordinary.

Performance, color video
(1 minute, 11 seconds), billboard,
and 5 color photographs.

Rosa

27.

2001

The director Lars Kraume approaches Jankowski for permission to use *The Hunt* and *My Life as a Dove* in his major German motion picture, produced by Columbia Tri-Star Pictures, *Viktor Vogel—Commercial Man*. The film tells the story of Viktor, an advertising executive who steals the concept for a campaign from an artwork made by his girlfriend, Rosa. Jankowski produces his own artwork on the back of *Viktor Vogel*, filming on the same sets, and utilizing the same actors, asking them to break out of character to answer questions about film and art relevant to each scene. Both films premiered in Berlin at the same time; Jankowski's at the Berlin Biennale, and Kraume's on general release.

35mm film transferred
to DVD (19 minutes).

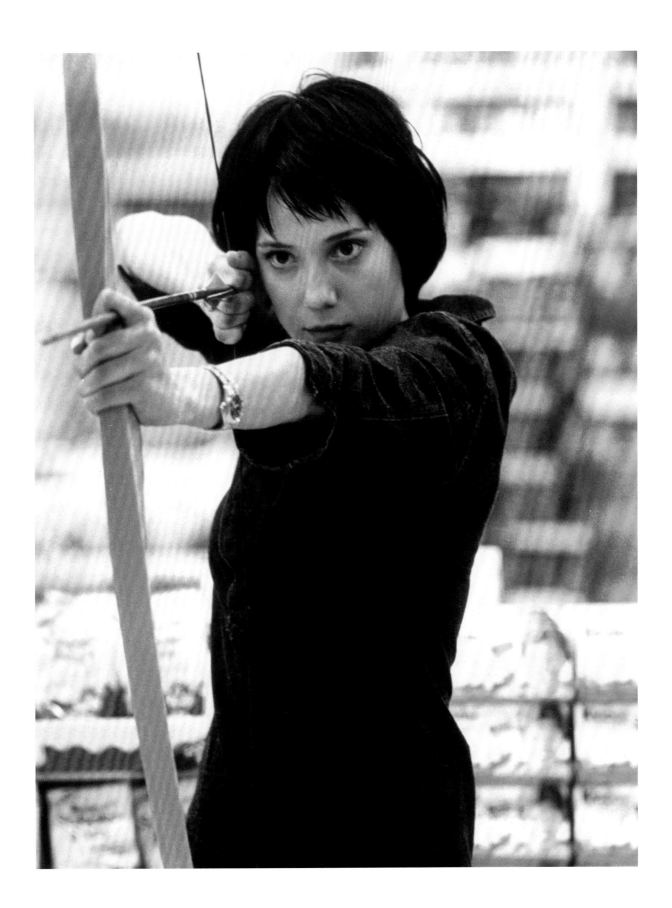

ROSA

**WELCHEN WERT
HAT KUNST?**

What's the value of art?

If everyone created a little more art,
things wouldn't be so fucked up, I'd say.

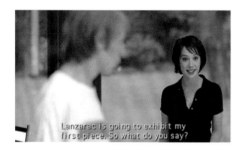

Don't you think that Rosa should paint
too? Video is no medium.

And...err...combining different
things and claiming that...sort of...

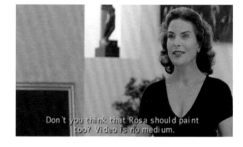

Don't you think that Rosa should paint
too? Video is no medium.

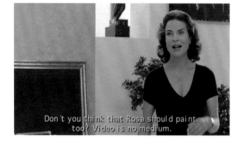

Lanzarac is going to exhibit my
first piece. So what do you say?

**WELCHE ROLLE
SPIELT SEHNSUCHT
IN DER KUNST?**

What is longing
within art?

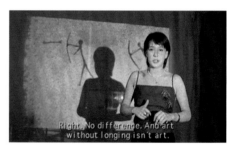

Firstly, I don't understand
what is that. Art...

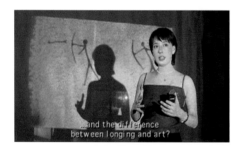

...and the difference
between longing and art?

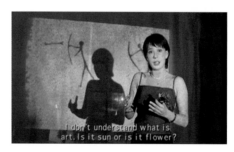

I don't understand what is
art. Is it sun or is it flower?

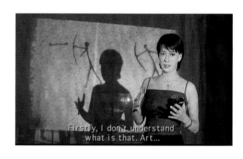

Right. No difference. And art
without longing isn't art.

I think it sounds like poetry,
coming from your mouth.

The International Situationalists?

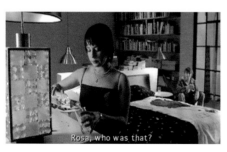

Rosa, who was that?

**WO SIND DIE
GRENZEN DER
KUNST?**

Where are the limitations
of art?

Hallo, what are you up to?

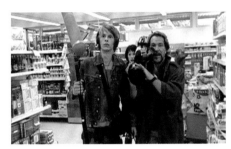

I'm trying to find out the limits myself at the moment.

But I wanted to say that artists should...err...jump beyond those limits.

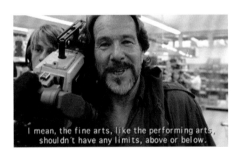
I mean, the fine arts, like the performing arts, shouldn't have any limits, above or below.

I mean...whatever sort we are... I at least am limitless.

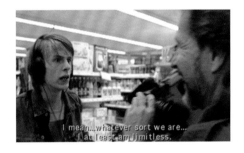
I mean...whatever sort we are... I at least am limitless.

Where is he?

BERÜHREN SICH KUNST UND HUMOR?

What do art and humor have in common?

" The doctor: "Where did these come from?" and Mickey: "No idea, doc. Is there a card?"

They don't go together. Art is art, neither serious nor funny.

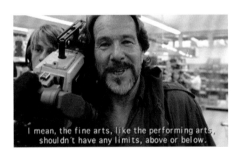
This is a joke, isn't it?

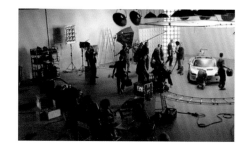

WAS IST SCHÖNHEIT IN DER KUNST?

What is beauty in art?

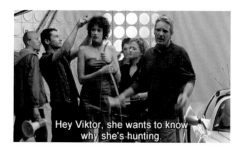

Hey Viktor, she wants to know why she's hunting.

The style's gone. The pan's too smooth.

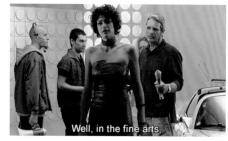

Well, in the fine arts,

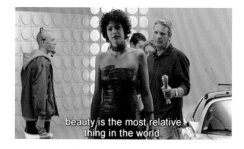

beauty is the most relative thing in the world.

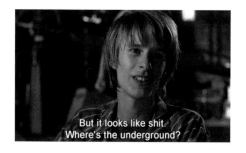

But it looks like shit. Where's the underground?

WIE FREI IST DER FREIE KÜNSTLER?

How free is the free artist?

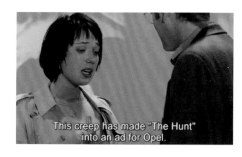

This creep has made "The Hunt" into an ad for Opel.

The critics will massacre us!

Don't cry!

no matter what the critics say...

BEEINFLUSSEN SICH KUNST UND KOMMERZ?

Do art and commerce influence one another?

Good evening, ladies and gentlemen! Welcome to our magic show!

Hello, are you the gallerist? - Yes, Jan Osterfeld.

when art becomes too commercial,

it loses the character of art, I think.

art evaporates and that's fine.

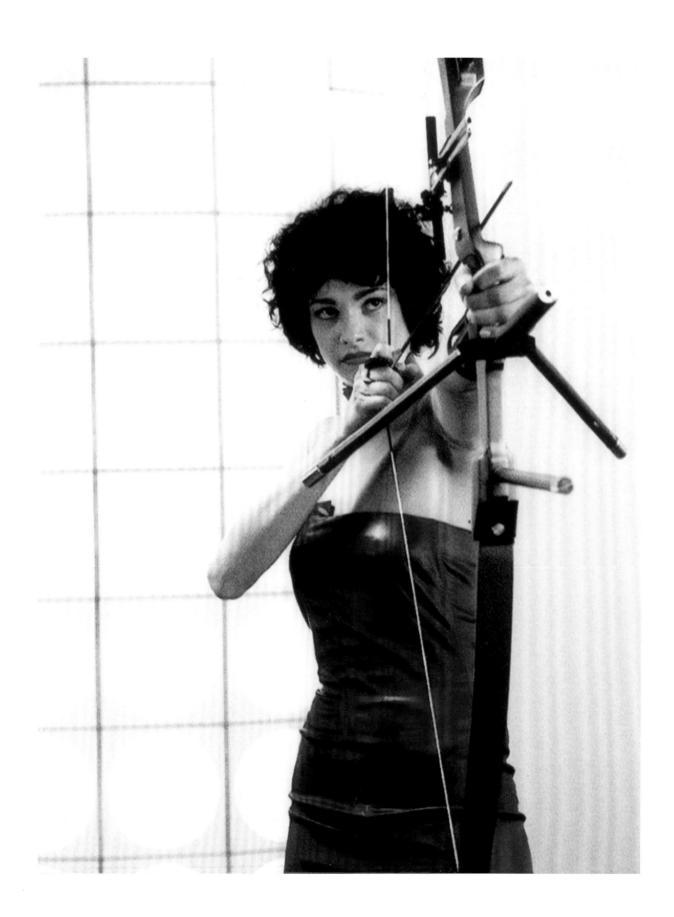

This I Played Tomorrow

2003

Jankowski interviews cinéastes, aspiring actors, and random passers-by he meets at the entrance of the Italian studio Cinecittá about their dreams and ambitions regarding cinema. Their answers are then turned into a film shot at Cinecittá on the set of *Francesco d'Assisi*, where they perform their ideal roles. The script comprises direct quotes from the interviews; the interviewees' beliefs and opinions, including their ideas concerning performance, costume, and set, become the film's content. The casting video and the film are installed adjacent to one another, and run simultaneously.

Color film in 35mm (12 minutes, 45 seconds)
and color video (68 minutes 6 seconds).

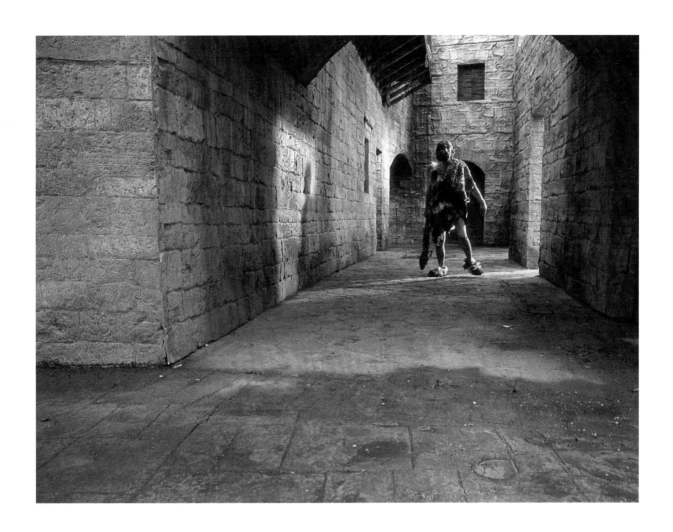

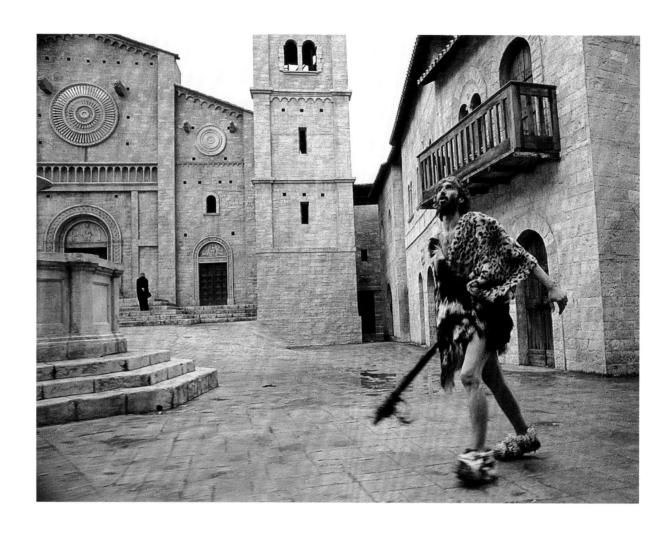

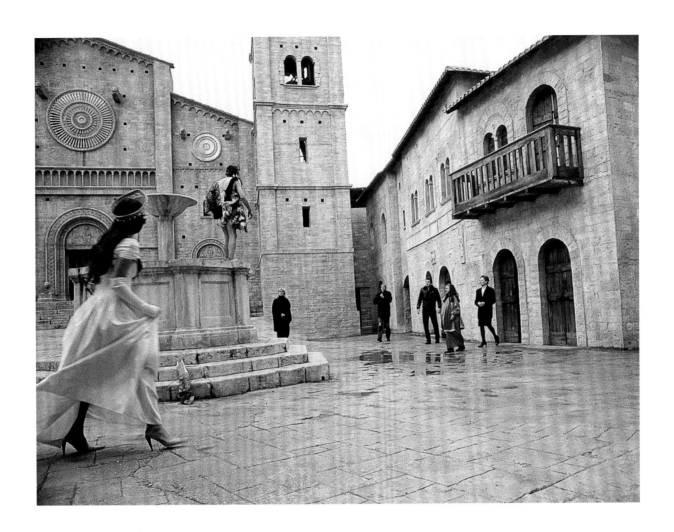

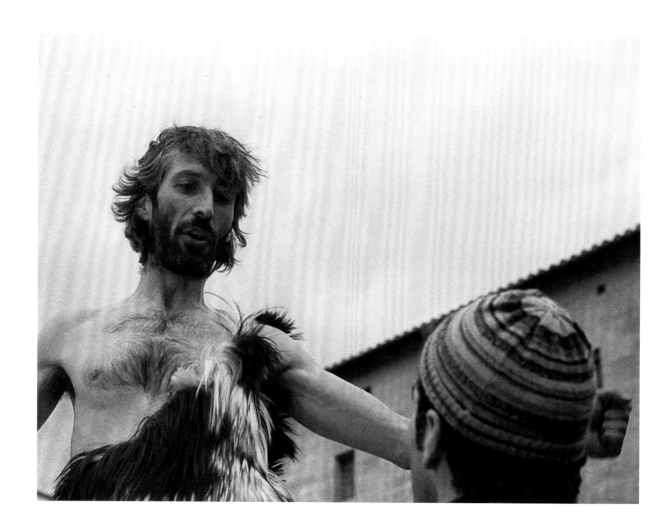

<u>Scene 1</u>

Pasquale enters the square

Pasquale ———— Ooohhhaa … ohhhh … ooooohhhaaa! *(His primal screams attract a group of people).* I'm the one who gets to introduce language into primitive society. I'm the first man to bring dialogue. My message is that we obtain much more with dialogue than with violence.
Ralph ———— Why are you screaming? The big lies come from Hollywood. It's depressing to see everything in black and white.
Pasquale ———— All this is damaging and not constructive. I like to construct, not to destroy.
So I say: no weapons, no violence. Dialogue! Dialogue!
Ralph ———— If you think that truth lies here or there, you've missed it. Because you're not considering the complexity of reality and of what we are.
Ilaria ———— But no! The fact that something might be impossible in reality just might be a lie.

People applaud

Ralph ———— It's also important to convey imagination, to inspire people to imagine. In this sense, one can not talk of salvation but of another point of view which can be useful. This way you can face a situation of personal trouble.
Aurora ———— For Catholics, salvation does not come from cinema but from somewhere else, from up there. And it could be an important message, a message of peace, since at the moment we do need it.

Scene 3

Aurora stands in front of the church and speaks to the people in the square.

Aurora —————— Not even a month ago, I lost my only son. He was thirty. And I am ... I want to dedicate this to him. This is the reason why I'm here. He was a musician and ... I can also sing. I think my son would have had this to say: "Peace among the youth and all the people in the world." This is his message and so it's also mine. And out of love for him I'm looking to convey something to others in his name. Also to those mothers who have lost their children, to give them hope that one day we'll meet somewhere. If one believes in such things.

she hums and sings

Mmm ... San Francesco, poor and humble, is entering rich into heaven, honoured with celestial praises ... mmm ...

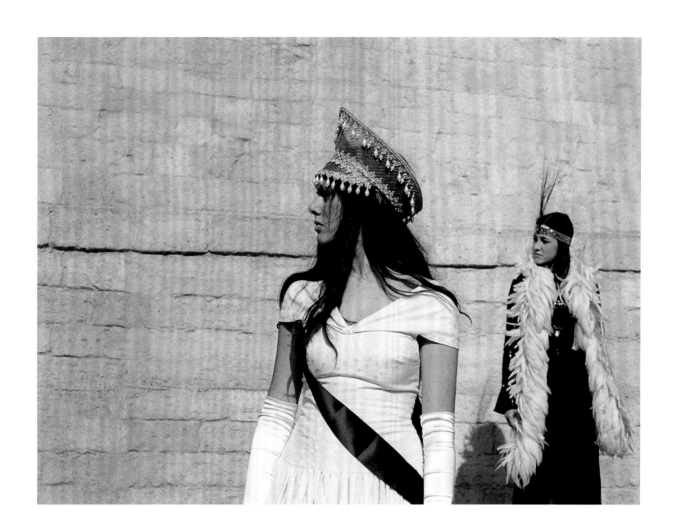

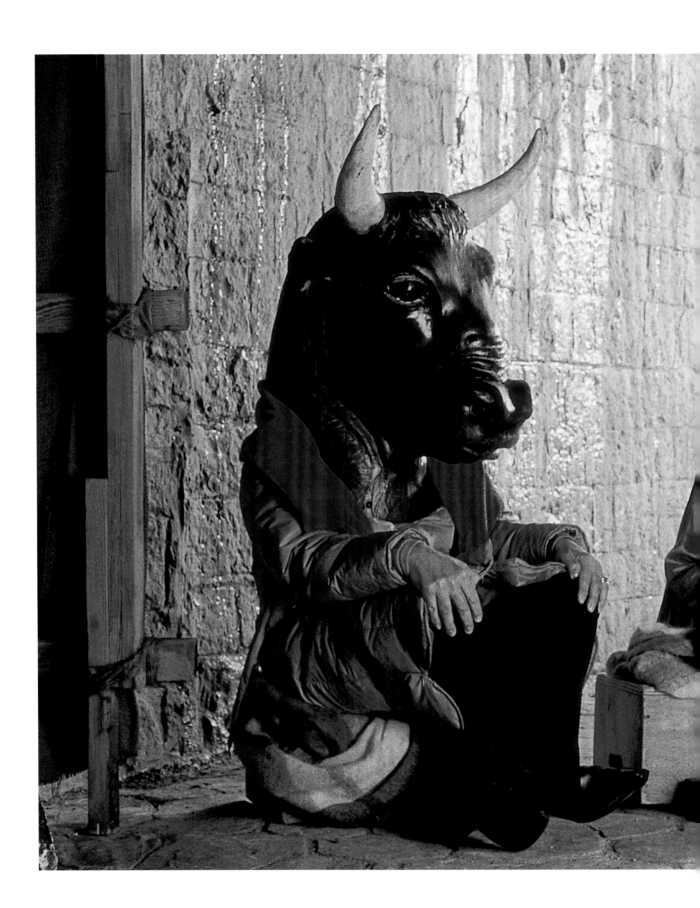

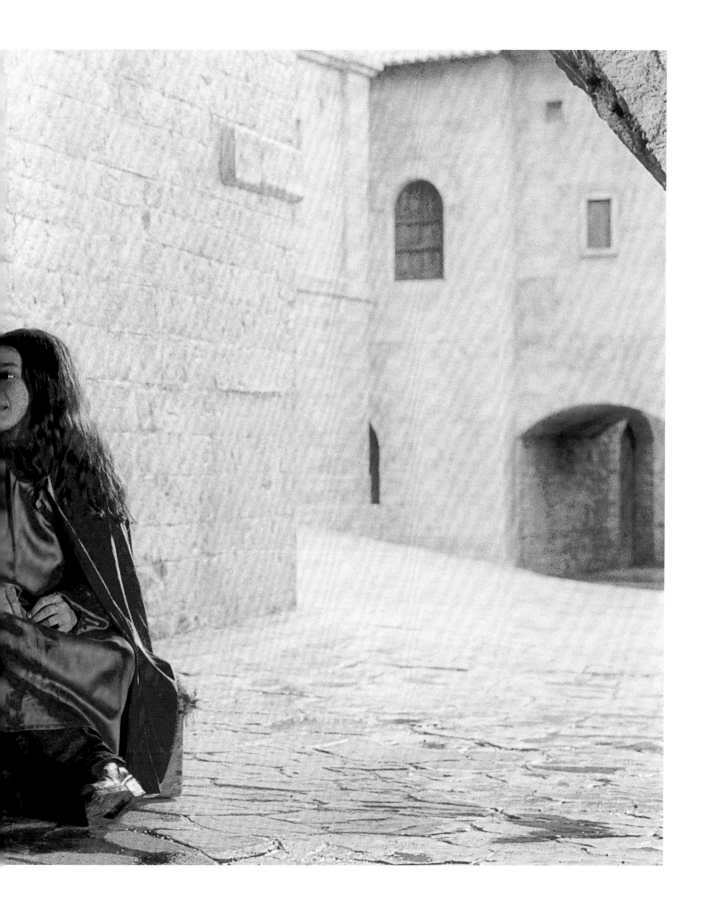

Scene 8

Alessia ——————— At night I stay up for hours, reading and committing scene after scene to memory.

Federico ——————— I spent tons of money on theatre classes in Bergamo, a gloomy and dark city in the North. And you know, they never made us act.

Alessia ——————— Earlier, I talked about that book by Goethe I finished reading recently, *The Sorrows of Young Werther*. I'd like to play the part of Lotte, the girl Werther falls in love with. What it tries to convey is beautiful and symbolic: to live life to the fullest, to live the present ... Don't live like young Werther, who destroyed himself in his search for truth. Live, Federico! Live this moment. It's an extraordinary way of escaping reality! Only now do I realize that I've been taken ...

as they walk, set construction becomes visible from behind ...

Federico ——————— Alessia, it's us! We're the ones being devoured by this mass pseudo-culture ...

Alessia ——————— Federico, what do you want to prove?

Federico ——————— What do I want to prove? I always thought that cinema can't express opinions. It's not a channel of truth, but must express emotions. And I'd like to express the emotion of astonishment at human beings. It always hits me, when I meet someone new, like you now ...

they come closer, as if about to kiss, then something behind Federico catches Alessia's attention

Alessia ——————— Look, Federico, look!

they turn around towards the cast and film crew—all join jumping and celebrating

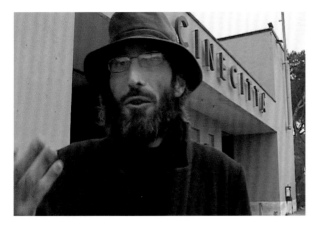

What role would you like to play in a film?

Pasquale Guarini ———— What role ... ? I'd say, something medieval, maybe. A medieval film. A film shot in costumes, something medieval or before that. Frankly, I'd really enjoy something before Christ, something prehistoric, with prehistoric men. I'd like that. I'd enjoy the prehistoric thing very much.

Why is this interesting for you?

Pasquale Guarini ———— You see, I was born in a city where ... a Neolithic city, a primitive city, one of the most ancient cities in the world. I was raised looking at caves, at the homes of primitive people, and that was always intriguing to me.

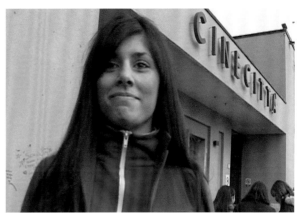

What role would you like to play in a film?

Ilaria Cervelli ———— I think I'd like to play a princess, because... because it's always been every girl's dream. And I think I'd like to cry in front of the camera. I'd like to know how to cry in front of the camera, because I think that the best actors are those who know how to cry.

Would you like to do anything else, or just cry?

Ilaria Cervelli ———— Well, everything else, maybe ...

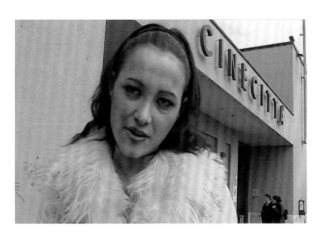

What role would you like to play in a film?

Alessia Natale ———— Well, I think that my personality, or let's say rather ... my extensive education will be useful, and identifying oneself with someone else requires sensitivity. But if I had to play the... If I had to think only about the ... main role, I'd think of a dream I had as a child, the dream of becoming a policewoman. So that would be the role I'd like the best. An armed woman, guns, martial arts ... Yes, that's it.

What's the most important message that you'd like to convey to the audience?

Alessia Natale ———— Well, I ... Earlier I talked to you about this book by Goethe I finished reading recently, *The Sorrows of Young Werther*. I'd like to play the girl's part ...

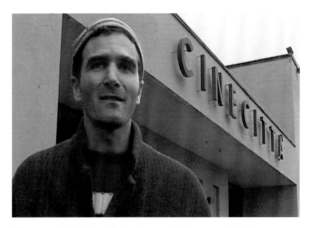

What are the big lies of the cinema which you wouldn't want to be yours?

Ralph Hendriks ———— To me, all those big lies come from Hollywood, because seeing everything in black-and-white is so depressing. It doesn't correspond to the complexity ... of people, and relationships between people. It warps reality.

Would you like to act in a film, even without getting paid?

Ralph Hendriks ———— Yes, I'd like to, for sure! It would add to my resumé, and it would build my reputation. So I'd like it, yes.

29. **What Remains**

2004

Jankowski stations a van with a small studio in its back outside New York theaters. There he asks exiting moviegoers to recreate, in the present tense, thoughts or emotions that had gone through their head while watching the movie they had just seen, without revealing the film's title.

Color film in 16mm
(11 minutes, 33 seconds).

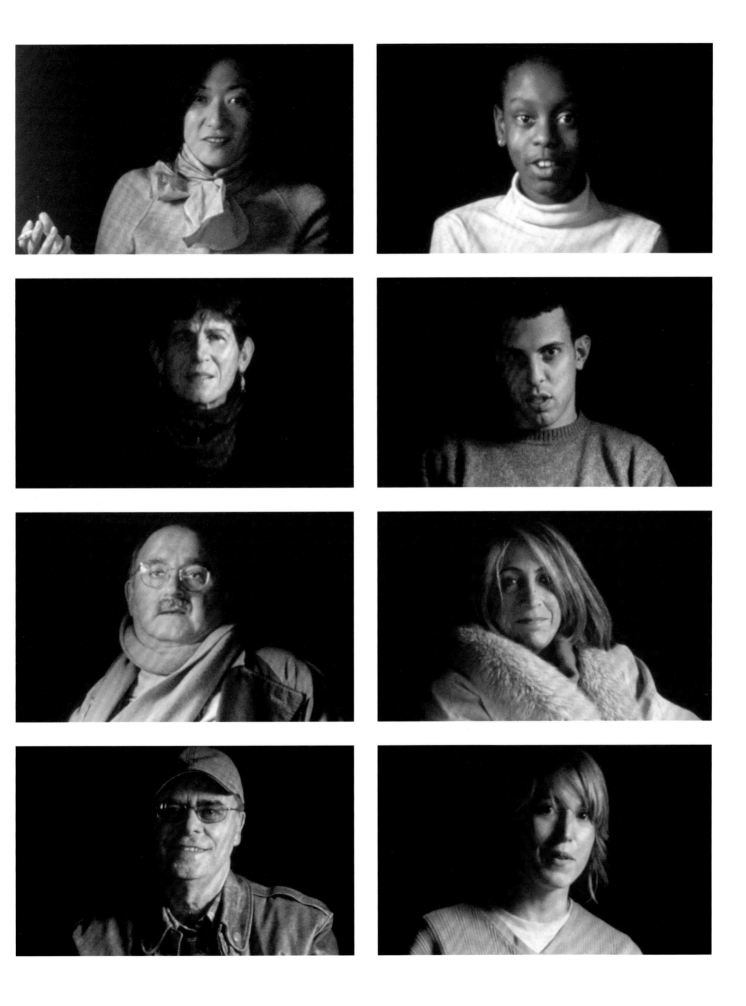

Hollywood Snow
Hollywoodschnee
2004

Members of the German film business who normally work on a film's practical realization, as opposed to the creative process ... a private investor, a state funder, a producer, a distributor, a festival director, and a film critic ... describe their visions of the ultimate cinematic moment. As they recite their monologues, a special effect occurs, the exact nature of which they have until now been unaware.

Color film in 16mm
(12 minutes).

And I can't really describe my vision in an image,

I can see a simple and comprehensible fiscal framework

I laugh and I cry, and the mystery of love unravels before my eyes.

It's a circle with lots of colors.

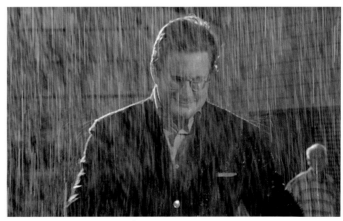

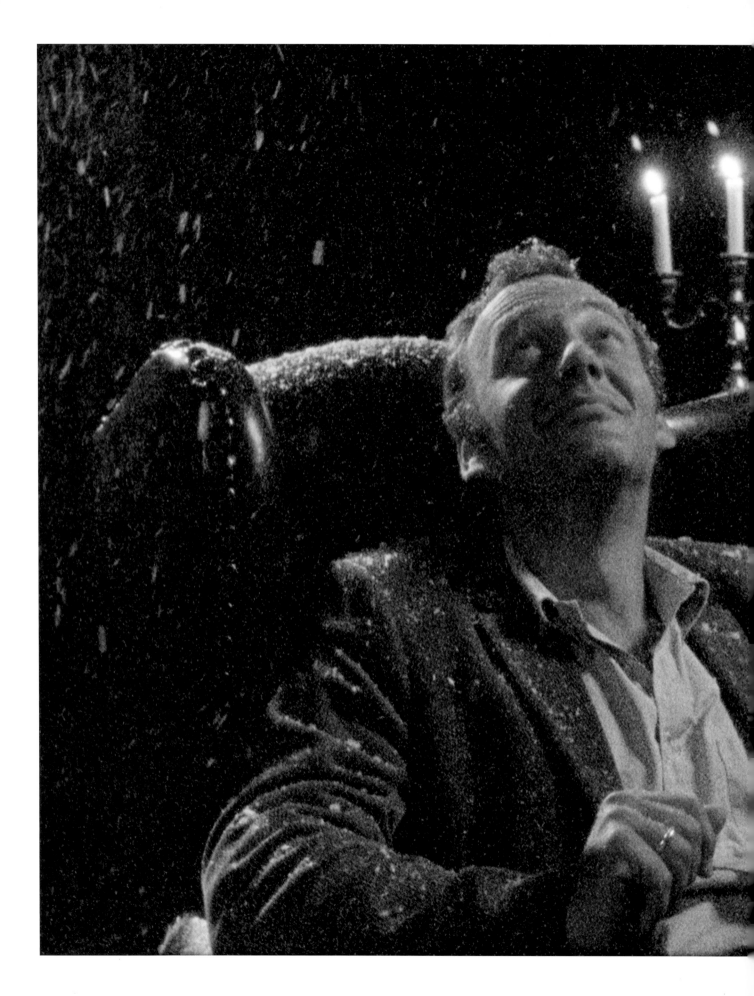

16mm Mystery

2004

Jankowski approaches two special effects experts, the Hollywood-based Brothers Strause, to help him bring to life a 35mm film project. Jankowski insists upon the skeleton of the action: The artist carries film projection equipment to a place, where he sets it up and screens a film. The film screening then triggers a special effect. Jankowski commissions the Brothers Strause to flesh out the details and choose what type of digitally-created effect the screening will generate.

Greg and Colin Strause set the action on the roof of a parking lot against the background of the Los Angeles city skyline. Jankowski sets up a 16mm projector atop the parking lot and starts his film rolling. He then walks out of the picture as the projector continues to run. Ten seconds later, the silence is jarred by a loud rumble, and the skyscraper in the background explodes in magnificent Hollywood blockbuster fire. When the dust settles, Jankowski returns, packs up his equipment, and leaves the scene without ever revealing the content of the 16mm film.

Color film in 35mm
(5 minutes).

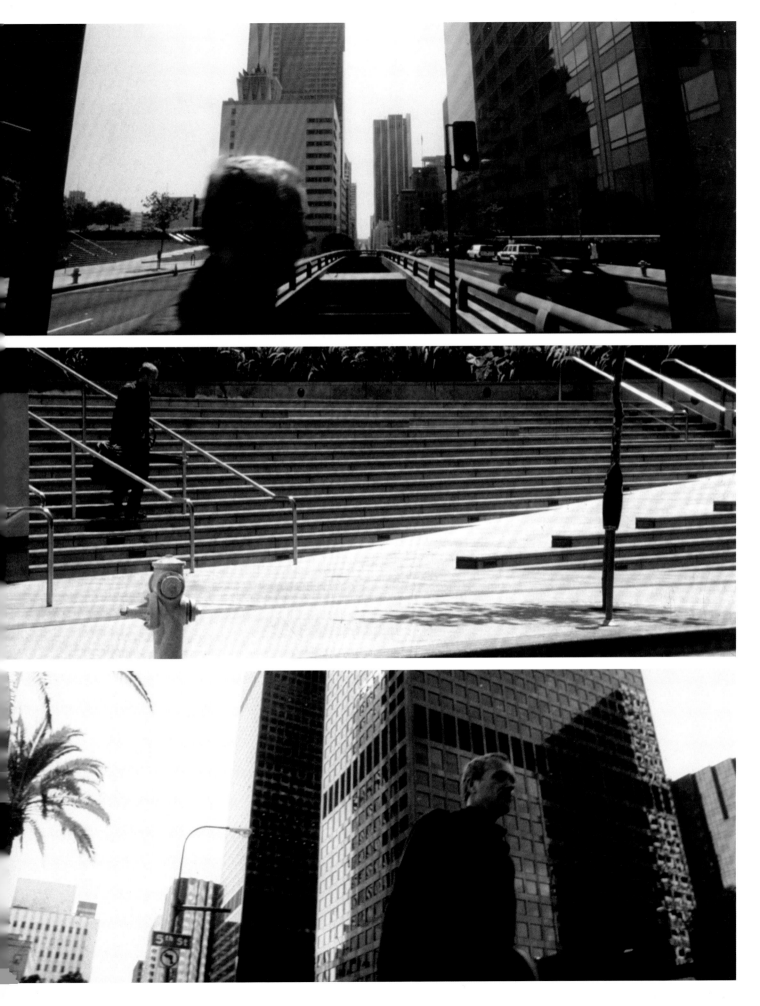

Conversation between the Brothers Strause and Christian Jankowski

CJ ———————— When I came to LA, I only knew that I wanted to make a work using special effects created by Hollywood professionals. Driving up and down Sunset Boulevard didn't help me find the contacts I was looking for. So my gallerist here in New York, Michele, sent me to some LA galleries, to see if they had any collectors in the film business. Blum & Poe mentioned a collector of theirs who was the producer of *The Fast and the Furious* (2001), Ori Mamor. After a couple of weeks I got an appointment with him, and I went in there and just talked about my concept to him and explained what I wanted to do. He said "I know two brothers ..." and immediately he picked up the phone and called you and somehow he hooked us up.

Greg Strause ——— It was funny because our manager for our feature career on the directing side, he knows Ori. He had just introduced us. It was probably a matter of great timing that Ori had just been over here a few weeks before and seen the special effects work we were doing on *The Day After Tomorrow* and a bunch of other movies we had been working on. It was just one of those serendipitous, perfect timing, good luck kind of situations.

CJ ———————— Greg, I met you first and showed you some of my work, and described my idea for *16mm Mystery*. As I initially explained, I wanted you guys to do everything for the film— the initial concept constituted my only participation in this whole project. What was your impression, and how did you explain "this crazy guy" to Colin?

GS ———————— "The crazy German guy?" As filmmakers and as effects guys, it's pretty easy to get pigeonholed. If you make a spaceship for a movie, the most likely thing people are going to give you work on is another spaceship. So when Ori said I should meet with you and you came over, your proposal was very attractive to me because it offered us the chance to do something completely different, to work in a whole different field. Our work appears either on music video stations, or cable and TV stations, or it's in the movie theater. We never thought we would do a piece that would be shown in a museum. The idea of showing something we made to a whole different audience was very appealing—not to mention the concept's really cool. So I said to Colin, "Here, check this guy's stuff out. This is kind of cool." And, at least to us and to Hollywood, cool is everything. If it's cool, we want to do it. If it's not cool, we want to charge a shitload of money. But if it's a really cool movie and it's going to do something good for your career and you have a good time doing it, you figure out ways of doing it for less.

Colin Strause ——— It was fun, too. My first thought when I heard Christian's idea was "How the hell would we ever do it?" But once we started to wrap our heads around it, we started to look at the project as a fun challenge. We are so busy, but it's nice to do something fresh and I actually loved being this little guerilla film unit running around downtown Los Angeles, stealing shots.[1] It was cool. We've never done that before. We've never had such a small crew, but it still came out so nice. You think you would need a giant budget and a giant crew to pull that type of thing off.

CJ ———————— When you worked on *Titanic*, the director or somebody would say "Oh! You know, we need an iceberg." So you guys made the iceberg. What was it like to start working without a clear story line?

GS ———————— We like to contribute as much to a project as possible. For the movies we do usually have to execute someone else's vision, but when we direct commercials and music videos, we have a lot more creative influence, especially with music videos, where oftentimes we come up with the concept from scratch. So, having a little bit of room to actually give the project life is actually a really fun part of our work.

CJ ———————— I said you could also use special effects that you had lying around, or had even been used previously, but you really created something totally new.

CS ———————— We sold ourselves on the idea of trying to reuse as much of our know-how [as possible], but the reality is that we did have to come up with it from scratch.

CJ ———————— Were there also other ideas that went through your head before you decided on the skyscraper? I know you were also talking about doing something in the desert.

GS ———————— I have to say I honestly gravitated right towards the city thing almost immediately.

CS ———————— I thought an iceberg would be a good idea.

CJ ———————— You thought what!?

CS ———————— A giant iceberg breaks apart in the background! No, I honestly have never deviated from that first mention of the concept. A building coming down is just an unbelievable sight, and I think from our initial conversation where you mentioned that old painting and how those buildings in the background are coming down, just that thought of "What would it be like today?" got me hooked. A falling skyscraper, especially since September 11, provokes such a huge emotional reaction it seemed like such a perfect image to help show the power of film. It just seemed perfect to me.

CJ ———————— The Baroque painting represents God's power, as well as the power of painting, and I put you two guys in the position of being God-like creators. How did you feel? Did you think about your God-like responsibility? Or, did you immediately think about the audience you had in mind? How was it?

GS ———————— It was a pretty natural feeling.

CJ ———————— Yeah?

GS ———————— No I'm kidding. I mean, I don't know if we ever approach filmmaking thinking like we're Gods, but I guess in some ways we do have that power because in the world of digital post production we can put anything anywhere and make anything happen. Maybe we get so numb to it because we do it every day, though. Then it's no longer special. Sometimes it's very hard to disconnect from that because you are so used to being like "Blow up a building? Sure!" or "Make the dinosaur walk? No problem!" It doesn't even cross your mind that you're making something that no one has ever seen before. It's hard sometimes to pull yourself back into the audience and appreciate it from their point of view. It's like mechanics: If you went back in time and showed someone from a thousand years ago a Ferrari, they would just have their mind blown, but then if you interviewed the mechanic who worked on them for the last twenty years, he would be like, "Whatever. It's moving parts, it's metal." It's two totally different reactions, and it just depends on how desensitized you have become.

CJ ———————— How did you then feel when you saw the final piece?

CS ———————— My favorite works of art are always ones that remain open to interpretation. Sometimes when you give away too much, the audience can't take anything away with them, or so I've found in our own projects. If you go on-line to the different chatrooms where people are talking about your music video, the people that like the video liked it for reasons that we never even

thought of when we were directing the video. Something like, "Oh this video means this to my life because this happened to me and I really love how this image symbolized that." And we're thinking "wow, well that's cool, but that wasn't even the angle we were going for." I think what's cool about *16mm Mystery* is that you don't see the screen: the falling building can be interpreted so many different ways. I see September 11 when I see the work, but I know other people see completely different things. Some people see it and they are not even sure exactly what to think. That's what makes it cool.

GS ——————— For me, it was more about the power of media and how it can be a devastating force. A dangerous thing.

CS ——————— I'm curious about the reactions to the first viewing—the first time you showed everyone.

CJ ——————— For me one magical part about the project was that I saw it the first time in Berlin only two days before the opening of the show. I deliberately wanted to stay out of the production process. I was sitting there with my girlfriend and some people from the gallery and we were all quite impressed, especially about the high production quality. I realized that my idea could be interpreted in ways I hadn't thought of. I also put myself in the place of the audience and I thought "Oh, you are really playing with fire".

CS ——————— It's one of those things that could go over great or it could go the other way.

CJ ——————— Exactly. *16mm Mystery* is very open. But everything gets so meaningful as I walk down the streets to this music, with the great big shots of the city—it prompts you to think about the unique way in which filmic language has developed so that every event is read moralistically, especially in Hollywood. By acting in this, I implicate myself. It is almost impossible even just for the sake of an artwork to blow up a building and still remain neutral. People immediately think, "Oh, he is a sniper or a terrorist" Is he a baddie or a goodie?

GS ——————— I think that is an interesting thing about art.

CJ ——————— You know what, I think that's one of the great things about art. A lot of people really love this piece. Actually, there were two critics who wrote about it in art magazines, and one got the whole idea and gave a very positive review, and the other reviewer missed the point, that the work was a collaboration. She saw it only as bringing cinema into the gallery. So people were really divided about it.

CS ——————— People always choose a side.

GS ——————— To me the most interesting character is the guy who could go either way. It's funny that some people don't know how to handle that. They need to label him immediately. What if he is a flawed hero? What if he is a good cop and an alcoholic? Oh, we can't do that. It's strange how some people have a hard time with that concept because in real life everything is a shade of gray. It's almost a fake out in a way with *16mm*, because here is this happy guy. Wait a minute, he's not really happy. His facial expression is a little hard to judge. It's a beautiful sunny day but the film's colors are dark and blue. You can't quite figure out what the hell this guy is about to do. He displays a total lack of emotion even at the end—you still can't tell if he is going to do something good or bad.

CS ——————— It starts off with the way we introduce our character. As the audience, you want to have that emotional connection. I think that the interesting moments happen when people are nervous to embrace a character because they are not sure exactly what side of the fence they are sitting on yet. That's what keeps people intrigued, too. By keeping it so uncertain, you make the audience want to watch because they are trying to

figure out what the hell is going to happen. That builds up to that moment when the building comes down.

CJ ——————— So you don't regret doing this project?

GS ——————— My only regret is that there weren't twelve naked supermodels, up on that rooftop. That's the only regret that I have.

CJ ——————— What about you, Colin?

CS ——————— I don't think I can think of any other thing, besides the supermodels. It all worked out great. The color looked good, the edit was good, the music was awesome. Everything fell together.

1. It is illegal to film in LA without a permit.

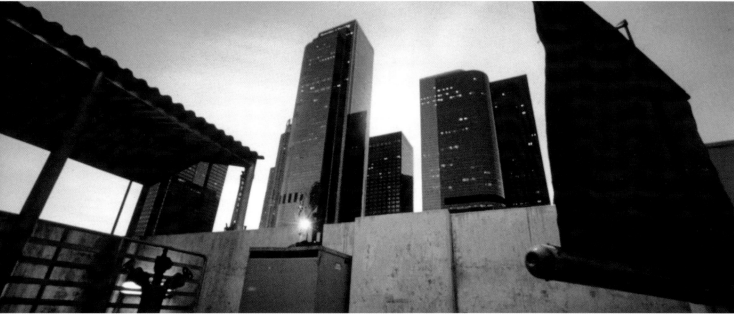
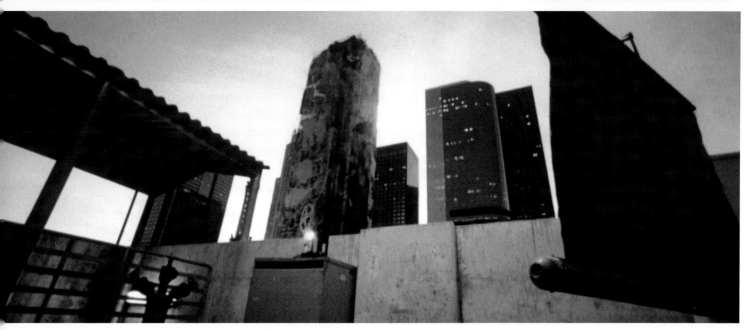

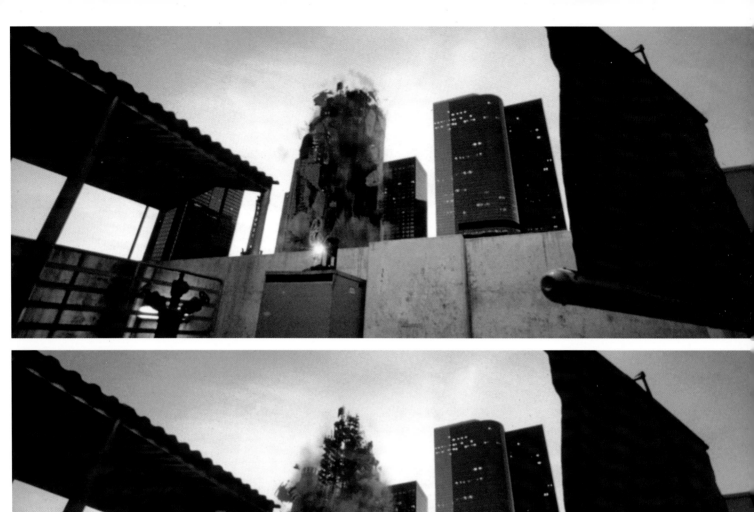
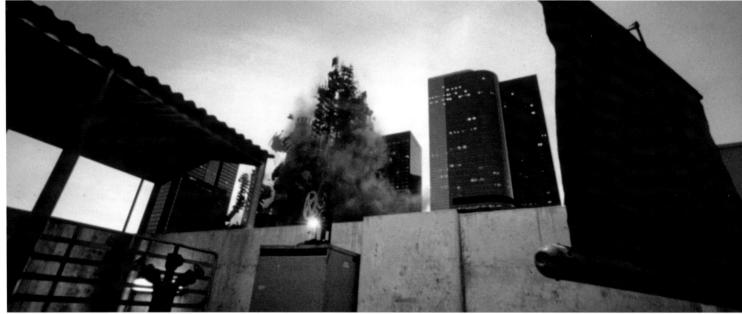
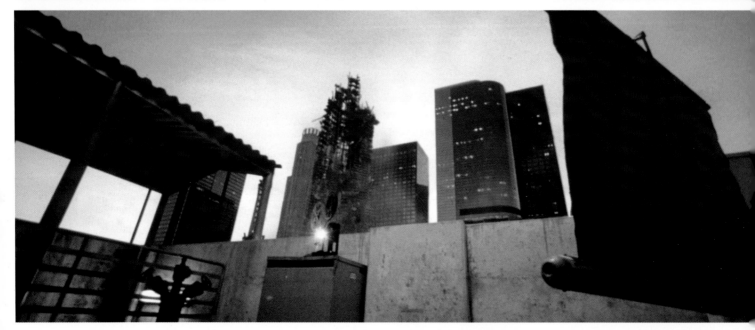

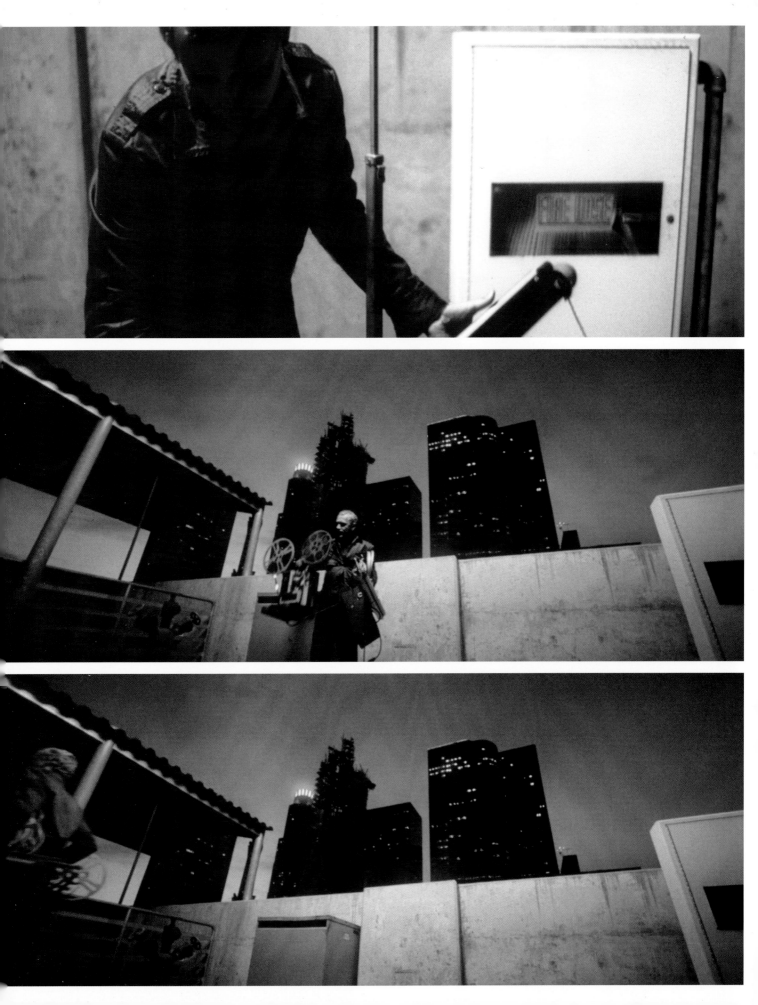

Colin Strause

Greg Strause Jeff Fleming

Michele Maccarone